PHOTOSHOP® CS
TRICKERY AND FX

STEPHEN BURNS

CHARLES RIVER MEDIA, INC.

Hingham, Massachusetts

Publisher: Jenifer Niles
Cover Design: The Printed Image
Cover Images: Stephen Burns

CHARLES RIVER MEDIA, INC.
10 Downer Avenue
Hingham, Massachusetts 02043
781-740-0400
781-740-8816 (FAX)
info@charlesriver.com
www.charlesriver.com

This book is printed on acid-free paper.

Stephen Burns. Photoshop CS Trickery and FX.
ISBN: 1-58450-297-5

All brand names and product names mentioned in this book are trademarks or service marks of their respective companies. Any omission or misuse (of any kind) of service marks or trademarks should not be regarded as intent to infringe on the property of others. The publisher recognizes and respects all marks used by companies, manufacturers, and developers as a means to distinguish their products.

Library of Congress Cataloging-in-Publication Data
Burns, Stephen, 1963–
 Photoshop CS trickery and FX / Stephen Burns.—1st ed.
 p. cm.
 ISBN 1-58450-297-5 (pbk. with CD-ROM : alk. paper)
 1. Computer graphics. 2. Adobe Photoshop. I. Title.
 T385.B86435 2004
 006.6'86--dc22
 2004024522

Printed in the United States of America
04 7 6 5 4 3 2 First Edition

CHARLES RIVER MEDIA titles are available for site license or bulk purchase by institutions, user groups, corporations, etc. For additional information, please contact the Special Sales Department at 781-740-0400.

PHOTOSHOP® CS
TRICKERY AND FX

This book is dedicated to my mom and dad
for inspiring me to always excel at what I do.
They are excellent parents.

CONTENTS

ACKNOWLEDGMENTS

Without the support of many others this book would not have been possible.

I would like to thank Jenifer Niles, Meg Dunkerley, Lance Morganelli, and Colin Smith for their patience and professionalism in properly seeing this book to fruition.

Thanks to Janis Wendt and Josh Haftel and the rest of the nik Multimedia team for their ever growing encouragement and support. Great job guys on producing a great plugin package for Photoshop.

In addition, I feel it is only appropriate to thank Adobe and Newtek for creating such outstanding software.

Also, I would like to thank the members of the San Diego Photoshop Users group (*www.sdphotoshopusers.com*) for their dedication and support in helping me build a strong network of digital artists from which I draw inspiration always.

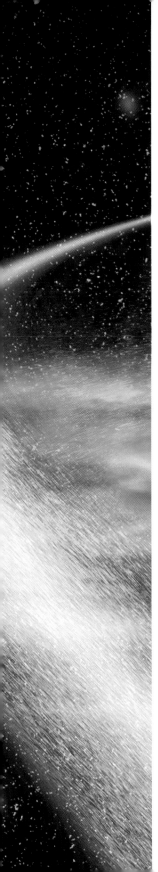

FOREWORD

When I first met Stephen Burns I knew I was talking to some-one who was in love with art. Not just any art, but digital art. Stephen is one of the most passionate people you will know when it comes to this exciting new media that melds technology with visual indulgence. Some people are still ignorant when it comes to computer assisted and generated art. They even have the audacity to assume that because you are using a computer, you need no artistic skill. I am still looking for the magic button that says "create awesome artwork automatically" and it still eludes me. In the past, photography won the fight to be recognized as a valid form of art. Today a similar battle rages with the usual opponent: tradition. This time the fighter in the opposite corner is digital art in its many forms. With a desire to see the spread of skillful digital art, Stephen spends a large part of his time educating people about the relevance and importance of this form of expression.

Because he is versed in digital art, photography, and 3D, Stephen has a lot to teach you about digital art and Photoshop. This book will be invaluable to anyone who is seeking to push the boundaries and become not just a manipulator of photos, or user of filters, but a digital artist in the true sense of the word.

Colin Smith
Digital Artist
Founder—PhotoshopCAFE.com

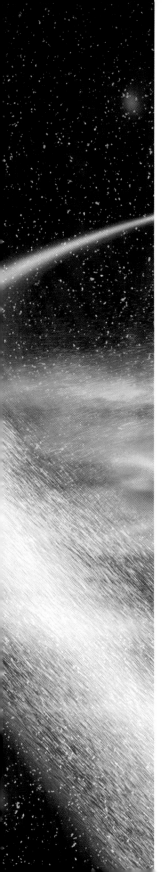

PREFACE

There is a new movement in art, and it is digital. The buzzword today is *computer artistry:* we see this not only in the special effects of fantasy movies but also in the works of common artists. For the first time in history all art forms are accessible on the Internet. Art forms such as music, poetry, literature, sculpture, painting, photography, architecture, and collage to name a few, are available to the general public as software. In addition, not only can we be creative with the computer, we can also communicate internationally with little or no financial burden. What are the consequences?

One of the immediate consequences is that a new type of artist has emerged. Many people are now inspired to become artists because, for the first time, there is a creative device that allows them to be expressive beyond just one or two mediums. They have all of the creative traditions at their disposal and they are excited about the possibilities.

Digitally produced art transcends any one style and approach, and many galleries have not yet accepted this medium as a commodity to market. This is partly because gallery owners are not quite sure what to market—most galleries are just beginning to learn about the computer's capabilities in terms of creativity and final output. Digital artists, who use the Internet to share and network with one another, create a culture whose primary focus is to discover the means to be more creative and alleviate the huge computer learning curve. This has produced an information culture with the concept of sharing at its very core. In a sense, digital artists are forced to put aside competitive differences and network with one another to survive in an astronomically changing industry.

I feel it is important to understand that the goal of a digital artist is not just about the trickery and effects that can be recreated to impress the viewer. Instead, the process for producing successful digital creations is the same formula applied to being a successful painter, photographer, sculpture,

poet, musician, and so on. Art is a language. The more fluent you are, the more successful you will be at connecting with your audience. For the first time in history, all creative mediums can be accessed and created electronically, which creates a whole new set of rules to abide by. This is why mastering the artistic medium of your choice is so important. If you can converse without stumbling over word choice, then you are a clean conduit of ideas and concepts. In other words, if you learn to understand your tools well, then you can visually express yourself with ease. That's right: learn to understand the tools because it's not enough just to know what the tools do.

This book is written for those who are already using Photoshop but are looking to advance to the next creative level. It is written in the spirit of sharing my insights about creative approaches to the digital art form. My hope is it will serve to bring together creative and technical approaches so that the reader gains an understanding of this new medium in which he can create more intuitively. In this book we will explore the thinking process of an artist as they create in Photoshop. Hopefully, you will take the concepts and ideas presented here and develop them into your own.

The tutorials are designed to prompt the reader to think more about a concept, a feeling, or just an idea, and bring it to completion. Each tutorial has a theme and together we will work to create that theme with explanations as to why and how we achieve our goals so that this book goes beyond tips and tricks.

In addition, this book is designed for use in the classroom. Students will experience a first hand example of how to work creatively through technical issues, while expressing their creativity with Photoshop. Although this book is aimed at intermediate and advanced users, beginners can easily follow the tutorials and gain insight into how to overcome technical stumbling blocks that are often produced by such a complex program as Photoshop.

I hope that this book inspires you to always find new ways to create. Enjoy.

ABOUT THE AUTHOR

Stephen Burns has discovered the same passion for the digital medium as he has for photography as an art form. His background began as a photographer 24 years ago when he specialized in creating special effects photography using a 4 × 5 camera. His studies led him to discover painting where he embraced the works of the great abstractionists and surrealists, including Jackson Pollock, Wassily Kandinsky, Pablo Picasso, Franz Kline, Mark Rothko, Mark Tobey, Francis Bacon, Willem de Kooning, and Lenore Fini, to name a few.

In time, he moved toward the digital medium to discover Paintshop Pro, Aldus Photostyler, Painter, and Photoshop. He settled on Photoshop as his program of choice.

In addition to being the president of the prestigious San Diego Photoshop Users Group (*www.photoshopusers.com*), of which there are currently 1500 members and growing, Stephen Burns has been an instructor and lecturer in the application of digital art and design for the past 10 years. His teaching style comes from his ability to share an understanding of Photoshop with his students so that they gain the ability to intuitively apply it to their own creations.

Artistically, he has exhibited digital fine art internationally at galleries such as Durban Art Museum in South Africa, Citizens Gallery in Yokohama, Japan, and CECUT Museum of Mexico, to name a few. You can see more of Stephen's work at *www.chromeallusion.com*.

SIMPLIFYING THE INTERFACE

IN THIS CHAPTER

- A brief overview of the organization of the interface
- A brief explanation of the tools bar
- A brief explanation of cascading menus
- A brief explanation of palettes

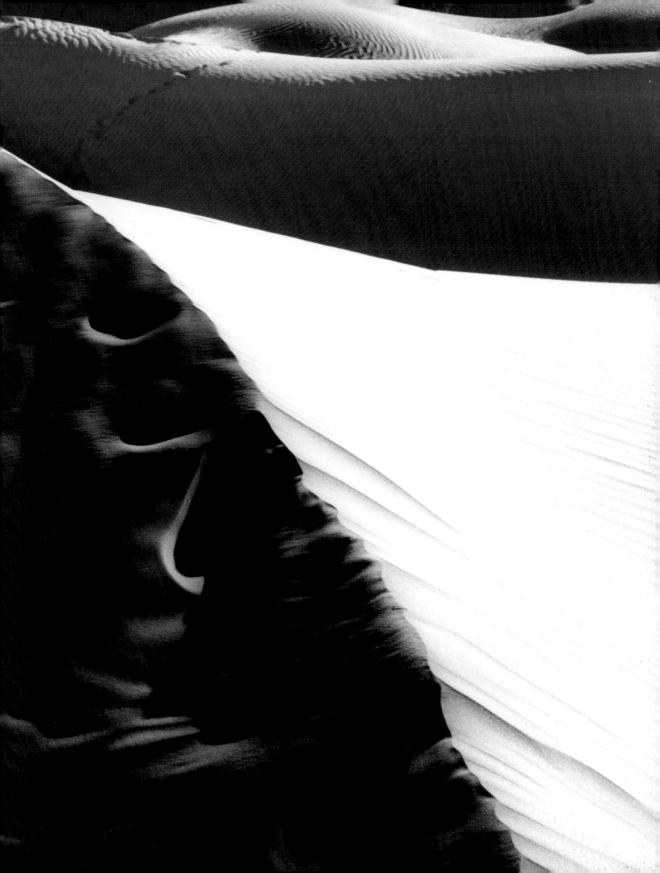

here are many technique-oriented tutorials, but few really discuss why Photoshop does what it does. We are going to take a journey to understand our digital medium, Photoshop CS. In other words, we will not just learn about what our tools can do, but we'll learn how and why they are applied. We will gain insight and understanding of Photoshop CS in the same manner as a painter understands the tools he uses to formulate his vision on the canvas. Throughout this journey we will discuss the traditional (or analog) approach so that we can make a connection to how things were done in the past. Having an insight into the past not only helps us to understand the terminology used in Photoshop CS but also serves to give us insight into what we are doing throughout the creative process.

This chapter is not intended to provide an intensive listing of all of the tools and commands in Photoshop CS. We will assume that you already have

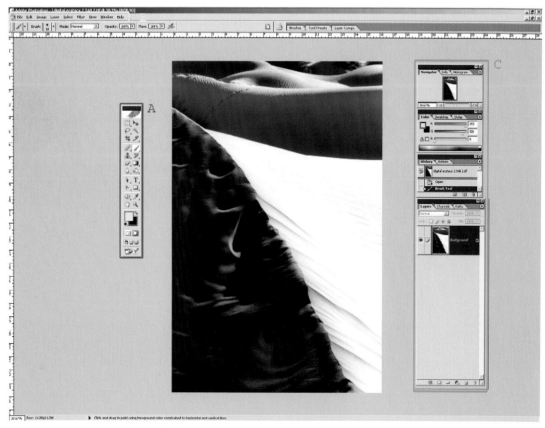

FIGURE 1.1 The Photoshop interface.

a basic understanding of the Photoshop CS interface, but in an effort to make sure that we are on the same page in terms of navigating the interface, we have included a brief explanation of the layout. Practical uses of each aspect of the interface are covered in later sections. So let's begin.

There are only three places that you will access all of your commands in Photoshop CS (see Figure 1.1). They are the:

- tools bar
- menus
- palettes

TOOLS BAR

The Tools Bar is the vertical slender bar that houses a visual representation of the variety of brushes and tools that you will use in your creations. When each one is clicked, you'll notice that the options bar changes accordingly. This happens because, like a painter, we usually don't want to apply 100% of our pigment to our canvas. Normally we start in lower opacities to build form, saturation, and density over time. This gives us control over our techniques. Also, notice that the bar is divided into sections by a thick line. The first section is your Selection tools (see Figure 1.2). The next section is your Painting tools (see Figure 1.3). Following, are the Vector Graphic tools (see Figure 1.4). Finally, there is the Annotation tool set (see Figure 1.5). As we work together we will use the Painting and the Selection tools quite regularly.

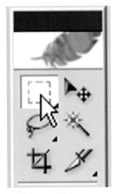

FIGURE 1.2 Selection tools.

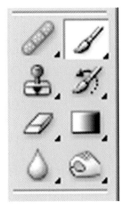

FIGURE 1.3 Painting tools.

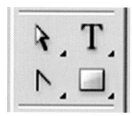

FIGURE 1.4 Vector graphic tools.

FIGURE 1.5 Annotation tools.

MENUS

The second place that you will access Photoshop's commands is in the drop menus as shown in Figure 1.6. Within each one of these are submenus that give you access to deeper commands within the program.

FIGURE 1.6 Photoshop menus.

PALETTES

The third and last place that you will access Photoshop's commands is in the palettes. Palettes are basically visual shortcuts to many of the commands found in the text menus. Note that all palettes have a drop menu located at the top right corner that looks like a small black triangle, as shown in Figure 1.7, which gives you other options for that palette.

FIGURE 1.7 Photoshop palettes.

WHAT YOU HAVE LEARNED

- A brief overview of the organization of the interface.
- A brief explanation of the tools bar.
- A brief explanation of cascading menus.
- Command palettes are shortcuts to what can be accessed in the cascading menus.

Now let's move on to a deeper understanding of how Photoshop CS works.

MASTERING PHOTOSHOP FUNDAMENTALS

IN THIS CHAPTER

- The importance of selections and how to create them
- How to save selections
- The connection between masks and channels
- How to create and edit alpha channels
- The application of layer masks
- How and why layer blend modes work the way they do

*T*he key to mastering Photoshop is mastering selections. Selections, masks, and channels are identical.

You will hear this mantra consistently throughout this book because Photoshop does not know what it is that we are trying to achieve. We must tell it what, when, where, and how to apply its effects. We do this through selections. Let's prove this concept.

By accessing the Rectangular Marquee tool, we make a selection around the door, as shown in Figure 2.1.

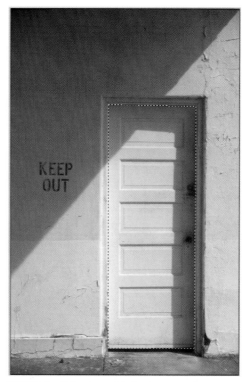

FIGURE 2.1 Selecting with the Rectangular Marquee tool.

Notice that we now have what is affectionately called *marching ants*. This is our selection. Our program is communicating to us that any areas outside the borders of these marching ants will not be applicable to any of Photoshop's commands or tools.

As an example, if we apply the Hue/Saturation command while our se-
lection is still active all of its effects will be applied only within the selected
area. In fact, all areas outside of our selection have been masked off which
supports the concept that masks and selections are the same. This approach
gives us much flexibility in choosing localized areas to apply any of Photo-
shop's commands or tools, as shown in Figures 2.2 and 2.3.

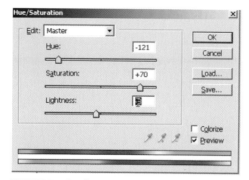

FIGURE 2.2 Applying a command to the selected
area.

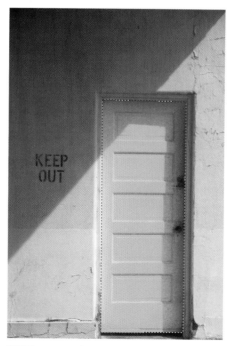

FIGURE 2.3 Working with a selected area.

SAVING SELECTIONS

We work diligently to create our selections, so it's a good idea to have the ability to save them. Photoshop gives us this ability. Because we are about to modify a selection, we will access the Select menu to save it to the file (Select > Save Selection). Note that our dialog box gives us the option to name our marching ants. In this example we choose to call it "Door" and commit our changes. If we want to gain access to our selection again, then let's discover where to go to retrieve it.

This is where we make the connection to an often intimidating area of Photoshop called the Channels palette. Make sure that your Channels are visible (Windows > Channels) and look at the thumbnail at the very bottom. Does it look familiar? Our selection has now become an Alpha Channel (see Figure 2.4).

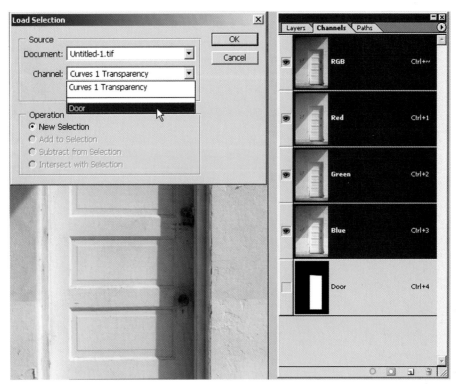

FIGURE 2.4 Using the Channels palette.

Channels, selections, and masks are the same. In essence, our selection has become an additional channel to our original RGB color channels. In fact, it is titled "Door" just as we named it. It is important to understand that when selections are saved they go straight to channels. Now let's look a bit further.

If we can save a selection into channels then sometimes we will need to recall them. So how do we bring our selection back again? We can activate our Load Selection command (Select > Load Selection). If you select the Channel Drop menu you will see a list of our alpha channels. In this case we have only one. If we select "Door" and commit our changes, our marching ants are once again loaded into our document. The shortcut for loading our channels as a selection is simply to Ctrl click on the channel itself.

Editing Our Alpha Channel

Now let's deselect our marching ants (Ctrl D) and click directly on the "Door" alpha channel. We now have a visual of our mask. Note that in Figures 2.5 and 2.6 our foreground and background colors are now black and white. Why?

FIGURE 2.5 Mask view on desktop.

FIGURE 2.6 Mask view in layers.

This mask is nothing more than an image made up of 256 shades of gray. In fact, we have the ability to create selections that will have 256 levels of effects. Therefore, we should be able to paint directly on the mask to alter its form. Let's try it.

If we access our Paintbrush tool and make sure that our foreground color is white, we can alter the image by painting directly on the alpha channel itself as shown in Figures 2.7 and 2.8.

FIGURE 2.7 Painting on the alpha channel.

FIGURE 2.8 Selecting the alpha channel.

If we load this as a selection (Ctrl click on the mask) we can see what our marching ants will look like (see Figure 2.9).

As before, we can now apply any of Photoshop's commands and tools to this selected area (see Figures 2.10 and 2.11).

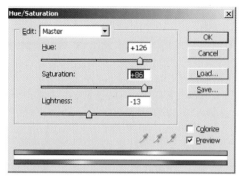

FIGURE 2.10 Changing the newly selected area.

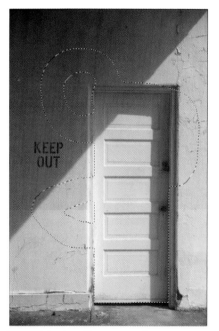

FIGURE 2.9 Loading our work as a selection.

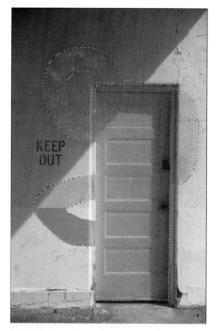

FIGURE 2.11 Changing the newly selected area.

LAYER MASKS DEMYSTIFIED

The key to mastering Photoshop is mastering selections. Selections, masks, and channels are identical.

Now that we have gained some insight into the uses of selections lets look at some of its more important applications. Let's delve into their uses in creating layer masks. To understand layer masks we must understand the creative necessity of layers.

One of the most widely used aspects of Photoshop is its ability to gracefully integrate almost an unlimited amount of imagery with the use of layers. What are layers? Let's visit before the advent of digital and discover how the concept of layers was originally applied.

Let's say that your artwork was to be produced for the front cover of a magazine. The publisher's graphic department would need to place the title as well as any graphic effects on the artwork. The artists did not apply the graphics to the art directly, but instead they laid over it a clear sheet of acetate and on that they placed the title of the magazine. In turn, they placed another sheet of clear acetate on top and on it they created the border graphic effects. In registration, they generated the final copy from which they produced the color separations for the magazine cover.

FIGURE 2.12 The black portions of the negative block out our view of the transparency.

FIGURE 2.13 Two images in registration.

On a creative level, layers are important because we can apply all of Photoshop's commands and tools to each object independently from the entire scene. Placing most of the elements on separate layers gives us control and flexibility. Once the layers are established we can apply layer masking to control how each object blends and integrates into the entire image.

Layer masking is an excellent way to control the opacity or transparency of local elements of an image. Traditionally this process was done by sandwiching a litho negative with a color transparency. Sections of the litho negative were clear to allow the enlarger to expose the original image. Other sections of the negative were black, which blocked out the visual aspects on the transparency as shown in Figure 2.12. The two in registration (complete alignment) as shown in Figure 2.13 were placed into a photographic enlarger so that the image showing through the clear portion of the litho negative was exposed onto the photographic media. How do we achieve this in Photoshop?

CREATING THE LAYER MASKS

Step 1

Open an image in Photoshop and duplicate the original layer. Fill your background layer with 50% gray (Edit > Fill > 50% Gray). Your duplicate layer above your background remains untouched. To this we will apply our mask to blend part of the image with the neutral gray background, as shown in Figures 2.14 and 2.15.

Step 2

Make sure that your top layer is selected and associate a layer mask by clicking on the icon that is second from the left on the bottom of the Layers Palette (see Figure 2.16).

FIGURE 2.14 View of a sand dune.

FIGURE 2.15 The layers of the sand dune image.

FIGURE 2.16 Associating a layer mask.

Step 3

Take a look at your layers and notice that you have an extra white thumbnail connected to your image. This is the layer mask. On this you can paint with 256 shades of gray. Photoshop is telling you that like litho film, if you paint within this area with white then you will be allowed to view the image in the canvas area. If you paint with black then you will mask out the object. As a result, the image will disappear. Let's prove this concept.

Make sure that you are in mask editing mode by clicking on the white image mask, as shown in Figure 2.17.

Note that if you want to edit the image in RGB, click on the image thumbnail, as shown in Figure 2.18.

FIGURE 2.17 Click the white image mask.

FIGURE 2.18 Editing the image in RGB.

Step 4

Press the D key to set your foreground and background to white and black. Select the Gradient tool and make a gradient across your image starting from the left side and continuing to the right side of the canvas. What happened in Figure 2.19?

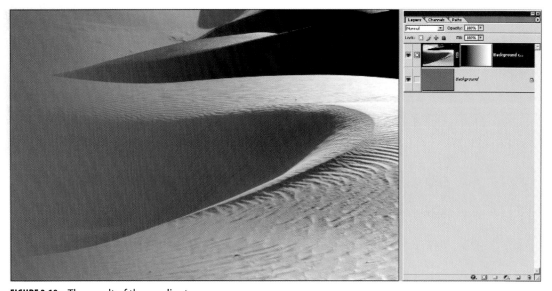

FIGURE 2.19 The result of the gradient.

We can see through the areas that were painted black and we have partial transparency of the areas with various tonalities of gray.

If we press the Alt key and click on the layer mask we can view our gradient (see Figure 2.20).

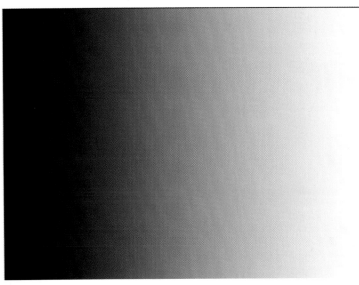

FIGURE 2.20 Our gradient.

A layer mask is basically an image made up of 256 shades of gray. This affords us 256 levels of transparencies! Now we can produce all types of subtle blending effects.

LAYER BLEND MODES

Finally, let address Photoshop's layer blend modes.

At the top left-hand corner of our Layer palette there is a drop menu where our layer blend modes reside. By default it says Normal. We will take a close look at three of the blend mode sections and discover what these blend modes do.

To view the blend modes make sure that you have a layer highlighted and not the background. The background is your base canvas. It is not a layer. As a procedure, duplicate your background (Ctrl J) so that Photoshop creates the image on its own layer. Now you have access to your blend modes, as you can see in Figure 2.21.

See Figure 2.22. Note that there are three large sections separated by a thick black line. The first section blends the highlighted layer with the layer underneath it so that all of the blacks are maintained and the whites become completely transparent.

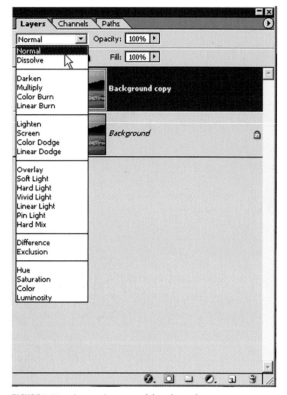

FIGURE 2.21 Accessing your blend modes.

FIGURE 2.22 Blending the different layers.

The second section blends the highlighted layer with the layer underneath it so that all of the whites are maintained and the blacks become completely transparent.

The third section blends the highlighted layer with the layer underneath it so that all of the blacks and whites are maintained and the medium grays or midtones become completely transparent. Let's prove this theory.

Step 1

Open a file in Photoshop and duplicate the background because we will be working on a layer. In this case it is helpful if your chosen image is horizontal.

Step 2

Create a new layer and press the D key to set your foreground and background color to black and white, as shown in Figure 2.23.

FIGURE 2.23 Setting the foreground and background to black and white.

Step 3

Select your Gradient tool. Starting from left to right click and drag on your canvas while holding the Shift key on the keyboard. The Shift key constrains the flow to one direction. You have just created a fill made up of 256 shades of gray. Now let's see the effects of each gradient as we apply our blend modes.

Section 1

> **Darken:** Whites go transparent, however, some residual midtones persist (see Figure 2.24).

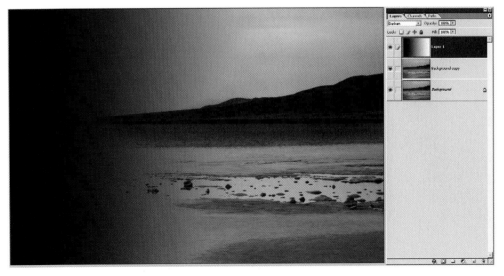

FIGURE 2.24 The results of darkening.

Multiply: Whites go transparent, however, all midtones are nonexistent (see Figure 2.25).

FIGURE 2.25 The results of multiplying on an image.

Color Burn: Whites go transparent, however, greater saturation occurs where midtones are present (see Figure 2.26).

FIGURE 2.26 The results of color burn.

Linear Burn: Whites go transparent with a truer representation of the gradient (see Figure 2.27).

FIGURE 2.27 The results of linear burn.

Section 2

Lighten: Blacks go transparent, however, some residual midtones persist (see Figure 2.28).

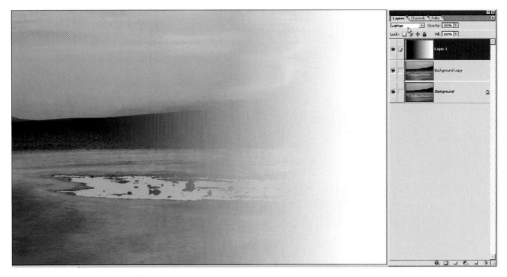

FIGURE 2.28 The results of lightening.

Screen: Blacks go transparent, however, all midtones are nonexistent (see Figure 2.29).

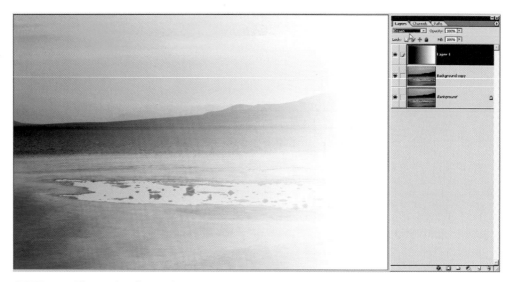

FIGURE 2.29 The results of screening.

Color Dodge: Blacks go transparent, however, greater brightness occurs where midtones are present (see Figure 2.30).

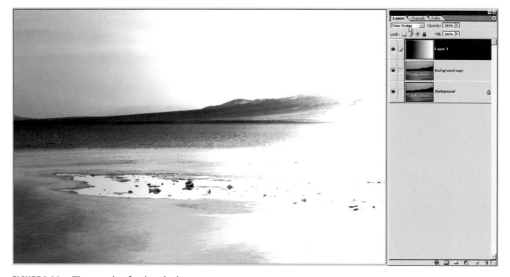

FIGURE 2.30 The result of color dodge.

Linear Dodge: Blacks go transparent with a truer representation of the gradient (see Figure 2.31).

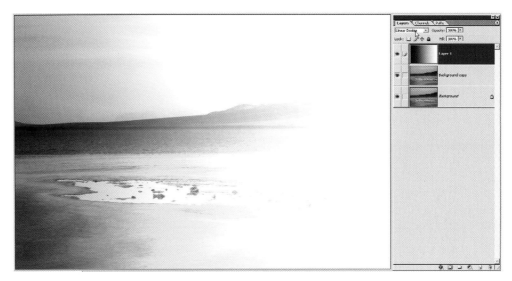

FIGURE 2.31 The result of linear dodge.

Section 3

Overlay: Midtones are transparent with some increased saturation in the low tones and higher brightness in the high tones (see Figure 2.32).

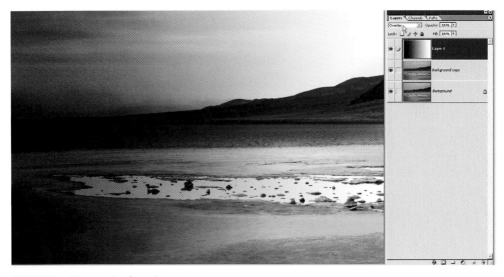

FIGURE 2.32 The result of overlay.

Soft Light: Midtones are transparent with subtle saturation in the low tones and subtle increased brightness in the high tones (see Figure 2.33).

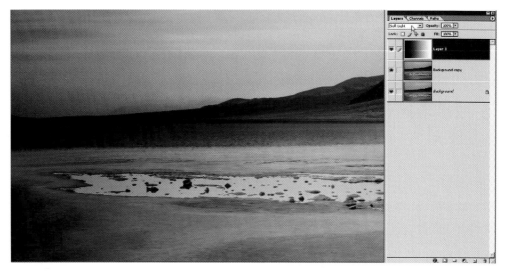

FIGURE 2.33 The result of applying soft light.

Hard Light: Midtones are transparent with higher dominance of black and white (see Figure 2.34).

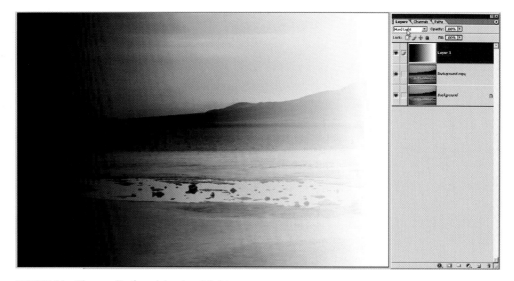

FIGURE 2.34 The result of applying hard light.

Vivid Light: Midtones are transparent with drastic dominance of black and white (see Figure 2.35).

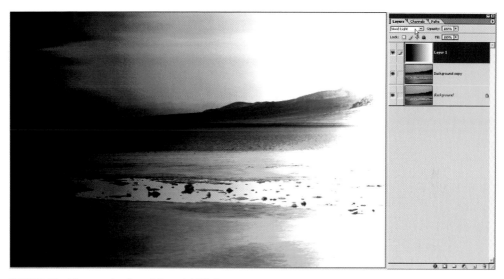

FIGURE 2.35 The result of applying vivid light.

Linear Light: Midtones are transparent with purer representation of black and white (see Figure 2.36).

FIGURE 2.36 The result of applying linear light.

Pin Light: Midtones are transparent with truer representation of the gradient (see Figure 2.37).

FIGURE 2.37 The result of applying pin light.

Hard Mix: Midtones are transparent with a posterizing effect (see Figure 2.38).

FIGURE 2.38 The result of applying hard mix.

WHAT YOU HAVE LEARNED

- The importance of selections and how to create them
- How to use selections to isolate localized areas to apply color effects
- How to create and edit alpha channels to create layer masks
- How and why layer blend modes work the way they do

Now that we have an understanding of selections, masks, and layer blending modes, let's move on and apply this knowledge to some creative endeavors.

COMPOSITING PHOTOGRAPHIC IMAGES TO ACHIEVE REALISM

IN THIS CHAPTER

- Powerful approaches to compositing photographic imagery
- How to use layer sets to organize your work
- How to use Layer Bending modes to assist with composition
- The power of the Free Transform and Distort for localized areas
- Practical applications for using layer masks
- Creating masks from channels
- Filters to enhance your creations

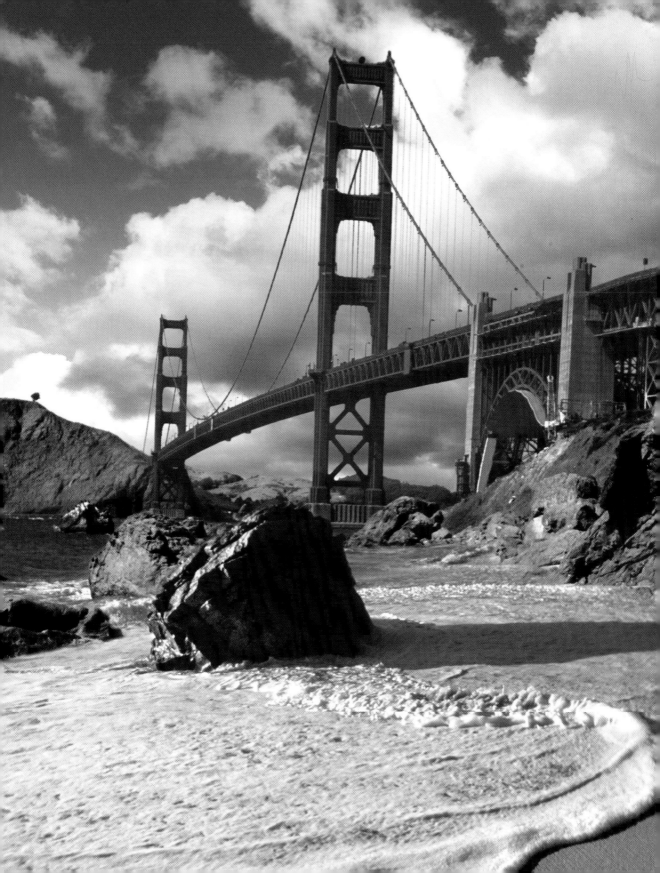

The advent of Photoshop and digital cameras has forced photographers to reconsider how to compose their subject matter when looking through the view finder. Once you discover the power of the digital medium your vision and compositional style will change. The way you compose a photograph as well as how you choose your subject matter will be influenced by how you intend to use the final imagery in Photoshop. Will your image be composed as a single shot? Or will it consist of a multitude of digital images? If you choose to use multiple images then consider taking several photographs of your subjects at various angles and vantage points to give you a variety of creative possibilities. You can never tell up front what the outcome of the creative process will yield, so the more material at your disposal then the more dynamic the outcome.

ON THE CD

We will have some real fun and use what we have learned to composite photographic imagery in a way that appears as if it was taken in a single shot. In this exercise we will use three images to composite into one final piece using selections, masks, and layer blending. You can access what you need to create this tutorial in Tutorials/Chapter3–Compositing With Photography/ on the companion CD-ROM.

Figures 3.1 through 3.3 show the original images.

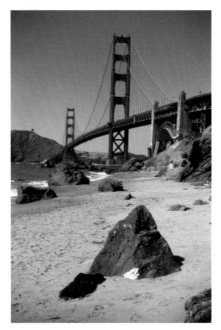

FIGURE 3.1 The Golden Gate Bridge.

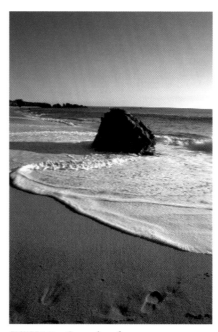

FIGURE 3.2 Carmel surf.

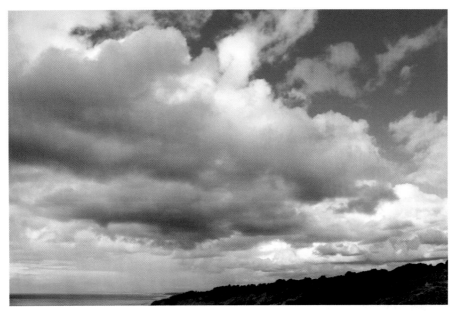

FIGURE 3.3 Carmel cloud bank.

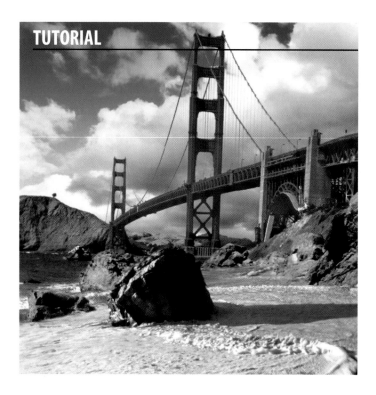

BLENDING THE FOREGROUND

Figures 3.2 and 3.3 were shot in Carmel, California. The location is ideal for its compelling coastline and angry cloud formations. These shots were chosen because of the angle at which they were photographed. They provide great material to replace the foreground below the Golden Gate Bridge as well as to replace the mundane sky with more interesting cloud formations.

Step 1

The Golden Gate Bridge serves as the base layer. Using the Move tool drag the Carmel surf image into the Golden Gate Bridge image file so that it is the top layer.

Use blending modes to position the top layer. Change the blend mode to Darken to leave the bulk of the lower and midrange tonalities untouched and to allow the highlights of the image from underneath to show through (see Figure 3.4).

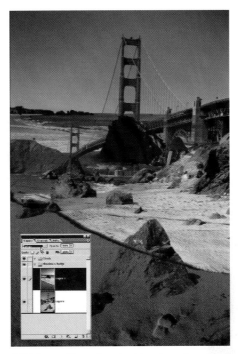

FIGURE 3.4 Changing the blend mode to Darken in the Golden Gate image combined with the Carmel coast figure.

Step 2

It's always a good idea to organize your layers in anticipation that you will end up with quite a few. In this case, two Layer Sets are created: one is titled "shoreline & bridge" and the other "clouds" (see Figure 3.5).

FIGURE 3.5 Creating layer sets.

Each layer is placed in the folder by physically dragging it. Now we can click on the folder's drop arrow to the left and cascade or hide the contents as we choose. Note that we can only drag layers into layer set folders; our original background is not a layer. It's our base canvas and Photoshop does not treat it as a layer. In fact it remains locked, so to convert the background, double-click and give it a name (see Figure 3.6).

Step 3

At this point in the process we are not overly concerned about aesthetics; we are simply composing the foreground element (see Figure 3.7).

FIGURE 3.6 Converting the background to a layer.

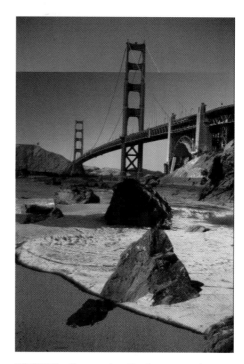

FIGURE 3.7 Composing the foreground.

If you look at the direction of the sun, you'll see that the light source is coming from the right. Our background is showing the light coming from the opposite direction. Flipping the layer (Edit>Transform>Flip Horizontal) makes the scene a lot more homogeneous as shown in Figure 3.8.

Finally, by activating the Move tool we use the arrow keys on the keyboard to nudge the image into the exact position that best represents our final vision (see Figure 3.9).

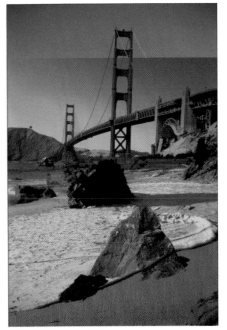

FIGURE 3.8 Flipping the Carmel surf layer. **FIGURE 3.9** Nudging layer.

Step 4

Changing the blend mode to Normal gives us a full view of the Carmel surf (see Figure 3.10).

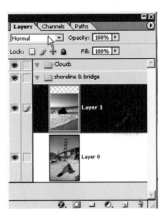

FIGURE 3.10 Normal blend mode applied.

Step 5

Now we will add our layer mask. Hold down the Alt/Opt key and activate the layer mask icon.

By default, clicking this icon gives us a mask that is filled with white, but the Alt/Opt command fills it with black, which blocks out the visual aspects of the foreground image (see Figure 3.11).

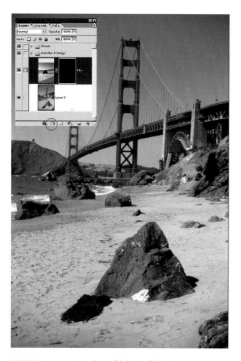

FIGURE 3.11 Results of black-filled layer mask applied.

This places us in a position to work like a painter by using Wacom's® tablet's pressure sensitivity to expose our foreground subtly. But first we must activate the paint brush.

Step 6

Activate the Brush palette and check the Other Dynamics option. Also set the preferences to Pen Pressure. Now we can use the tablet's sensitivity to paint our mask (see Figure 3.12).

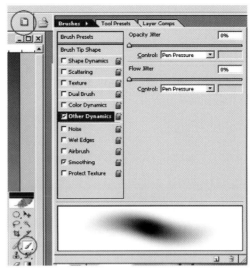

FIGURE 3.12 Paintbrush options.

Use the bracket keys ([]) to enlarge or reduce the size of your mouse. The left bracket reduces and the right enlarges. Another useful hint is to use shift[to soften the edge of the brush or use shift] to harden the edge of the brush. These shortcuts are helpful to speed up the process.

Step 7

You are now ready to edit the mask. Be sure that you are in the mask-editing mode by clicking on the black icon associated with our Carmel surf layer. Remember our goal is to reveal the waves. So painting with white reveals the image and painting with black masks out the image.

Use a large brush with a very light pressure at first then build up the opacity until you achieve your goal. If you do not have a Wacom® tablet then set the pressure to 8% to 12% to gently build onto the effect (see Figure 3.13).

Figure 3.14 is an example of what the layer mask looks like after the initial editing.

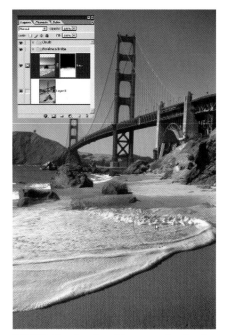

FIGURE 3.13 Results of layer mask edited.

FIGURE 3.14 Results of layer mask after initial edit.

Step 8

Use CTL+ to magnify areas that will need closer attention and adjust your brush accordingly. CTL– decreases the screen size and aids to fine tune the mask (see Figure 3.15).

After much attention to detail the mask is complete and the foreground flows quite well with the original beach (see Figure 3.16).

Step 9

Sometimes adding some fine adjustments is all it takes to make an image more visually compelling. In this case we want the lines of the waves to reach out to the viewer and pull him into the composition. We use a duplicate layer of the Carmel surf (Ctrl J) to achieve this. By selecting the lower third of the image with the Rectangular Marquee the leading lines from the white wash of the waves become the objects to be transformed (see Figure 3.17). Remember, "the key to mastering Photoshop is mastering selections."

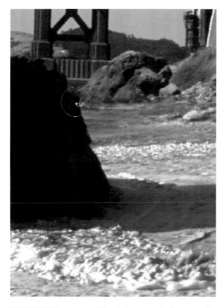

FIGURE 3.15 Magnified view to help us edit the details.

FIGURE 3.16 Results of editing the layer mask.

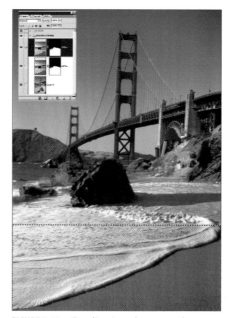

FIGURE 3.17 Duplicating the waves layer.

Step 10

By accessing the Distort command (Edit>Transform>Distort) you can pull each point independently and transform the shape further into the foreground

as shown in Figure 3.18. Because this is a duplicate of the original foreground, the end result blends quite effectively.

Now take a look at the final result shown in Figure 3.19.

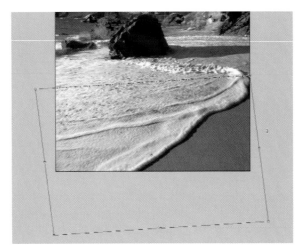

FIGURE 3.18 Transforming the waves.

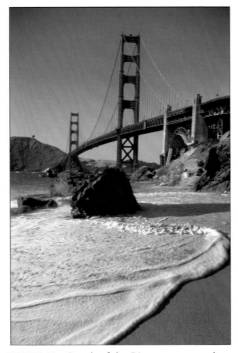

FIGURE 3.19 Result of the Distort command.

INSERTING THE CLOUDS

Here is where we get firsthand experience with practical applications as well as the connection between channels and masks.

Step 1

In Step 2 of Blending the Foreground, we made a layer set folder titled "Clouds." Place the cloud image into this folder with the Move tool. Because most of the information exists in the higher tonalities, change its blend mode to lighten so that the cloud detail remains visible. Remember the lighten mode keeps the whites and sets the lower tones transparent. Again, this technique is used only to assist us in composing the clouds (see Figure 3.20).

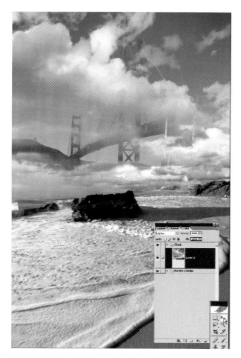

FIGURE 3.20 Adding the cloud layer.

Step 2

With the Move tool activated the cloud image can be nudged by using the arrow keys on the keyboard (see Figure 3.21).

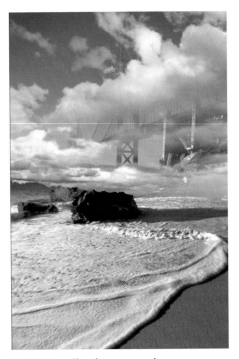

FIGURE 3.21 Clouds composed.

After the clouds are positioned it's a good idea to change the blend mode back to normal and turn off the layer's visual aspects. We will now work with the bridge to create a mask.

Creating the Cloud Mask

The goal is to mask out areas around and through the bridge. To accomplish this we will turn to our channels for help. *Channels and masks are identical.*

Step 1

Select the Channels palette because we need to decide which one gives us the best separation between the bridge and the background (see Figure 3.22).

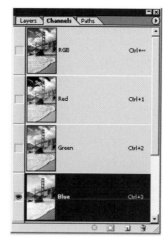

FIGURE 3.22 Channels view.

Clicking on each channel gives us the visuals on our canvas. It is clear that the blue channel gives us a more distinct separation between the bridge and the background (see Figures 3.23 through 3.25).

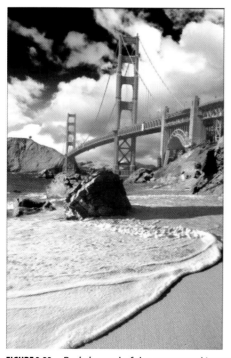

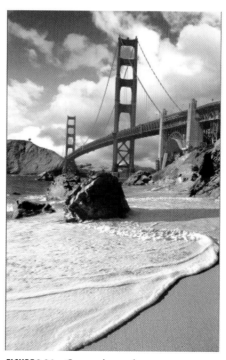

FIGURE 3.23 Red channel of the composed image.

FIGURE 3.24 Green channel.

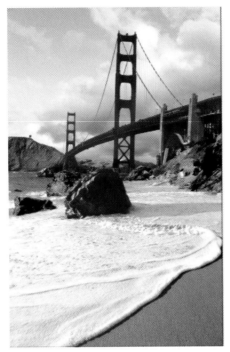

FIGURE 3.25 Blue channel.

Step 2

By duplicating the blue channel we create an alpha channel. By default it is called Blue Copy. We will modify this to create our mask (see Figure 3.26).

FIGURE 3.26 Blue channel copy.

Step 3

We will start by accessing the Curves dialog box (Ctrl M) as shown in Figure 3.27.

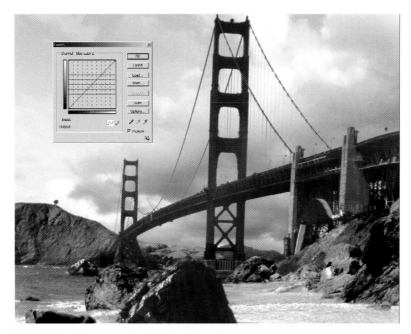

FIGURE 3.27 Curves applied to blue channel copy.

Let's understand what Curves is doing. Take a look at the gradient along the bottom edge of the box. This represents our 256 shades of gray. In other words the extreme left represents our black with no detail. The extreme right represents our white with no detail. In between the two tones represent the 254 range of potential grays that are displayed in our image.

If we want our black tones in our image to become a lighter shade of gray then all we have to do is click on the point at the lower left which sits over our extreme blacks and drag it upward to the chosen gray along the left side (see Figure 3.28).

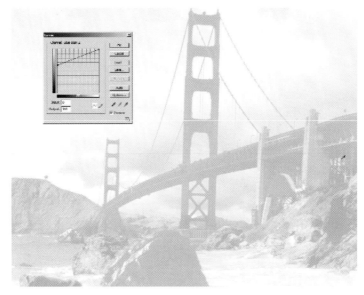

FIGURE 3.28 Black point modified.

If we want our white tones in our image to become a darker shade of gray then all we have to do is click on the point at the upper right and drag it downward to the chosen gray along the right side (see Figure 3.29).

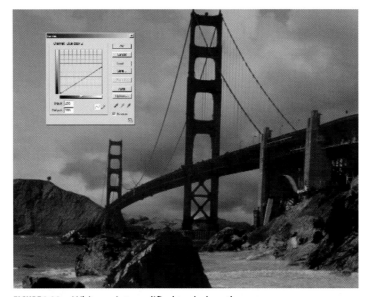

FIGURE 3.29 White point modified to darken the grays.

The same is true for any tone in our image. Click on the middle section of the line and notice that we can place additional points to further adjust tones in our image. Adjusting the curve upward shifts our tones to higher shades of gray and adjusting the curve downward shifts the tones to deeper shades of gray.

Curves behave like a Bezier tool in which you have a line between two points and that line is just points on a curve. As the curve is shifted so are the other points. Visually your tones become brighter or darker (see Figures 3.30 and 3.31).

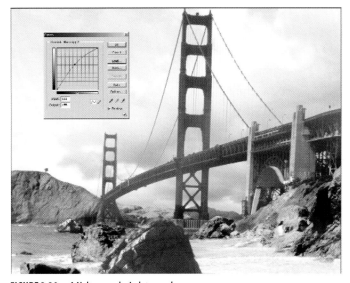

FIGURE 3.30 Midtones brightened.

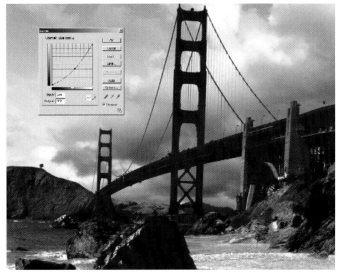

FIGURE 3.31 Midtones darkened.

Step 4

If we can shift tones on the curve then that means that we can pull them apart as well. This is our goal. We need to pull the tones apart so that our bridge and landscape becomes black and the sky becomes white. Let's have some more fun.

With the Curves tool open (CTL M) we will identify the area to be shifted to white. By holding the Ctrl key and clicking on the bright area of the clouds notice that a point is placed on the curve (see Figure 3.32).

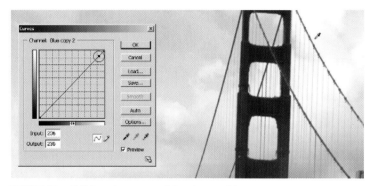

FIGURE 3.32 Shifting the tones of the sky to white.

Step 5

Next we will identify the areas to be modified to black that are adjacent to our sky. A portion of the bridge has been chosen. With a Ctrl click a point is placed on the curve (see Figure 3.33).

FIGURE 3.33 Shifting the tones of the bridge to dark.

Step 6

We must apply one last point to assist us in our goal. If we click dead center on the curve this new point serves as an anchor. This point will not be touched as the other two are shifted (see Figure 3.34).

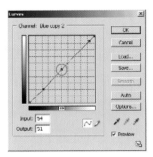

FIGURE 3.34 Placing the midpoint.

Step 7

Now comes the easy part. By dragging the bottom left point straight downward and the top right one straight upward we shift the two tones to their extremes. If you look at the mask you'll see that we achieve satisfactory results as shown in Figure 3.35.

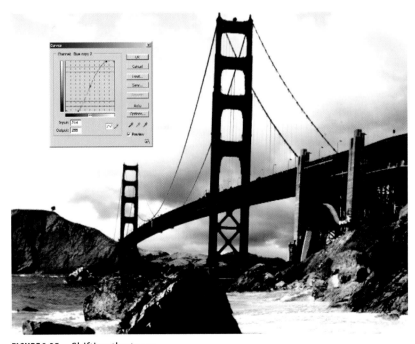

FIGURE 3.35 Shifting the tones.

Step 8

Be aware that all we are concerned with at this point is making sure that we get clean separation between our sky and bridge. The Burning and Dodging tools will assist us greatly.

With the Dodge tool chosen, the Highlights are selected in the options panel, and the Exposure is set to 100% (see Figures 3.36 and 3.37).

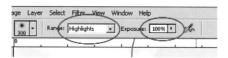

FIGURE 3.37 Dodge tool options.

FIGURE 3.36
Dodge tool.

Step 9

By quickly painting the highlights a much more definite edge and separation is defined. Doing the same with the black tones by using the Burning tool, which resides in the same palette as the Dodge tool, renders the black mask. This time make sure that Shadows are selected in the options bar (see Figure 3.38).

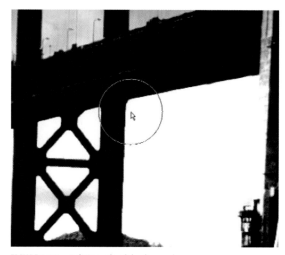

FIGURE 3.38 Editing the black mask.

After working on the mask it should resemble Figure 3.39.

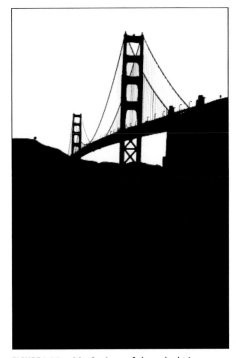

FIGURE 3.39 Mask view of the whole image.

Step 10

Now that we have our mask, let's apply it to our layer. Ctrl click on the newly created alpha channel to get your selection. Remember: *selections and masks are the same*. Click the layer mask button and notice that a mask in the shape of our bridge outline is now associated with the layer (see Figure 3.40).

Now our clouds are visible exactly where we want them based on how the mask is designed. Finally, to add subtle brightness additions to the clouds we duplicate the cloud layer (Ctrl J) and set its blend mode to Soft Light. That's it in

a nutshell. Remember, a mask is nothing more than an image made up of 256 shades of gray. We can edit it at any time (see Figures 3.41 and 3.42).

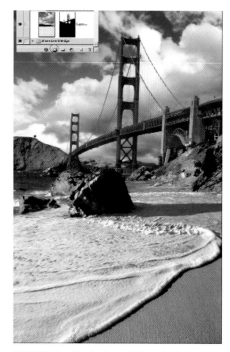

FIGURE 3.40 Mask view of the whole image.

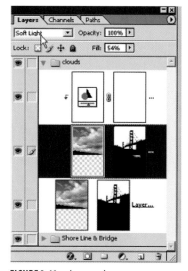

FIGURE 3.41 Layer view.

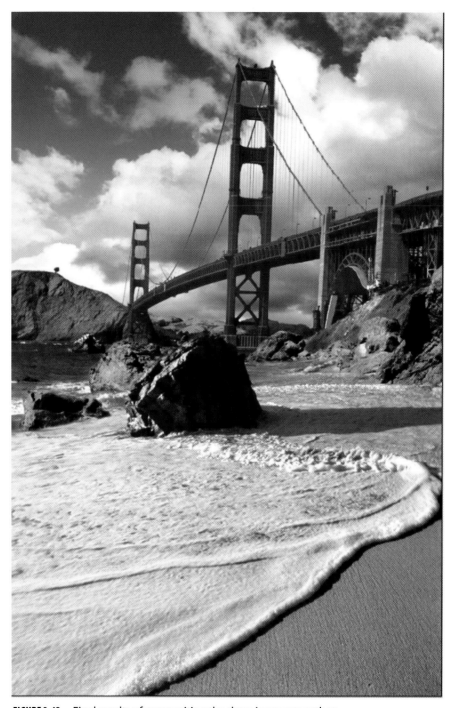

FIGURE 3.42 Final results of compositing the three images together.

IMAGINATIVE LANDSCAPES

As you begin to understand Photoshop you will become addicted. The more you work with photographic imagery and learn to apply effects trickery your imagination will sore.

The next example is a variation on the previous theme. This time we will not only composite photographic imagery but we will custom create a moon resting in the horizon to offset and enhance the overall composition. In addition, distance fog will be incorporated to give the landscape a more ethereal feel.

The complete piece was created using only two photographic images as shown in Figures 3.43 and 3.44. The rest is custom created using Photoshop's effects engine and nik Color Efex Pro 2.0. You can access what you need to create this tutorial in the Tutorials/Chapter3–Imaginative Landscapes/ on the companion CD-ROM.

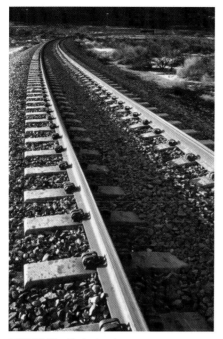

FIGURE 3.43 Train tracks.

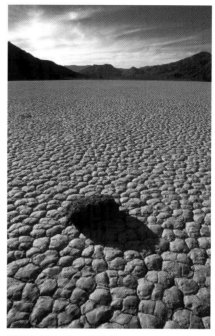

FIGURE 3.44 Death Valley.

Step 1

Starting off with both images side by side, the train tracks are placed into the Mud image file. This of course gives us the two layers that we need (see Figures 3.45 and 3.46).

Step 2

The goal is to integrate the tracks and make it appear as if they are partially constructed over the mud terrain, but first it's a good idea to create our layer set to stay organized. In this example our layer set is called "desert landscape." We will place both layers into it. Remember that you can only drag layers into layer set folders. Your original background is not a layer. Therefore, to convert the background, double-click on it and give a name. That's all there is to it.

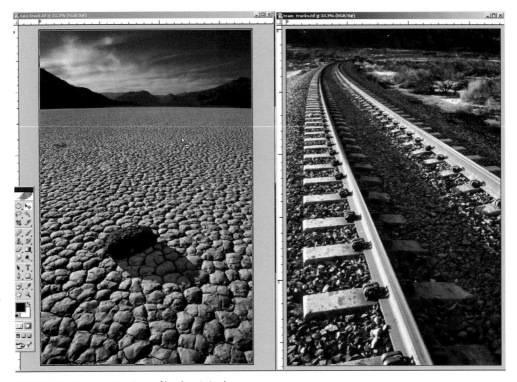

FIGURE 3.45 Composite view of both originals.

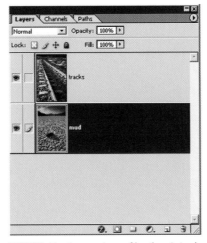

FIGURE 3.46 Layer view of both originals.

Step 3

By applying the layer mask the external elements around the tracks can be visually removed to achieve our objective of isolating them (see Figure 3.47).

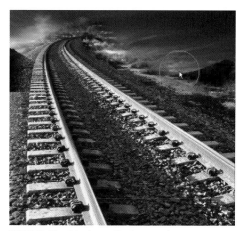

FIGURE 3.47 Mask applied to tracks.

Step 4

Using Wacom's tablet's pressure sensitivity, we further edit the mask to reveal the tracks only. At first we use a very large brush size to quickly isolate our subject, but as we approach the edges of our image, finer detailed editing is required so we use a much smaller brush size. Our subject is modified with various edge softness or hardness. Figures 3.48 and 3.49 show the current editing stage in both image and mask preview.

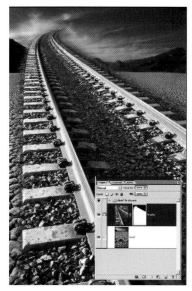

FIGURE 3.48 Layer view of both images together.

FIGURE 3.49 Mask view of the same stage of progress.

Step 5

The tracks do not quite fit the perspective of the mud landscape, so by accessing the Distort command (Edit>Transform>Distort) each handle bar in our outline is dragged to place the image that we desire in the composition. Distort it so that the left rail reaches toward the viewer as shown in Figure 3.50.

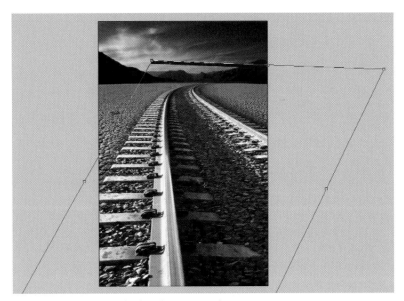

FIGURE 3.50 Distort applied to the train tracks.

Step 6

As you can see in Figures 3.51 and 3.52, after the transformation is applied, some fine tuning to the mask is needed. This is a good time to take out undesired extraneous elements.

Step 7

We do not want to preserve the track in its entirety. It serves as a single element to assist us in creating a new perspective from the original imagery.

Zooming in closer (Ctrl+), edit the mask so that the rear portion fills the screen as shown in Figure 3.53.

FIGURE 3.51 Fine tune the mask.

FIGURE 3.52 Additional fine tuning to remove unwanted objects.

FIGURE 3.53 Magnified view of the end of the tracks.

Step 8

By continuing to edit the mask, the rear one-quarter portion of the track is re-moved and edited so that the final look resembles an incomplete construction

of the railroad. The brush size is modified to sculpt the tracks as shown in Figures 3.54 through 3.56.

FIGURE 3.54 Using the brush to work with the tracks.

FIGURE 3.55 Adjusting the details.

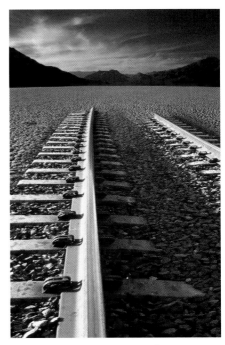

FIGURE 3.56 Fine tune the mask.

Step 9

Using the Perspective tool, the rear of the tracks are narrowed to give the scene a greater sense of depth (see Figure 3.57).

FIGURE 3.57 Perspective tool applied to give depth to the image.

Step 10

Currently, we have a rough layout of our composition. Once the important elements are in place, fine tuning brings it all together. The tracks need to be color balanced to match the background. In fact, it is slightly on the cool side so by using Color Balance (Ctrl B), we add yellow and red to the shadows and highlights (see Figures 3.58 through 3.60).

Step 11

The gravel in the center of the railroad tracks is a little too dark so we duplicate the tracks layer and give it a blend mode of Linear Dodge. This mode not only significantly brightens the lower tones in favor of whites but it also gives the image some nice contrast and texture detail that is not seen in normal mode (see Figure 3.61).

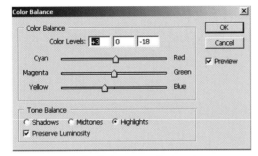

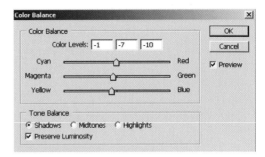

FIGURE 3.58 Color balance applied to the highlights.

FIGURE 3.59 Color balance applied to the shadows.

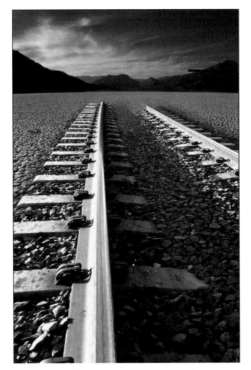

FIGURE 3.60 The result of the color balance adjustments.

With the duplicate layer given a black mask, selected areas are allowed to come back by painting with white. Also, note that if you Shift Click on the mask a red "X" appears, which allows you to view the entire image without the effects of the mask. This is the stage where you will clean up the mask to

FIGURE 3.61　Blend mode set to linear dodge.

better integrate the tracks (see Figure 3.62). Once complete, one last element is left to be added—our moon.

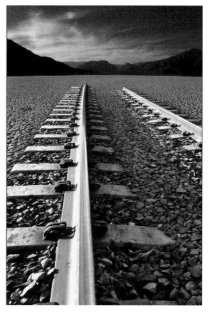

FIGURE 3.62　Adjusted blend.

CREATING A MOON

Step 1

The key to mastering Photoshop is mastering selections. There's that mantra again. So let's go and apply it.

We will start to create our moon by selecting the Elliptical Marquee on our Tools palette. Holding down the Shift and Alt keys constrains the selection to a perfect circle and resizes from the center (see Figure 3.63).

Step 2

Set the foreground color to white and the background color to brown and apply the Render Clouds command (Filter>Render>Clouds) as shown in Figure 3.64.

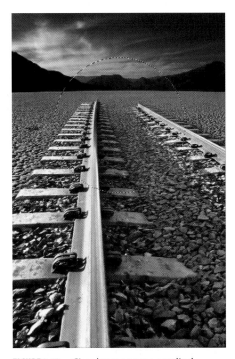

FIGURE 3.63 Circular marquee applied.

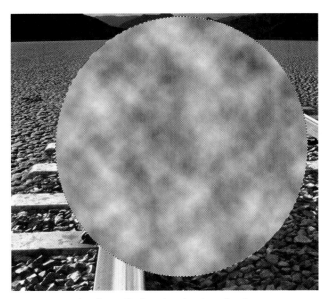

FIGURE 3.64 Clouds applied to the circular selection.

Step 3

Our moon needs some texture so a displacement effect is applied. The way displacement works is that a 3D-like texture is created based on tones in our objects. The brighter the tones the higher the relief. Adversely, the lower tones are not affected, making them appear as valleys in the image. This is what we will create using the Lighting Effects panel (Filer>Render>Lighting Effects).

Under the Texture Channel's drop list, we choose the red channel. Remember, *channels and selections are the same*. In this case the red channel is the source of our selection. The white areas are the ones that are completely selected and where the effect is applied the most. The black areas are not selected and no effect occurs. The midrange tones give a partial relief. In the midrange tones the intensity of the effect depends on how close or how far they are tonally from white.

In this example, the light source is placed on the right, and the red channel is used to apply the displacement effect. Why red? Each channel represents a different aspect of the digital file. Red harbors all of the contrast. Green has all of the midrange grays. The blue is susceptible to ultraviolet noise. Since it is contrast that is needed to create the texture, the red channel is used. The mountainous slider is used to allow more or less of the displacement texture (see Figure 3.65).

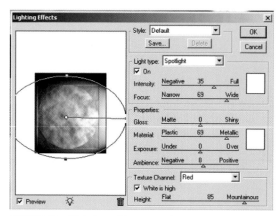

FIGURE 3.65 Lighting effects panel.

When this is applied our clouds are instantly transformed into something that resembles stone as shown in Figure 3.66.

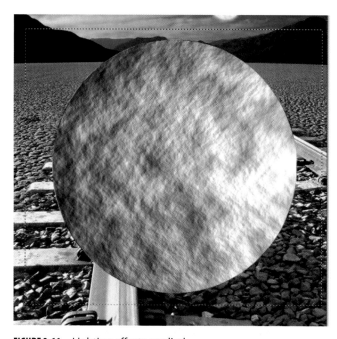

FIGURE 3.66 Lighting effects applied.

Again, it is important to experiment to come up with satisfactory results that best suit you.

Step 4

By accessing our Liquefy program (Filter > Liquefy) we can push, pull, rotate, expand, and compress local areas of our image to create what looks like moon craters (see Figure 3.67). Enlarge and reduce the brush size to gain various shapes of craters and surface texture. This tool requires that you play extensively with it to achieve its full creative potential.

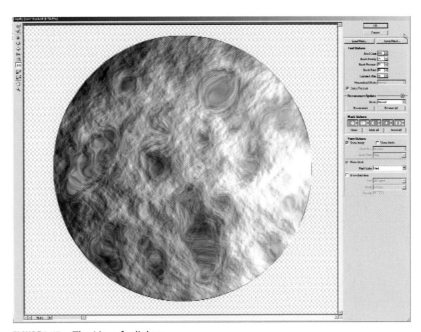

FIGURE 3.67 The Liquefy dialog.

Step 5

Once the Liquefy tool is applied, the moon's layer blend is set to Linear Dodge. This blends it with the bottom layer in such a way that the clouds appear to rest in front of the moon. In addition, the moon is rotated so that the highlighted portion is facing left in the direction that the light is coming from. So that the object doesn't have a hard edge appearance, Gaussian Blur is applied (see Figure 3.68).

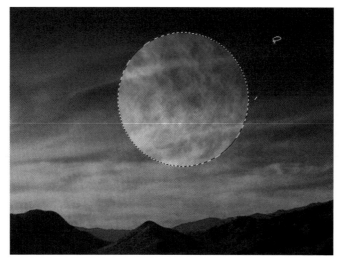

FIGURE 3.68 Linear Dodge blend mode applied.

Step 6

Although the Gaussian Blur helps to reduce texture detail, the outer edges still seem sharp. The objective here is to soften only the edges leaving the rest of the detail untouched.

Since the moon is on its own layer, a selection of it is quickly created with a Ctrl click on its layer.

Step 7

Using the free Transform Selection command (Select>Transform Selection) we can reduce the marching ants to a smaller shape that is just inside the outer edges of our moon. Remember that holding down the Shift and Alt key constrains the selection to a perfect circle and resizes it toward the center point (see Figure 3.69).

Step 8

Finally, the marching ants are inverted (Select>Inverse) to select everything opposite of our original choice. In effect we now have only the edges chosen. To make sure that our technique is subtle, a feather of 30 pixels is applied (Select>Feather). Now Gaussian Blur can be applied to the edge of the moon (see Figures 3.70 and 3.71).

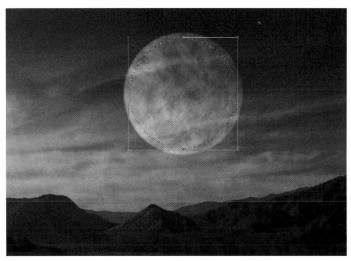

FIGURE 3.69 Transform selection while holding down Shift and Alt to constrain the proportions.

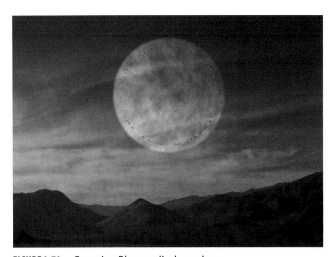

FIGURE 3.70 Gaussian Blur applied to edges.

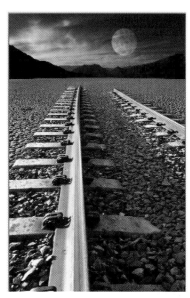

FIGURE 3.71 Moon with Gaussian Blur.

Step 9

The sunlight is coming from the left so let's allow the moon to honor the lighting perspective. If you recall, the moon has a blend mode of Linear

Dodge applied to it. If any highlights are preserved as a result, then the shadow tones will recede to transparency. That being the case, we will use our Burn tool to darken the right side of the moon which in effect makes is transparent. The Wacom® tablet allows pressure subtlety so that is a good choice for a situation such as this (see Figures 3.72 and 3.73).

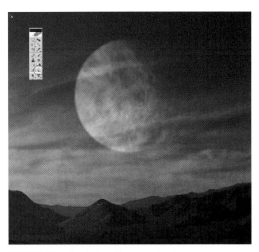

FIGURE 3.72 Applying the Burn tool.

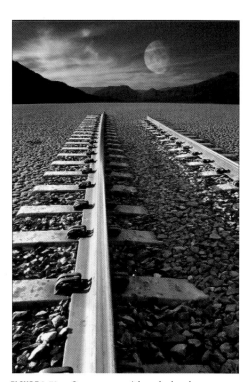

FIGURE 3.73 Our moon with a dark edge.

CREATING DISTANT FOG

What makes custom created landscapes more appealing is the integration of atmosphere. This is what our eyes see everyday when we look at nature. There is always some sort of atmospheric haze visible in our surroundings. This section explores a technique to create distance fog. Let's get started.

Step 1

We create an additional layer on top of the recently created moon and fill it with white and gray clouds (see Figure 3.74).

FIGURE 3.74 Clouds applied to the image.

Step 2

We set the blending mode to Hard Light to allow the medium gray to go transparent as shown in Figure 3.75.

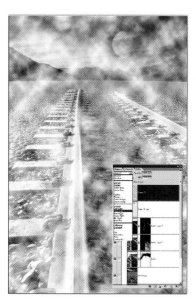

FIGURE 3.75 Hard Light blend mode applied to the clouds.

Step 3

The edge detail of the fog seems a little harsh so we apply Gaussian Blur as seen in Figure 3.76 to soften it up a bit.

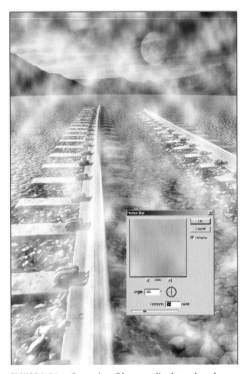

FIGURE 3.76 Gaussian Blur applied to clouds.

Step 4

According to the rules of perspective anything at a distance is smaller and anything in close proximity is larger. To give the fog an appearance of depth the Perspective tool is used to enlarge the bottom portion of the fog layer as shown in Figures 3.77 and 3.78.

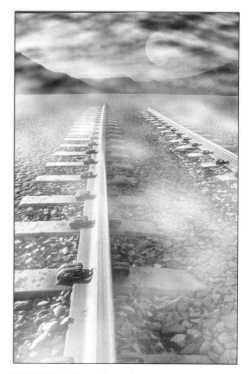

FIGURE 3.77 Perspective applied to the fog.

FIGURE 3.78 Fog adjusted.

Step 5

The haze should look like it is extending across the landscape so we apply Motion Blur in a horizontal direction to simulate the look as shown in Figure 3.79.

Step 6

Using a layer mask the fog effect can be restricted to mostly below the horizon (see Figures 3.80 and 3.81).

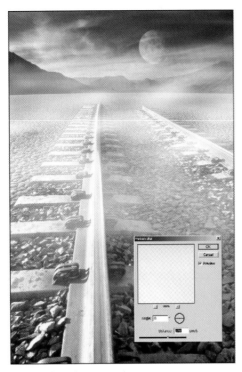

FIGURE 3.79 Motion Blur applied to the fog.

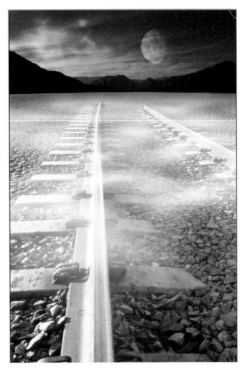

FIGURE 3.80 Our goal is to have the fog only go to the horizon.

FIGURE 3.81 Editing the mask so the fog doesn't extend into the sky.

Step 7

After duplicating the fog layer we transform it (Edit>Free Transform) and squeeze it into the horizon giving the entire image a greater sense of depth (see Figure 3.82).

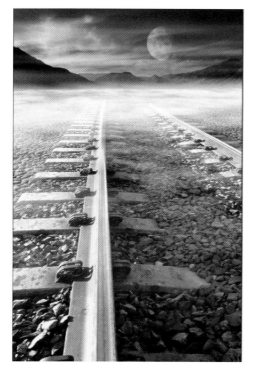

FIGURE 3.82 Fog layer duplicated.

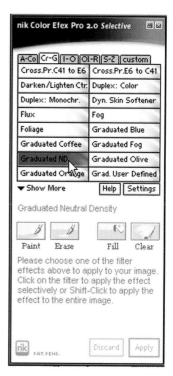

FIGURE 3.83 Color Efex Pro 2.0 Selective.

Step 8

Let's add some finishing touches with nik Color Efex Pro 2.0 to give our landscape scene a little more visual interest. nik Multimedia, the company that introduced nik Sharpener, has some wonderful filters for Photoshop that cater to the photographic community. The newest is the nik Color Efex Pro 2.0. Their filters are ideal for a situation like this one.

When it is activated (File>Automate>nik Color Efex 2.0 Pro) a panel floats over the Photoshop interface that lists all of the plug-in filters in alphabetical order (see Figure 3.83).

A couple of their filters are ideal for our final enhancements. The Graduated Neutral Density filter adds some richness to selected portions of our landscape (see Figures 3.84 and 3.85).

But it is the sunshine filter that adds character to the final image giving it an ethereal feel as shown in Figures 3.86 and 3.87.

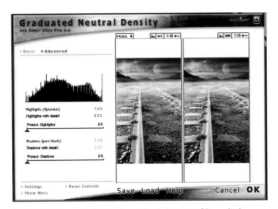

FIGURE 3.84 Graduated neutral density filter dialog.

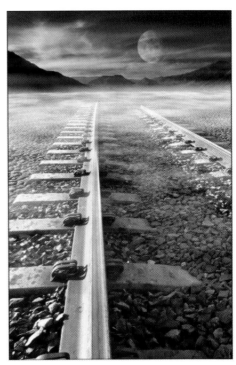

FIGURE 3.85 Results of applying the graduated neutral density filter.

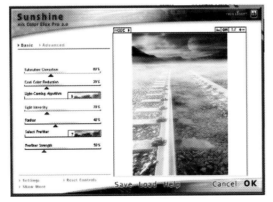

FIGURE 3.86 Sunshine filter dialog.

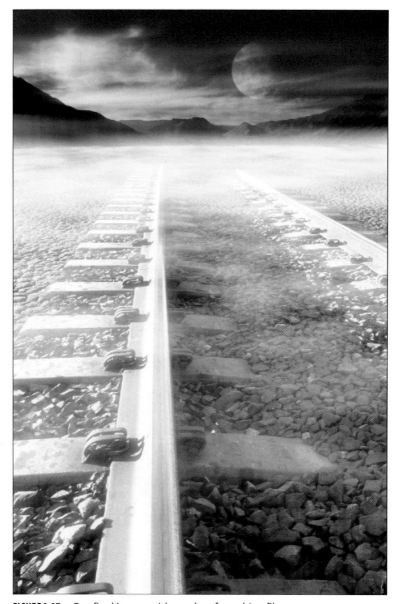

FIGURE 3.87 Our final image with results of sunshine filter.

WHAT YOU HAVE LEARNED

- The use of layer masking to composite photographic imagery
- The importance of organizing with layer sets
- How to custom create fog

APPLYING OUR PRINCIPLES FROM SCRATCH— CREATING RINGED PLANETS

IN THIS CHAPTER

In the previous chapter we learned how to apply our principles to photographic imagery. It is time to discover how to apply them to a blank canvas. Unlike using photography we do not have preexisting images that can be used to stimulate our imagination to create spontaneously. Instead we will have to use our knowledge of composition, lighting, and technique to custom create a planetary scene.

CREATING RINGED PLANETS

CREATING STARS

Let's start by giving the ringed planets a star system. The star system that you create can take on many different forms. It can be a simple spread of points of light or it can be a complicated array of spiraling and streaking gasses. In this approach a simple star field is used so that it does not compete with the main subject—the ringed planets. Shall we begin?

Step 1

Create a new document (File > New) a dimension of 5 × 7 inches with a resolution of 300 ppi. Create a new layer and fill it with 50% gray (Edit > Fill > 50% Gray). Double click on the layer's text and rename it "Star." Much of Photoshop's filters require some sort of pixel information in order to apply their special effects. Therefore we fill it with 50% gray (see Figure 4.1).

FIGURE 4.1 Filled layer with 50% gray.

Step 2

Now that this color is on our layer we will tell Photoshop to break up the tonality into a series of colored pixels by accessing the Noise dialog box. Start with an amount set around 91% to create a significant amount of noise (see Figure 4.2).

Check the Monochromatic check box to give your noise a black and white quality. This will be the basis of the stars (see Figure 4.3).

FIGURE 4.2 Adding noise.

FIGURE 4.3 Making the noise black and white.

Step 3

Each star should have its own character in terms of its shape and size. To help Photoshop achieve this use some Gaussian Blur (Filter > Blur > Gaussian Blur) with an applied radius of 1.0. Our goal is to slightly expand the tonal quality of each pixel so that we can create our stars in the next step (see Figure 4.4).

FIGURE 4.4 Gaussian Blur.

Step 4

Access the Threshold command (Image > Adjustments > Threshold) and notice that you are given a histogram of our noisy gray layer. The results show that the image is converted to a bitmap consisting of only two colors—black and white (see Figure 4.5). By pulling the slider to the left the tonal information of image is shifted toward white, as shown in Figure 4.6.

FIGURE 4.5 Threshold before applying adjustment.

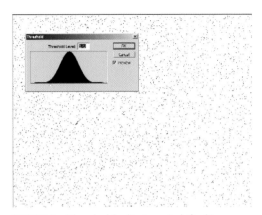

FIGURE 4.6 Threshold adjustment shifted to expose white.

As can be seen in Figure 4.7, by pulling the slider to the right the tonal information of the image is shifted toward black. Figure 4.8 shows the completed results.

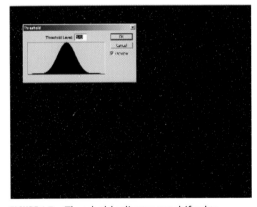

FIGURE 4.7 Threshold adjustment shifted to expose black.

FIGURE 4.8 Results of the threshold adjustments: our starfield.

Step 5

It's always a good idea to add a sense of depth to stars so that some of them will appear to be closer than others. Remember, according to the rules of perspective, that anything closer to us will be larger and anything receding into the

background will appear smaller. After we duplicate the star layer we transform it (Ctrl T) so that it is physically four times the size of it previous state(see Figure 4.9).

Step 6

Next make sure that the layer blend mode is set to Lighten so that the black pixels become transparent and the white stars are all that remain visually to gain a little more diversity in the star pattern (see Figure 4.10).

FIGURE 4.9 Duplicating and transforming the stars layer.

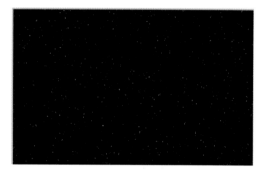

FIGURE 4.10 More diversity in the stars.

Step 7

To further aid with the visual diversity we need to add some color. Choose two colors to be represented in your stars. Make sure one is set as the foreground color and the other is set as the background color. Create a new layer in between the two stars. On this layer add Clouds (Filter > Render > Clouds) to render a cloud formation based on the foreground and background colors. This becomes the basis for providing color for the stars. To keep organized rename the new layer "star color" (see Figure 4.11).

Step 8

The "star color" layer will be used as a tint for the stars, so to achieve this change its blend mode to Color. This mode allows the hues to tint the highlights but not affect the lower tones (see Figure 4.12).

FIGURE 4.11 Create a separate cloud layer.

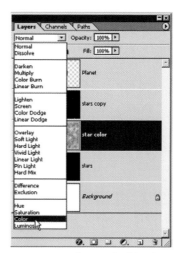

FIGURE 4.12 Change the blend mode to Color.

Step 9

The cloud pattern is a little predictable so apply a layer mask and fill it with a black and white cloud pattern to break up the consistency of the color as shown in Figure 4.13.

To add further interest, duplicate the "star color" layer and use the Hue/Saturation dialog box (Image > Adjustments > Hue/Saturation) to alter the present color. Next, add another cloud pattern to the mask so that its hue affects other locations on the star image (see Figure 4.14).

FIGURE 4.13 Creating the cloud mask.

FIGURE 4.14 View of all our new layers.

Step 10

There is one last little detail to our star pattern. We will add a series of lens flare effects to also serve as stars. So create another layer on top of the stars and fill it with 50% gray. Apply a lens flare (Filer > Render > Lens Flare). To maintain the circular shape make sure that it is positioned in the center of the preview window and click OK. Your results should look something like Figure 4.15.

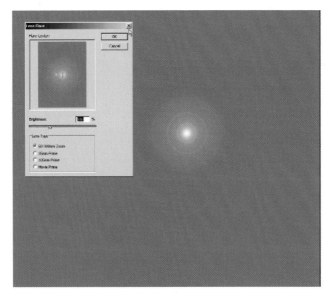

FIGURE 4.15 Lens flare applied.

Step 11

We now have our lens flare on the 50% gray pixels. Change the layer blend mode to Hard Light to allow the gray pixels to go transparent. We simply duplicate the Lens Flare layer several times, resize each one, and add a little Gaussian Blur (see Figure 4.16).

Now let's create our planet.

FIGURE 4.16 Creating more stars.

CREATING THE PLANET

The key to mastering Photoshop is mastering selections. *Selections, masks, and channels are identical.* There's that mantra once again. Since we are interested in applying certain techniques within predefined shapes we will use our selections and masks quite a bit.

Step 1

Start by creating a new layer and renaming it "Planet." Access the Elliptical Marquee tool and use the Shift Alt key combination to constrain the marquee to a perfect circle and resize from the center. Save the selection (Select > Save Selection) to create an alpha channel (see Figure 4.17).

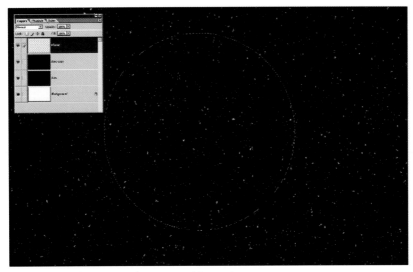

FIGURE 4.17 Selection used to start making a planet.

Step 2

Chose two earthy hues to represent the foreground and background colors and apply a cloud pattern (Filter > Render > Clouds) within the marching ants. Once complete, use Ctrl D to get rid of the marching ants (see Figure 4.18).

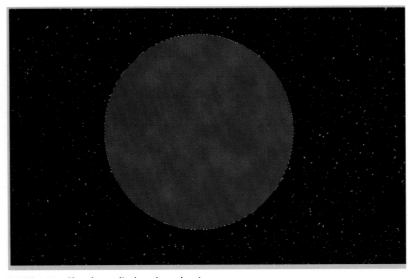

FIGURE 4.18 Clouds applied to the selection.

Step 3

This is a good time to get organized with layer sets. Create two and call them "planet" and "stars." Drag all of the layers relating to the creation of the stars into the "stars" folder. Do the same for the planet layers and place them into the "planet" folder as shown in Figure 4.19.

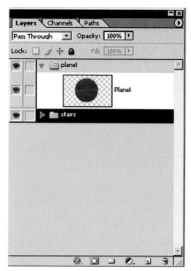

FIGURE 4.19 Organizing our layers into sets.

Step 4

We will now focus on giving the planet some texture. Channels are used to assist us in this process and just by clicking on each one we will achieve visual results (see Figures 4.20 through 4.22).

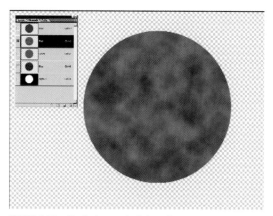

FIGURE 4.20 Red channel of the planet.

FIGURE 4.21 Green channel.

FIGURE 4.22 Blue channel.

Step 5

The blue channel in this case allows for the most contrast so duplicate it and rename it "planet texture" (see Figure 4.23)

FIGURE 4.23 Renaming the alpha channel.

Step 6

To further enhance the texture, apply the Curves command so that the highlights are enhanced and the shadows are richened as shown in Figure 4.24.

FIGURE 4.24 Contrast adjustment of the alpha channel.

Step 7

Next, apply Lighting Effects and make sure that the "planet texture" alpha channel is selected under the Texture Panel dialog box. Remember, this gives us our texture based on the tonal information in the alpha channel.

By adjusting the mountainous slider at the very bottom of the layout you can fine tune the strength of the texture. In this example, a mountainous value of 98 is applied to give our planet a more visible surface (see Figure 4.25).

Apply the changes and notice that the planet is slowly starting to shape up. Let's give it some more detail (see Figure 4.26).

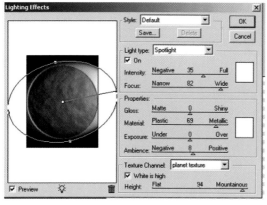

FIGURE 4.25 Applying the texture.

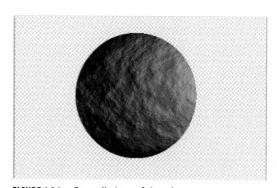

FIGURE 4.26 Overall view of the planet.

Step 8

Often the first effect is not enough to make the imagery feel complete, so more experimentation is needed to add additional character to the final image. Duplicate the planet layer, rotate it 180°, and change the layer blend mode to Darken. This adds more interest and spontaneity to our surface (see Figure 4.27).

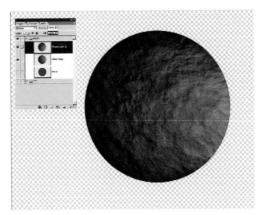

FIGURE 4.27 Layer duplicated with blend mode set to Darken.

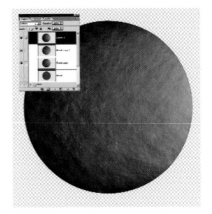

FIGURE 4.28 Preview of layer with color adjustment and Lighten layer blend mode.

Duplicate the planet one last time and use the Color Balance (Ctrl B) and shift the color to a subtle red to catch the eye a little better. Next, give it a blend mode of Lighten so that it gains more of a complete look (see Figure 4.28).

To give our image a more dramatic look use the Levels command (Ctrl L) to enhance the detail. Figure 4.29 shows the original unaltered layer and Figure 4.30 shows the low tones being intensified as the slider on the left pinches into the midtones of the histogram.

Next we will add cloud and atmosphere detail.

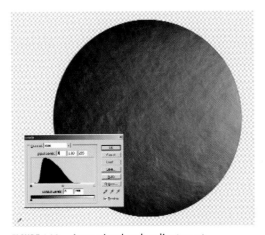

FIGURE 4.29 Accessing levels adjustment.

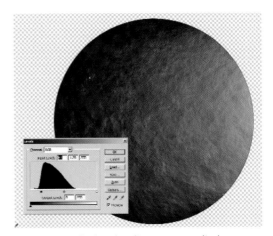

FIGURE 4.30 The levels adjustment applied.

CREATING THE CLOUDS

The importance of layers is that we can place each object on its own layer so that we can apply all of Photoshop's tools and commands to each image independently from the entire scene. The power of layers is ideal for the creation and placement of our custom clouds and atmosphere.

Step 1

Create a new layer and render some clouds using the Clouds command (Filter > Render > Clouds) with white as the foreground color and 50% gray as the background color. When done, change the layer blend mode to Hard Light so that the medium gray pixels go transparent. Finally, duplicate this layer and give the clouds a bit more detail (see Figure 4.31).

Step 2

We will design the clouds so that they are traveling across the surface of the planet with great speed. That means they will appear as elongated streaks of color. To create the effect use the Fibers filter (Filter > Render > Fibers). It's a good idea to rely on your creative eye when applying this effect (see Figure 4.32).

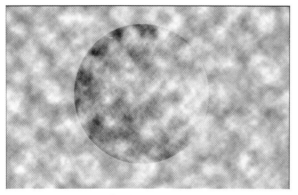

FIGURE 4.31 Creating the clouds and adding detail.

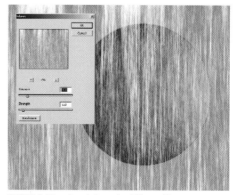

FIGURE 4.32 Applying the Fibers filter.

Step 3

Clouds usually do not have a sharp edge, so soften them with Gaussian Blur as shown in Figure 4.33.

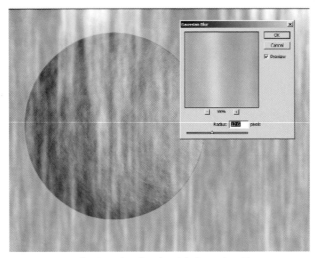

FIGURE 4.33 Softening the clouds with Gaussian Blur.

Step 4

Using our common sense we know that the planet his a circular surface. The clouds are currently traveling in a very linear direction. To correct this we use the Shear tool (Filter > Distort > Shear) as shown in Figure 4.34.

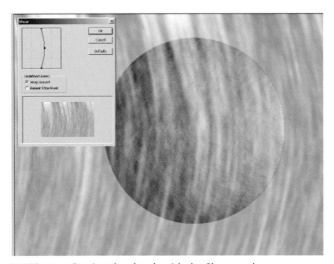

FIGURE 4.34 Curving the clouds with the Shear tool.

Step 5

Because the Shear tool only applies its texture in a vertical direction, use Free Transform (Ctrl T) to rotate the layer. In this case we rotate it 90°, clockwise (see Figure 4.35).

FIGURE 4.35 Free Transform applied in order to rotate the planet.

Step 6

Next we need to get rid of the extraneous cloud detail from around the planet so hold down the Ctrl key and click on the planet layer. This is a handy shortcut that creates a selection in the form of any object on a transparent layer (see Figure 4.36).

FIGURE 4.36 Selection made from planet layer.

Step 7

Currently the planet is selected. We want everything around the planet to be deleted so we use Ctrl Shift I (Invert selection) and hit delete (see Figure 4.37). Now let's see the results of our efforts as shown in Figure 4.38.

FIGURE 4.37 Inverted selection made from planet layer—now everything except the planet is selected.

FIGURE 4.38 Overall view of planet alone.

Step 8

By applying the levels to our clouds we can get some subtle improvements. Shifting the mid-tones to the right allows them to become slightly darker. This helps to add depth to our clouds (see Figure 4.39).

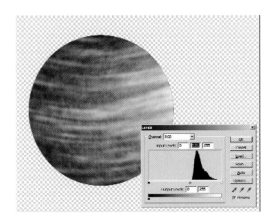

FIGURE 4.39 Shifting the midtones to become darker.

Step 9

Here is where we add some dynamic detail to our planet. Repeat Steps 1 through 7 to create a new cloud layer with a brownish-orange color. Do the same in another layer but this time make the color black. When complete, offset the two new layers so that each color is placed adjacent to one another. Make opacity changes so that the new additions do not overpower your composition. Repeat this as much as you like until you are satisfied. In this exercise only the two additional layers are created (see Figure 4.40).

Step 10

To give the feeling that the light source is coming from the right side of the planet apply a gradient mask to the black clouds layer only (see Figure 4.41).

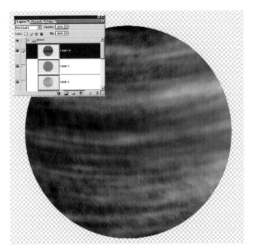

FIGURE 4.40 New layers of clouds added.

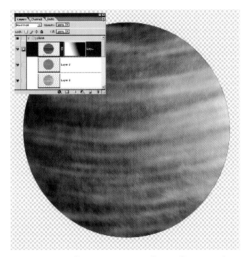

FIGURE 4.41 Close up view with gradient mask.

Step 11

Creating the shadow is fairly straightforward. Create a new layer above all of the planet layers. Make a selection slightly larger than the planet and fill it with black. This is the basis of the shadow (see Figure 4.42).

Step 12

Using the Move tool offset the shadow layer as shown in Figure 4.43.

FIGURE 4.42 Beginning to create the shadow.

FIGURE 4.43 Offsetting the shadow.

Step 13

The shadow should not have such a sharp edge. We want to simulate a smooth transition over the planet's surface. So we apply Gaussian Blur (see Figure 4.44).

FIGURE 4.44 Gaussian Blur applied to shadows to soften the edge.

Step 14

Once again Ctrl click on the planet layer to create a selection (see Figure 4.45).

FIGURE 4.45 Selecting only the planet shape.

Step 15

Our goal is to delete the excess shadows. So by inverting the selection and deleting the shadows we have a more complete planet as shown in Figure 4.46.

FIGURE 4.46 Excess shadow deleted.

Now let's turn on our stars layer and see a first hand view of our work as shown in Figure 4.47.

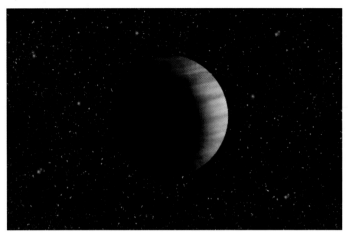

FIGURE 4.47 Planet with stars.

This is a good time to link the planet layers and merge them as one layer (see Figures 4.48 through 4.50).

FIGURE 4.49 Merge Linked menu.

FIGURE 4.48 Planet layers linked.

FIGURE 4.50 Merged layer.

CREATING THE PLANET RINGS

The really cool planets are the ones with rings. In the science fiction world they can be any size and color. Planets that we see in NASA images are spectacular but you as an artist can make them much more imaginative. Let's create some rings.

Step 1

We will place our rings on a new layer, so create a new layer set above the planet as shown in Figure 4.51.

Step 2

Activate the Rectangular Marquee tool and place a long thin selection in the center of the layer as shown in Figures 4.52 and 4.53.

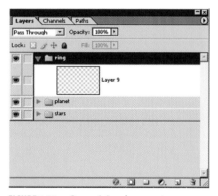

FIGURE 4.51 Organizing layer sets.

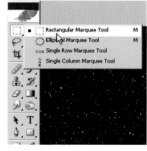

FIGURE 4.52 Activating the marquee.

FIGURE 4.53 Applying the marquee.

Step 3

Activate the Gradient tool to custom create the ring colors (see Figure 4.54).

FIGURE 4.54 Activating the Gradient tool.

Step 4

On the options bar (see Figure 4.55) you will see a sample gradient. If you click on it, a dialog box (see Figure 4.56) will appear that will give you the ability to edit your colors.

FIGURE 4.55 Gradient tool options bar.

FIGURE 4.56 Gradient tool dialog box.

Step 5

Look at the long slider gradient bar near the bottom of the dialog box (see Figure 4.57). By clicking on the triangular gradient points we can change the color (see Figure 4.58).

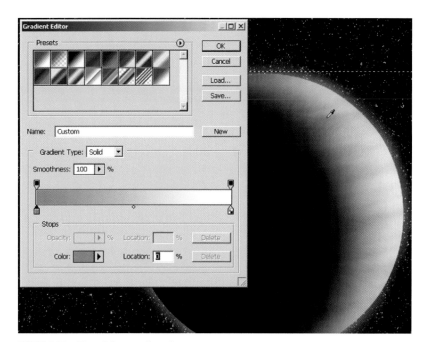

FIGURE 4.57 The slider gradient bar.

FIGURE 4.58
Changing gradient color by clicking the gradient points.

Step 6

You can add more gradient points by clicking on the blank area at the base of the gradient map (see Figure 4.59).

FIGURE 4.59 Adding more color to the gradient.

Step 7

In this example we see a series of color points that were added (see Figure 4.60). Along the top portion of the gradient, opacity points have been strategically placed. Opacity points allow us to place a transparency along any portion of our gradient. The transparency can be controlled in the opacity box. Notice that they are in groups of three. The slider in the middle represents total transparency and the outer two represent 100% opacity. This allows us to constrain the effect anywhere along the gradient. Once completed click OK.

FIGURE 4.60 Adding transparency to the gradient.

Step 8

With the Gradient tool selected, click and drag your mouse starting at the top of the selection and ending at the base (see Figure 4.61).

Next, we will add a little more color detail. By using the paint brush add some red (see Figure 4.62). We can create straight lines by holding the Shift key.

FIGURE 4.61 Creating the gradient.

FIGURE 4.62 Adding color detail to ring.

Step 9

A little more detail is added. This time we choose some darker color (see Figure 4.63).

FIGURE 4.63 Adding more color detail to ring.

Step 10

Accessing the Motion Blur (Filters > Blur > Motion Blur) the gradient is blurred in the vertical direction. Afterward, Free Transform (Ctrl T) is applied to vertically shorten the gradient. Now it is ready for the finishing touches, as shown in Figures 4.64 and 4.65.

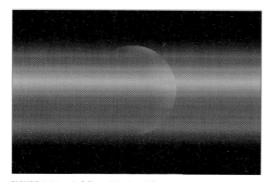

FIGURE 4.64 Adding Motion Blur.

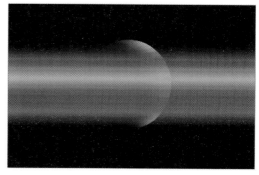

FIGURE 4.65 Transforming the gradient.

Step 11

We will use a little known filter called Polar Coordinates (Filter > Distort > Polar Coordinates (see Figure 4.66). This filter takes our rectangular shape and alters it into a circular ring.

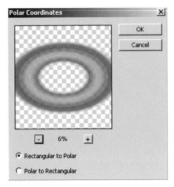

FIGURE 4.66 Creating the ring with Polar Coordinates.

When done, use Free Transform (Ctrl T) to vertically shorten and horizontally elongate the ring (see Figure 4.67).

Finally, transform the planet and position it inside the ring. Now, let's wrap the ring around the planet (see Figure 4.68).

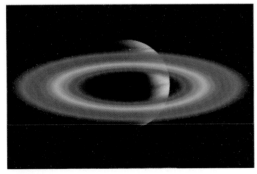

FIGURE 4.67 Transforming the ring horizontally and vertically.

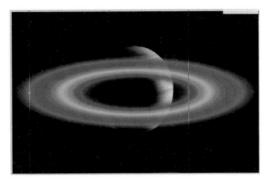

FIGURE 4.68 Transform the planet.

Step 12

Place the layers associated with creating the ring inside its own layer set. Now we are going to use a layer mask for the entire set. Ctrl click on the planet to create a selection (see Figure 4.69).

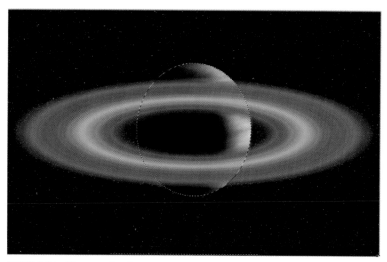

FIGURE 4.69 Planet selection.

Now, apply a layer mask to the layer set (see Figure 4.70).

Actually, we want the mask inversed so that we can see the ring; therefore inverse the mask (Ctrl I) as shown in Figure 4.71.

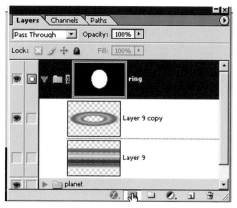

FIGURE 4.70 Layer set mask.

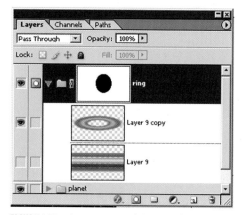

FIGURE 4.71 Layer set mask inverted.

The ring seems a little dull so we duplicate it and change the layer blend mode to overlay to obtain a more dynamic looking effect. Finally, further edit the mask to show the ring through the front of the planet as shown in Figure 4.72.

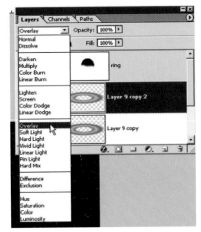

FIGURE 4.72 Changing the mask to make sure the ring shows.

Lets take a look at the complete image. The rings have much more of a glow to them. Remember when using your Layer Blend modes scroll through every one of them and preview each effect. There is no substitute for experimenting (see Figure 4.73).

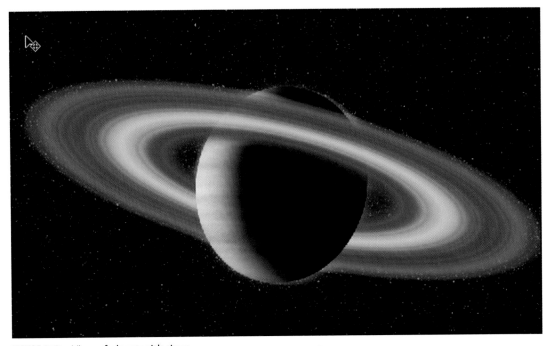

FIGURE 4.73 View of planet with rings.

ADDING OTHER PLANETS

Our ringed planet is mundane just sitting there by itself so let's compose it with other planets. Then let's add some sunlight.

Step 1

It is helpful to give our composition more space so let's extend our background. Access the Canvas Size dialog box (Image > Canvas Size) (see Figure 4.74). Make sure that Relative is selected and highlight the lower, middle box in the grid diagram. This tells Photoshop that you want the canvas to extend vertically upward. We are going to double the size of our canvas. Since it's currently 5 inches let's put in 5 inches for the height and click OK. We now have vertical composition. Note that you must resize the stars using the Free Transform tool to cover the background (see Figure 4.75).

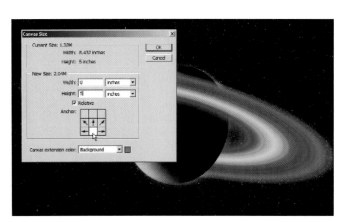

FIGURE 4.74 Canvas Size dialog box.

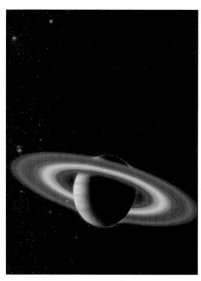

FIGURE 4.75 Extending the background.

Step 2

Following the steps we used to create the original planet, create another and resize it to take up two-thirds of the frame (see Figure 4.76).

FIGURE 4.76 Larger, second planet.

Let's add one last detail to the ringed planet. Since our light source is coming from the left, the shadow of the ringed planet casts itself onto the rings at the same angle. This can easily be achieved by making a slender oval selection around our ring layer and filling it with black. After rotating and resizing the layer it is blurred to soften the edges. Add a mask to fine tune the transparency of the shadow (see Figure 4.77).

FIGURE 4.77 Mask is applied to shadow.

Apply a blend mode of Hard Light and adjust its opacity to give the shadow some slight transparency. This adds a little more depth to the image. Finally, place the ringed planet in the upper one-third of the composition (see Figure 4.78).

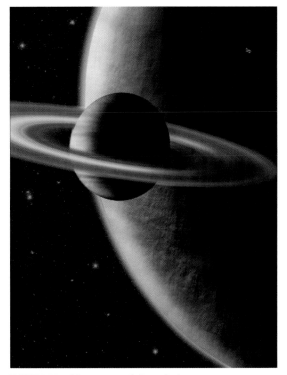

FIGURE 4.78 Placement of ringed planet.

Step 3

Create a ring for the larger planet and duplicate it. Change its blend mode to Overlay to enhance the highlights (see Figures 4.79 and 4.80).

FIGURE 4.79 Overlay applied to ring layer.

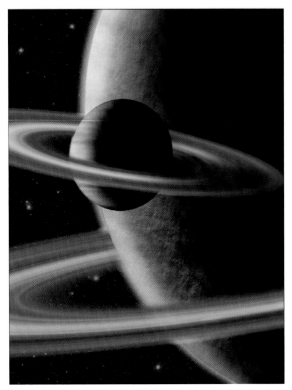

FIGURE 4.80 Full view with larger ringed planet.

Step 4

To give the larger rings some differentiation from their smaller counterpart use the Selective Color adjustment layer. Since red and yellow are the most dominating colors in the ring choose them as the colors to be altered (see Figures 4.81 through 4.84).

FIGURE 4.81 Selective Color adjustment layer applied to larger ring.

FIGURE 4.82 Selective Color settings for red hues.

FIGURE 4.83 Selective Color settings for yellow hues.

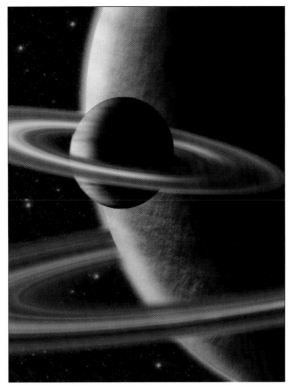

FIGURE 4.84 Results of changing the Selective Color settings of the larger ring.

Step 5

Next, apply a Hue/Saturation adjustment layer to desaturate the ring to give it even more of a differentiating look (see Figure 4.85).

Step 6

Since the sun will come from around the left side of the large planet add a highlight using a white fill in the shape of the large planet. Apply a mask to restrict the effects to the outer edge of the planet. Finally, give the white fill a blend mode of Hard Light (see Figure 4.86).

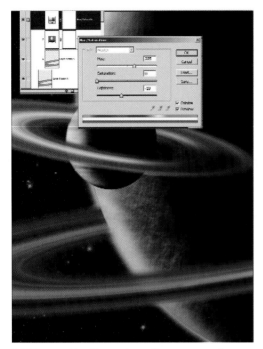

FIGURE 4.85 Hue/Saturation adjustment results.

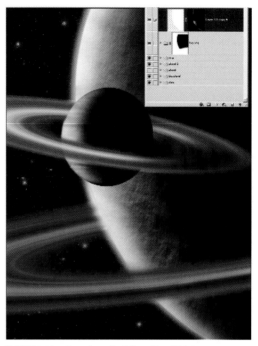

FIGURE 4.86 Results of adding Hard Light.

Step 7

Here comes the sun. Creating the sun is fairly simple. Apply a lens flare to a layer filled with medium gray. The lens flare is positioned to the upper left to get the streak distortions normally caused by light hitting the camera lens, to extend toward the lower right side of our composition. After applying a blend mode of Hard Light, only our lens flare is visible, positioned so that it appears to be peeking from behind both planets (see Figure 4.87).

Step 8

Using the planets that we have already created, duplicate and resize them to be placed throughout the composition (see Figure 4.88).

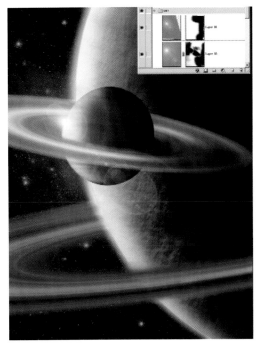

FIGURE 4.87 Results of lens flare.

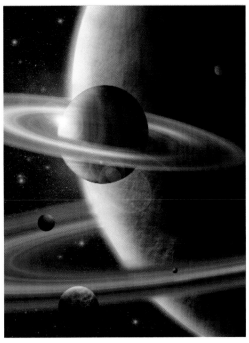

FIGURE 4.88 Duplicate our planets and place them throughout the image.

Step 9

To give the image a little contrast, add the Levels adjustment layer above all the other layers and adjust the black slider to increase the depth of the image (see Figures 4.89 and 4.90).

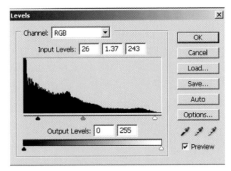

FIGURE 4.89 Working with Levels to change the image depth.

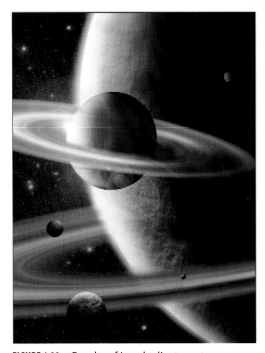

FIGURE 4.90 Results of Level adjustment.

Step 10

Now we will make a couple of adjustments that will change the look of the piece to become slightly more dynamic. Taking a close-up view of the rings for the larger planet, note that they appear rather soft (see Figure 4.91).

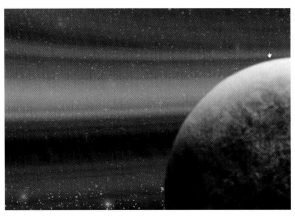

FIGURE 4.91 Rings of the larger planet.

Let's add some texture. If we duplicate the ring again and give it a blend mode of Dissolve, the transparent regions break up into individual pixels (see Figure 4.92).

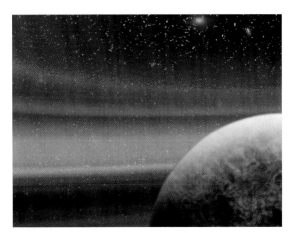

FIGURE 4.92 Dissolve blend mode applied.

This gives the illusion of particle texture. The effect is quite strong so we reduce its opacity to around 10% (see Figure 4.93).

Finally, the ring of the smaller planet gives us the feeling that we are looking down on it. We can change this composition by editing the small ring layer mask so that the ring in the rear comes forward and the one to the front is masked out (see Figure 4.94).

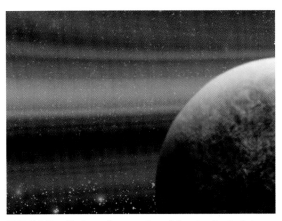

FIGURE 4.93 Reduce the opacity of the duplicated rings.

FIGURE 4.94 Editing the mask of the smaller planet's rings.

How about that change! Now we can see the detail of the sunlight flare rings a little better and the planet has the feeling that it is coming out toward the viewer as seen in Figure 4.95.

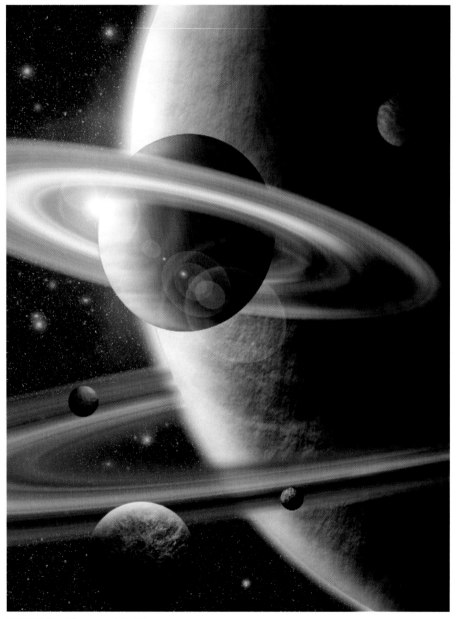

FIGURE 4.95 The completed image.

CREATING SPIRAL STAR SYSTEMS

There are many approaches to simulate spiraling gasses and stars. Often an artist will just use the painting tools alone and paint his scene, but Photoshop has some great effects to facilitate the process of creating spiraling star systems.

FORMING THE CENTRAL SPIRAL

Step 1

Create a layer set and make three layers using the Clouds filter. Each layer should have a medium gray and color combination. In this example the three colors are yellow, blue, and red (see Figure 4.96).

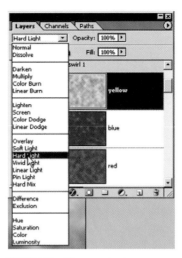

FIGURE 4.96 Three color layers created with the Clouds filter.

Step 2

Designate to each layer a blend mode of Hard Light (see Figure 4.97).

FIGURE 4.97 Hard Light blend mode.

Step 3

We will start the spiral gas effect by applying the Twirl filter to each layer (Filer > Distort > Twirl). It's a good idea to apply a different angle to each layer to give each one its own character (see Figures 4.98 through 4.101).

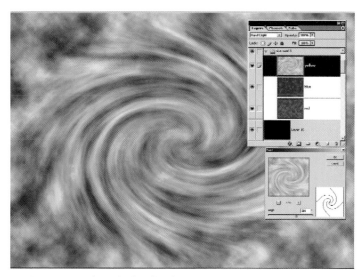

FIGURE 4.98 Twirl applied to first layer.

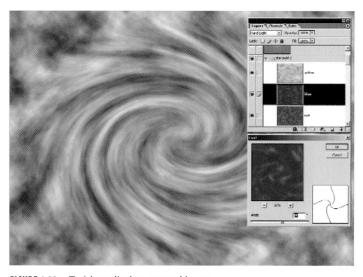

FIGURE 4.99 Twirl applied to second layer.

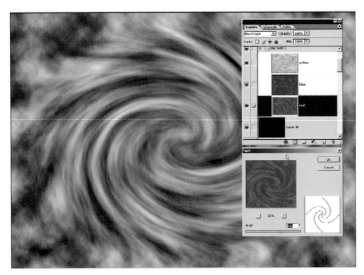

FIGURE 4.100 Twirl applied to third layer.

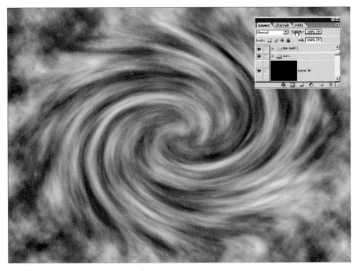

FIGURE 4.101 Overall view of Twirl.

Step 4

When we work with a large number of layers we must keep them organized, so create two layer sets and title them "Star Swirl" and "Stars." All of our swirl effects are placed into the star swirl folder. Using the steps for creating stars from the Ringed Planet tutorial, create your star field within the star layer set.

Step 5

Another great advantage of a layer set is that we can apply a layer mask to it and the mask affects all of the layers inside it equally. Our goal is to create some transparency in the form of a swirl to our color patterns. So we create a mask and fill it with a black and white cloud pattern to give transparency to those areas that are associated with the black texture (see Figure 4.102).

FIGURE 4.102 Layer mask applied to layer set.

FIGURE 4.103 Twirl applied to layer mask.

Now let's give the cloud pattern a twirl like we applied in the color layers (see Figure 4.103).

What do we have? We can now see through our color swirl patterns so that the stars are revealed more prominently (see Figure 4.104).

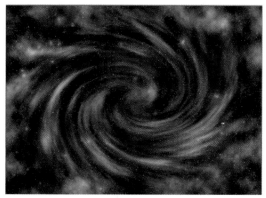

FIGURE 4.104 Overall view with stars in the background.

Step 6

The color swirls are coming along fine but they need a little more luminance that represents energy gasses swirling toward the center of their destination. Let's use our handy lens flare trick. We create a new layer filled with medium gray and place it above the star swirl layer, fill it with several lens flares, and give it a blend mode of Hard Light (see Figure 4.105).

Four flares are used in this example but you must experiment. Apply the Twirl filter to the flares (Filter > Distort > Twirl) as shown in Figures 4.106 and 4.107.

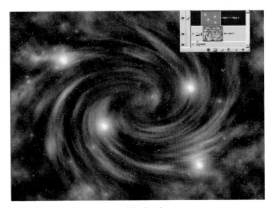

FIGURE 4.105 Working with the layer.

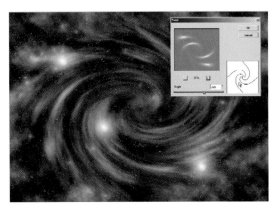

FIGURE 4.106 Twirl applied to lens flare.

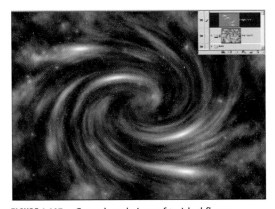

FIGURE 4.107 Completed view of twirled flares.

Step 7

To make it more dynamic, duplicate (Ctrl J) the lens flare layer and rotate it clockwise as shown in Figure 4.108.

Step 8

To keep with the swirl theme apply the Twirl filter (Filter > Distort > Twirl) as shown in Figure 4.109.

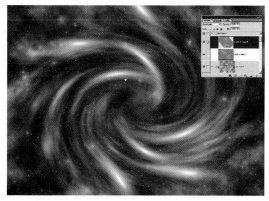

FIGURE 4.108 Lens flare layer duplicated.

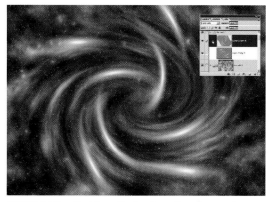

FIGURE 4.109 Twirl applied to lens flare in new layer.

Step 9

The new layer is now rotated and transformed to match the flow of the swirls. Finally, knock the opacity down a bit so that it blends well with the other elements (see Figures 4.110 and 4.111).

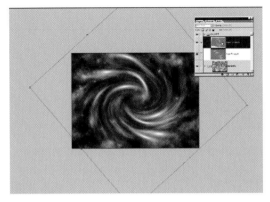

FIGURE 4.110 Rotate to match the rest of the swirls.

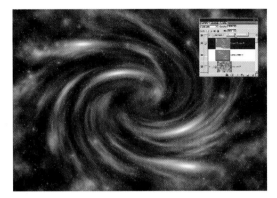

FIGURE 4.111 Seeing it all in Layer view.

Step 10

Let's use another trick to give our spiraling gasses more depth and vibrancy. Duplicate the star swirl layer set and apply the Twirl filter again to its mask. This allows for the layer to affect the colors is other areas (see Figure 4.112).

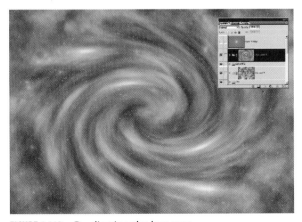

FIGURE 4.112 Duplicating the layer set.

Step 11

Apply the Overlay blend mode to the new layer set (see Figures 4.113 and 4.114).

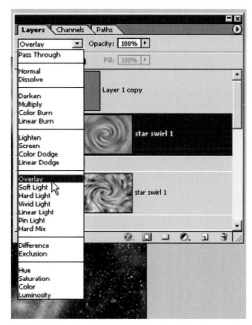

FIGURE 4.113 Applying the Overlay blend mode.

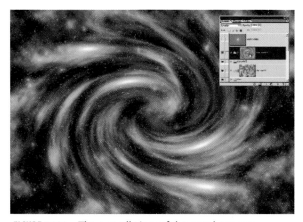

FIGURE 4.114 The overall view of the new layer set.

Step 12

Once again we use our lens flare trick to create a central star as shown in Figure 4.115.

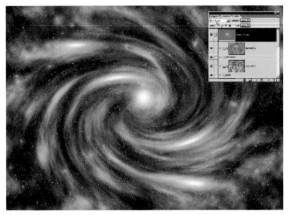

FIGURE 4.115 Making the central star.

Step 13

At this stage it would be very handy to transform all of the layers as one unit so we will create a master layer set. To achieve this we create a new layer set and title it "Set 1." Into it drag all layers including any of the other layer sets inside them (see Figure 4.116).

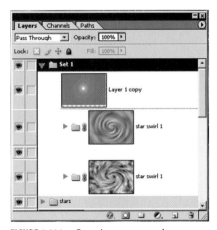

FIGURE 4.116 Creating a master layer set.

Step 14

Patterns may appear to be a little predictable so sometimes it's a good practice to flip an image on its side. Since we created a master layer set we can transform our entire star swirl scene as one unit using the Flip command (Edit > Transform > Flip Vertical) as shown in Figures 4.117 and 4.118.

FIGURE 4.117 Apply flip command.

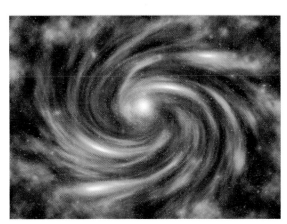

FIGURE 4.118 The result of slipping the star around.

Step 15

Using the Distort tool, transform Set 1 and apply a sense of perspective (see Figure 4.119).

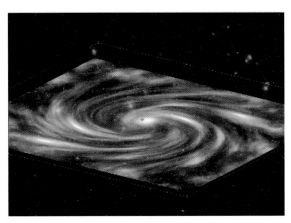

FIGURE 4.119 Distortion applied to Set 1.

Step 16

After applying a layer mask to the Set 1 folder, edit the sides to comply more with the circular spiral theme (see Figures 4.120 and 4.121). See the overall view in Figure 4.122.

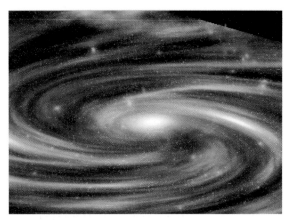

FIGURE 4.121 Apply a layer mask to a layer set.

FIGURE 4.120 Apply a layer mask to Set 1.

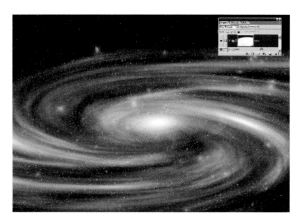

FIGURE 4.122 Overall view.

Step 17

Add another lens flare to enhance the glow of the central star but make sure to place it below the layers defining the spiral effects. This is done so that the natural color of the spiral blends with the flare making it appear as an integral part of the scene. We don't want the central star to look too independent (see Figure 4.123).

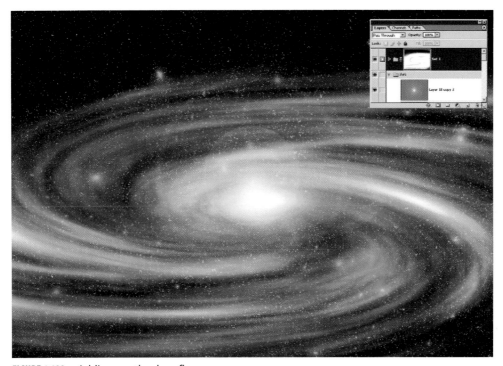

FIGURE 4.123 Adding another lens flare.

ADDING GAS BURSTS TO THE CENTRAL STAR

Adding unusual energy clouds and gas streaks is always a nice enhancement in a science fiction space scene. So we will finish up this piece with comet streaks and energy bursts.

Step 1

Using our faithful lens flare technique, create a number of lens flares on a single layer so that they are clustered vertically above the central star (see Figure 4.124).

Step 2

Apply a Motion Blur with a radius of 90° (see Figure 4.125). Next, transform it using Perspective (Edit > Transform > Perspective) so that the lower end of the flare is reduced. This gives the effect that it is shooting in all directions. Duplicate the layer again and reduce it so that its effect is applied only to the center of the gas burst.

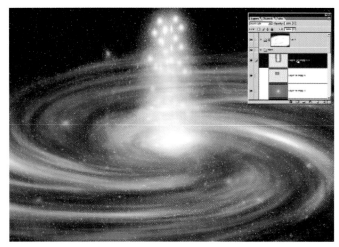

FIGURE 4.124　Lens flare cluster.

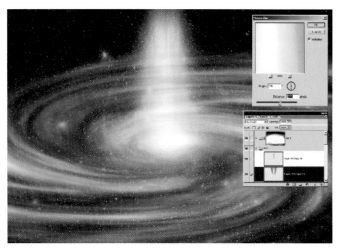

FIGURE 4.125　Soften the effect with Motion Blur.

Step 3

To gain a better sense of motion add Noise (Filter > Noise > Add Noise) to apply some particle effects. Next, add a Motion Blur (Filter > Blur > Motion Blur) to give it an exploding feel (see Figures 4.126 and 4.127). Let's move on to our comets and clouds.

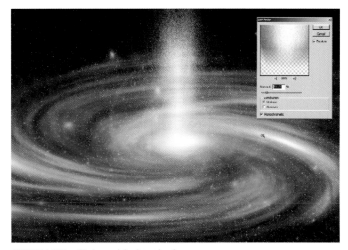

FIGURE 4.126 Noise added to the layer.

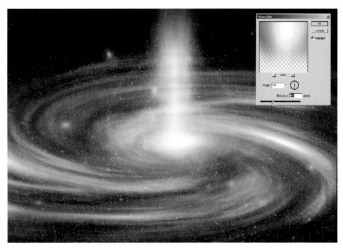

FIGURE 4.127 Motion Blur added to the layer.

ADDING A STREAKING COMET

Sometimes adding elements with motion can help lead the viewer's eye into the composition. In this case our comet tail does just that.

Step 1

Create a new layer inside of a new layer set. Rename the layer set "Comet." We will use a lens flare as the basis of the comet. Make sure that you turn off the other layers so that the detail they provide is not distracting (see Figure 4.128).

FIGURE 4.128 Using lens flare to make our comet.

After duplicating the layer, stretch it and apply some Motion Blur (see Figures 4.129 and 4.130).

FIGURE 4.129 Making the tail by stretching the duplicate layer.

FIGURE 4.130 Motion blur added to the layer.

Step 2

Once again, duplicate, stretch, and merge the new layer as shown in Figures 4.131 and 4.132.

FIGURE 4.131 Duplicated layer.

FIGURE 4.132 The duplicated layer is merged.

Step 3

Using the Perspective command (Edit > Transform > Perspective) make the right side larger to give the comet perspective as shown in Figures 4.133 and 4.134.

FIGURE 4.133 Perspective applied to the comet.

FIGURE 4.134 Our comet once the Perspective command has been applied.

Step 4

Now add both Noise and Motion Blur to gain some streaking qualities to the comet tail as shown in Figures 4.135 and 4.136.

FIGURE 4.135 Noise applied to the comet.

FIGURE 4.136 Motion blur applied.

Step 5

After selecting the comet layer set folder rotate it 90° counterclockwise (Edit > Transform > Rotate CCW) as shown in Figure 4.137.

FIGURE 4.137 Rotating the comet layer set.

Step 6

The comet will curve around the central star so we apply Shear (Filter > Distort > Shear) to give it that effect (see Figures 4.138 and 4.139).

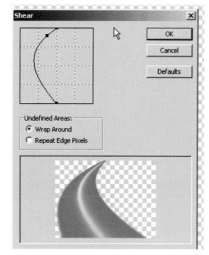

FIGURE 4.138　Shear effect applied to the comet's tail.

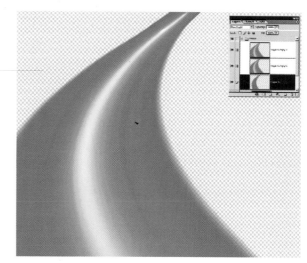

FIGURE 4.139　The tail after the effects have been applied.

Step 7

Select the Step 1 layer set and transform it horizontally so that it is thinner. This gives the scene a stronger perspective. We will add one last finishing touch to our scene: the energy clouds (see Figures 4.140 and 4.141).

FIGURE 4.140　Transforming spiral clouds.

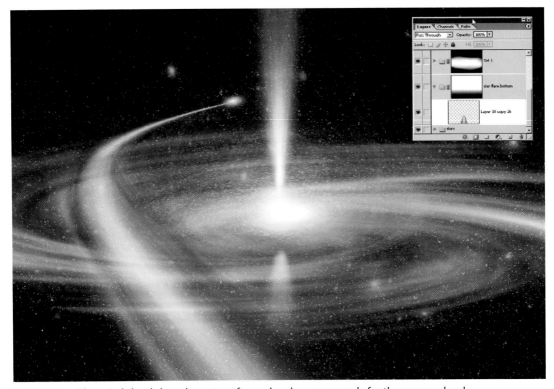

FIGURE 4.141 The spiral clouds have been transformed and are now ready for the energy clouds.

ADDING ENERGY CLOUDS

The energy clouds serve to add not only a greater centralized interest but also by juxtaposing it to the central star it provides a stronger sense of light.

Step 1

Using a custom-made animated brush, the clouds are painted around the central star (see Figures 4.142 through 4.144). Animated brushes will be discussed in detail in Chapter 5, "Photoshop's Paintbrush Engine—the Animated Brushes. Once finished, we duplicate (Ctrl J) this layer.

FIGURE 4.142 Choose a paint brush.

FIGURE 4.143 Paint brush preview.

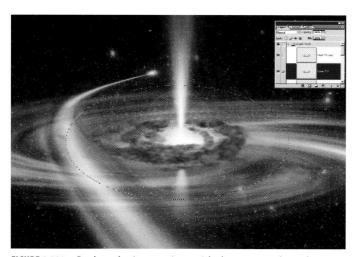

FIGURE 4.144 Back to the image view, with the center selected.

Step 2

We add Radial Blur (Filter > Blur > Radial Blur) with the Zoom option se-
lected to the first layer to gain the effect of the gasses exploding outward (see
Figure 4.145).

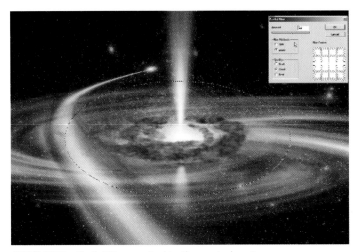

FIGURE 4.145 Radial Blur applied to the central region.

Step 3

Then we duplicate the unaltered cloud layer and apply a blend mode of Multiply to give it some richness (see Figure 4.146).

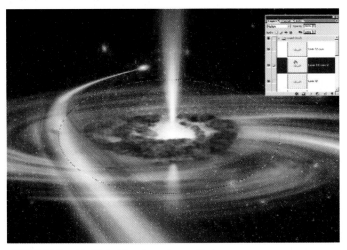

FIGURE 4.146 Multiply Blend mode applied.

Step 4

Next we apply a Radial Blur (Filter > Blur > Radial Blur) with the Zoom option selected (see Figure 4.147).

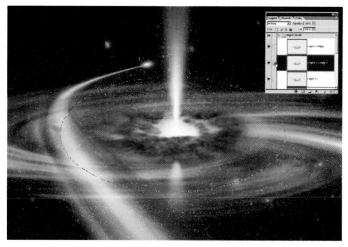

FIGURE 4.147 Radial Blur layer is duplicated.

Step 5

Again we duplicate the cloud layer and give it a Screen blend mode. Also, transform it to constrain its effects more to the center of the energy clouds (see Figure 4.148).

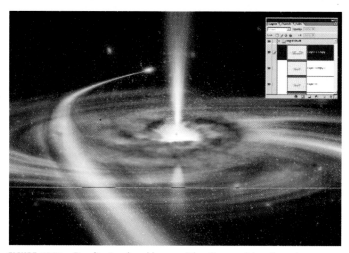

FIGURE 4.148 Duplicate cloud layer with a Screen blend mode transformed to constrain effect on the center of the image.

Step 6

Finally, we add another central star using lens flare but this time apply Hue/Saturation (Image > Adjustments > Hue/Saturation) to give it a strong yellow hue as shown in Figure 4.149.

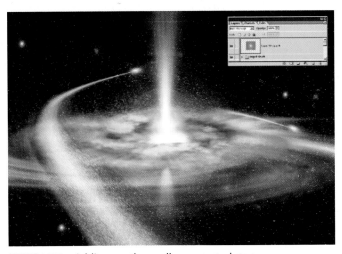

FIGURE 4.149 Adding another, yellower central star.

Your spiral galaxy is complete as seen in Figure 4.150. Remember the settings we used are only starting points, so experiment extensively and create variations on the theme. Hopefully, this exercise has given you insight into understanding the language of the digital program to assist you in applying your skills more intuitively. Next we will study a little further and discover the power and application of animated brushes.

What You Have Learned

- How to apply contrast adjustment tools to assist in creating a simple star field
- Basic techniques for creating the terrain of a planet
- The many uses of the lens flare filter
- Using canvas size to recompose your subject

In this chapter we applied our tools to create a ringed planet. Next we will learn to use the animated brush engine to enhance our creations.

FIGURE 4.150 The final image.

PHOTOSHOP'S PAINTBRUSH ENGINE— THE ANIMATED BRUSHES

IN THIS CHAPTER

- How to use the animated brush engine to custom create rust
- How to use the animated brush engine to custom create concrete
- FX tricks to create simple interiors
- How to use the animated brush engine to custom create smoke

Texture is fascinating. Consider taking an afternoon to go to the beach or the mountains and photograph any sort of texture, such as oil slicks on the roads, lichen feeding on large rocks, or tree bark. An interesting subject is an old abandoned storage shack or a burned out building. Experiment with and document the wonderful textures that these weather torn structures provide. The rich saturated colors of dilapidated and rusting steel walls are ideal for source material. Next time you take a road trip to the desert or mountains and you see those old abandoned and gutted out homes, plan to drive up and document the textures. Make sure to bring a tripod to work around the low lighting. You will want as sharp an image as possible.

CREATING RUST AND STONE FROM SCRATCH

TEXTURING THE WALLS

Dilapidated steel and concrete is eye candy for anyone who loves texture with character. For this tutorial we will follow a series of steps not only to cre-

ate seamless textures but also to use them to build a simple interior of an old dilapidated storage shed. The two main texture themes used for the interior are the wall with rust and the concrete floor. Let's begin with the rust. You can access what you need to create this tutorial in the Tutorials/Chapter5– Creating Rust and Stone/ on the companion CD-ROM.

Step 1

Access the Layers palette (Windows>Layers) and create a new layer. One of the beautiful features of Photoshop CS is its ability to create animated brushes. These are customizable brushes that will create several effects as you paint.

On the tools bar select your Paintbrush tool (B). On the preset drop menu at the top horizontal edge of the interface you will see shape options for your brushes. On the right-hand side of the brush text click on the drop menu options and choose a brush similar to the example shown in Figure 5.1.

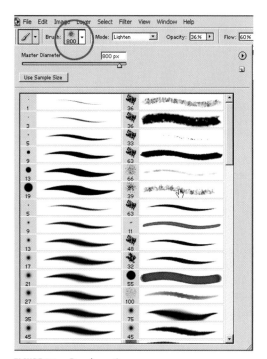

FIGURE 5.1 Brush options.

Step 2

Now click on the Brush Animation palette box and let's add some life to the selected brush (see Figure 5.2).

FIGURE 5.2 Animated brush options.

Brush effects use the foreground and background colors, so change the foreground color to a deep olive green and the background color to a brownish rust hue. Most of the animated commands use a jittering effect, which varies the size, rotation, intensity, and color over time as you click and drag to apply your paint. This requires that you experiment and play to get a handle on the best options for your texture. In the animated palette menu there are five areas of interest:

Shape Dynamics: Alters size and rotation
Scattering: Alters placement over a specified area
Dual Brush: Allows the effects of two brushes in one
Color Dynamics: Alters hue over time
Other Dynamics: Alters opacity over time

In this example the brush is modified so that it scatters the texture without causing a smoothing affect. A preview of your settings are provided on the bottom of the options box. Figures 5.3 through 5.7 show what we will use to create the beginnings of our wall texture.

FIGURE 5.3 Shape menu.

FIGURE 5.4 Scattering menu.

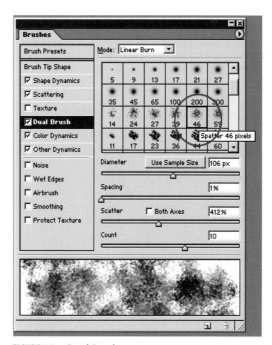

FIGURE 5.5 Dual Brush menu.

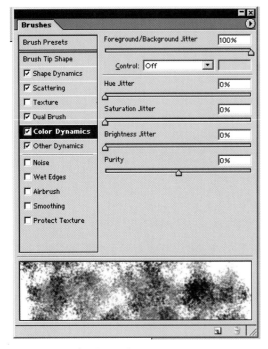

FIGURE 5.6 Color Dynamics menu.

FIGURE 5.7 Other Dynamics menu.

Now let's look at the beginnings of our texture (see Figure 5.8).

FIGURE 5.8 Initial results in creating our texture.

Step 3

Moving forward, let's change the background color to a lighter shade of brown. With the Brush tool still selected, look on the options bar to the right of the brush size options and change the mode from Normal to Lighten. Use the same animated brush and create the raised effect on the same layer (see Figure 5.9).

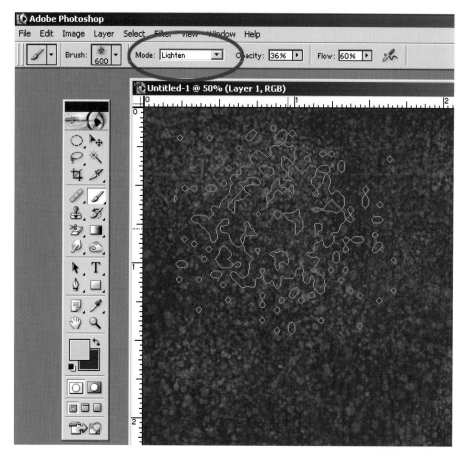

FIGURE 5.9 Animated brush in Lighten blend mode.

Step 4

Next we will change the foreground color by resampling. Holding down the Alt/Option key while in the paintbrush mode gives you the eyedropper. Use this to select a darker texture in your image. Change the brush mode from

Lighten to Multiply and paint on your image while varying the size of the brush as shown in Figure 5.10.

Remember, you can use the bracket keys ([]) on your keyboard to make the brush larger and smaller. We are now adding depth to our wall texture. That's it in a nutshell. From here, create other brushes and continue to resample in both Lighten and Multiply modes with a variety of brush shapes and dynamics so that the final image doesn't look too predictable.

Take a look at the final texture in Figure 5.11.

FIGURE 5.10 Animated brush in Multiply blend mode.

FIGURE 5.11 The finalized basic texture.

ADDING DETAIL TO OUR WALL TEXTURE

Step 1

Now we can start adding the detail. Make sure that your foreground color is black and create a new layer. Rename this layer "Shadow Grout" in order to be organized. Place your mouse on the left side of your image about one third of the way down from the top and click and release your mouse. Follow up

by placing your mouse on the right side of the screen on the opposite side and hold down the Shift key. When you click and release the mouse, a horizontal line is drawn between the two points. Do the same one third of the way from the bottom. Set this layer to Soft Light mode.

Create a new layer and name this one "Highlight Grout." Select white as the foreground color and duplicate the same procedures as in Step 1 but this time place your line adjacent to the black one just below it and change the layer mode to Overlay. Now our texture is starting to take on more of a 3D effect as shown in Figure 5.12.

FIGURE 5.12 Creating grout.

Step 2

Sample some color from your image and create a new layer. Draw some dripping effects beneath one of the white line layers and change the layer mode to Color Dodge. Now do the same for the other line as shown in Figure 5.13.

FIGURE 5.13 Creating drippings from grout.

Step 3

We have a file with dimensions that are 2000 × 2000 pixels. Now we're going to make this texture seamlessly tileable. Access (Filters > Other > Offset) and place 1000 in both the width and the height. In essence this is splitting your image in half and placing each piece head-to-head so that we can see how the detail flows when it is tiled. As you can see in this example, the edges of the tiles are visible so we will need to use the Clone and Healing Brush tool to patch up the defects. Once you are finished editing, apply Offset again and you'll have an image that will tile seamlessly as shown in Figure 5.14.

Let's take a look at the completed wall (see Figure 5.15).

It looks quite usable but it needs a little more contrast and desaturation. Keep it simple and use Curves (Ctrl M) to increase the contrast. Afterward use Hue/Saturation (Ctrl U) to desaturate the image. The end result is much improved (see Figure 5.16).

FIGURE 5.14 Creating an image that will tile seamlessly.

FIGURE 5.15 Edited texture.

FIGURE 5.16 Final texture.

CREATING THE FLOOR

To keep the flow consistent, the same techniques are used to create realistic concrete. However, by varying the brush shapes and sizes we can achieve a different look. A Wacom® tablet is excellent for this type of work because you can set the animated texturing properties to adjust with the pressure of the pen. The final image as shown in Figure 5.17 looked something like Figure 5.1

Don't forget to make it seamless in case you choose to tile the texture.

FIGURE 5.17 Final concrete texture for the floor.

BUILDING THE INTERIOR

Now that we have created our textures let's build something with them. This exercise demonstrates how to build a basic interior that resembles an old, rusting storage shack.

Step 1

After creating an 8×10 inch document, place the textures on their own layers. In the spirit of keeping organized, create several layer sets: floor, wall, ceiling, and light source. Let's start with the layer set titled "Wall" (see Figure 5.18).

FIGURE 5.18 Rust and concrete textures on a new document.

Step 2

Previously, the rust texture was created to tile seamlessly, so duplicate it (Ctrl J) and place the resulting files side by side. The longer perspective takes on the appearance of a single wall. With one wall layer selected, take a look at its duplicate layer. On this layer click on the empty box next to the eye and you will get a link symbol. This joins the two without merging so that if one is moved the other follows. However, for this example we will merge the two as one layer. In the top right-hand corner of the layers palette click on the black triangle and select the submenu titled Merged Link (see Figure 5.19). Now that they have been joined as one layer let's move on.

FIGURE 5.19 Merged textures.

Step 3

Duplicate the merged layer. This represents the next wall. Position its right edge one quarter of the way into the image with the grout detail aligned. Next, use Perspective (Edit > Transform > Perspective) to stretch the left-hand side to achieve the illusion that the viewer is at an angle to the corner of the wall (see Figure 5.20).

FIGURE 5.20 Perspective tool applied.

Step 4

Apply the same technique to produce the floor once the concrete texture is placed into the layer set titled "Floor" (see Figures 5.21 and 5.22).

FIGURE 5.21 Perspective tool applied to the floor.

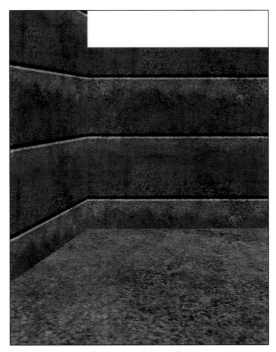

FIGURE 5.22 Perspective tool overall view.

Step 5

We use the same texture for the floor that was used for the ceiling so it simply needs to be duplicated (Ctrl J) as well as the layer inversed vertically (Edit > Transform > Flip Vertically). After placing it into the ceiling layer set position it below the top edge of the wall (see Figure 5.23).

FIGURE 5.23 Perspective tool overall view with the ceiling in place.

Step 6

Using the Polygonal Lasso tool create a skewed square and use it to cut its shape into the ceiling. This represents the ceiling hatch. Note that in Figure 5.24 that the edge of the hatch that is further away is shorter than the opposite side to honor the rules of perspective.

Step 7

Place the rust texture in a new layer above the ceiling layer and use Transform to create the outer hatch support (see Figure 5.25).

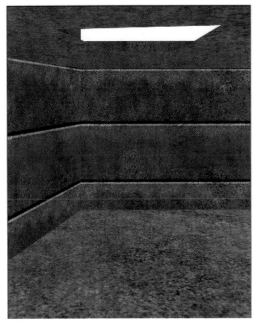

FIGURE 5.24 Perspective square in ceiling.

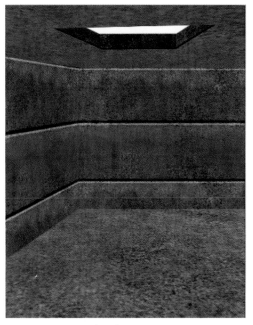

FIGURE 5.25 Outer hatch support.

Step 8

Next, use a series of adjustment layers to alter the color and tonality to modify the overall lighting of the scene. Let's look at why and how each one is applied.

First, the color of the far wall seems a little too saturated so apply the Hue/Saturation adjustment layer to slightly desaturate it. In addition, edit the mask so that the effect is applied to the side and rear wall (see Figure 5.26).

Next, the effects of two adjustment layers are constrained to the left perspective wall so that their effects are only applied to it. To accomplish this, hold down the Alt key and place your mouse in between the adjustment layer and the image layer. When your mouse changes to a black and white half circle click your mouse and you will see the adjustment layer offset slightly to the right. This signifies that it only affects the layer it is joined to. For the first adjustment layer apply the Curves adjustment layer as shown in Figure 5.27 to give the wall some separation from the other.

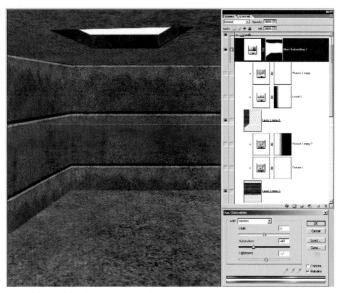

FIGURE 5.26 Hue/Saturation adjustment layer.

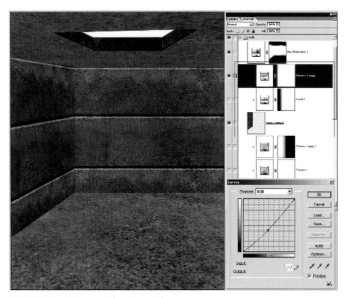

FIGURE 5.27 Curves adjustment layer.

Next apply the Levels adjustment layer as shown in Figure 5.28. In addition, edit the mask by applying a horizontal gradient of black to white so that the effect is applied more to the rear and less to the front.

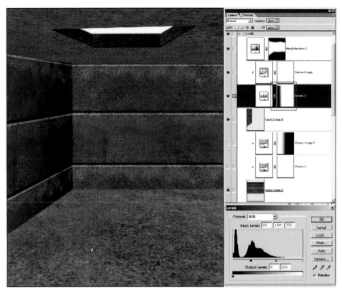

FIGURE 5.28 Levels adjustment layer.

Do the same to the rear wall with a Gradient layer applied so that the effect is strongest in the left corner as shown in Figure 5.29.

Finally, use another Curves adjustment layer to the entire rear wall as shown in Figure 5.30 to give it a rich tonality. Let's move on.

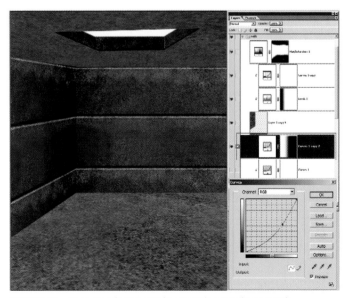

FIGURE 5.29 Curves adjustment layer with a gradient mask.

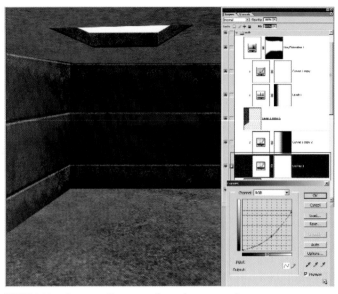

FIGURE 5.30 Curves adjustment layer for rear wall.

Step 9

Accessing the floor layer set, apply two adjustment layers to the floor as well so that the light source has a volumetric property. It appears to have density as if it is shining through haze or fog. The darker tonality of the background helps the light source to stand out (see Figures 5.31 and 5.32).

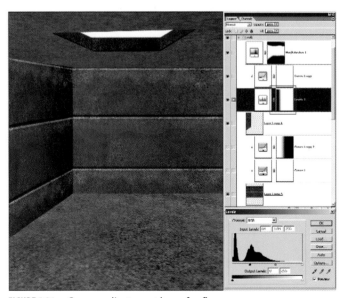

FIGURE 5.31 Curves adjustment layer for floor.

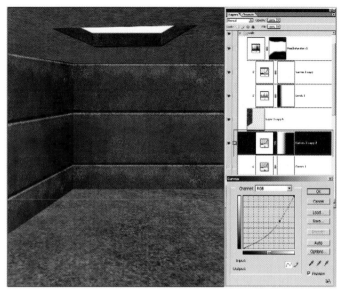

FIGURE 5.32 Adding a second adjustment layer for the floor.

ADDING THE VOLUMETRIC LIGHTS

The volumetric light source shines through the hatch piercing the interior to make contact with the ground beneath. In the real world, this type of lighting is caused by light that is diffused by atmospheric particles like dust or haze. Because light is linear, the effect of light passing through these particles produces light streaks. Volumetric light is a common 3D terminology in which the 3D program gives shape and density to the light source. We will produce the same effect using Clouds and Motion Blur. Several layers are needed to get this effect; we will create them in the next few steps.

Step 1

Use the Polygonal Lasso tool to form the basic shape for the light source and fill it with white. Apply some Gaussian Blur to soften the edges and set the layer's opacity to 48% (see Figure 5.33).

Step 2

Duplicate and transform the layer so that it is slightly smaller than its predecessor. Apply a mask to give the upper portion of the light less opacity (see Figure 5.34).

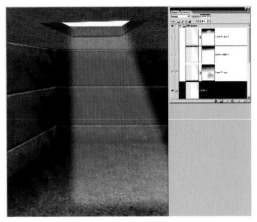 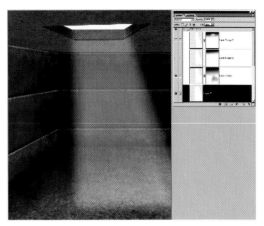

FIGURE 5.33 Volumetric lighting through Gaussian Blur.

FIGURE 5.34 Applying a mask.

Step 3

Now duplicate the layer and shorten it horizontally, but this time set the layer blend mode to Difference. This creates an effect of streaming rays on the outer edge of the light source (see Figure 5.35).

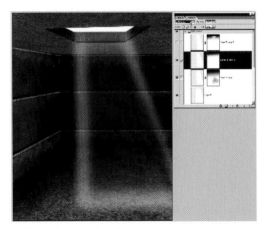

FIGURE 5.35 Creating the rays.

Step 4

Once again duplicate the current layer and transform it to be slightly smaller but this time set the blend mode back to Normal. Apply a Gradient mask with black dominating the top 10% of the image to control the opacity in the upper portion of the light as shown in Figure 5.36.

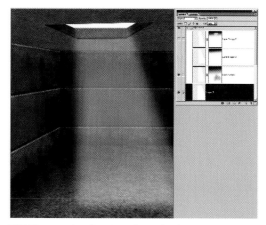

FIGURE 5.36 Gradient mask applied.

Step 5

When the light source hits the floor it projects the basic shape of the ceiling hatch. Using the Polygonal Selection tool create the basic shape and fill it with white and apply Gaussian Blur to taste. Finally, set the blend mode to Overlay to give it a slight glow to represent a subtle reflection of light off of the concrete (see Figure 5.37).

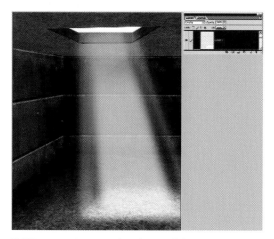

FIGURE 5.37 Creating the shape of the ceiling hatch on the floor with Overlay for subtle light reflections.

A Few More Details

We're almost done—just a few more details needed. If you look at the ceiling it is rather luminous. Since the light source is fairly directional, the ceiling should have a denser tonality.

Step 1

Let's add two adjustment layers (one Levels and the other Curves) to the ceiling to reduce brightness (see Figures 5.38 and 5.39).

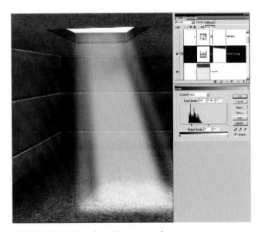

FIGURE 5.38 Levels adjustment layer.

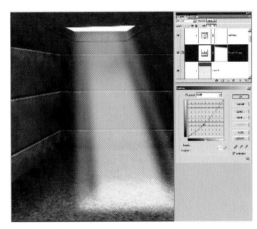

FIGURE 5.39 Curves adjustment layer.

Step 2

To add a little more character to the concrete floor we use a displacement texture. First, duplicate the floor layer. Next, access the Lighting Effects panel (Filter > Render > Lighting Effects) and select the Omni light source located under the Light Type drop menu. Under the Texture Channel drop menu choose the Blue channel. Place the Material slider toward Plastic so that the texture does not appear too harsh. Also, the Mountainous slider should be placed closer to Flat so that the floor gains texture that is not too aggressive (see Figures 5.40 and 5.41).

Step 3

To gain more subtlety as shown in Figure 5.42, we set the layer's opacity to 58%.

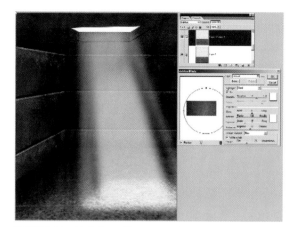

FIGURE 5.40 Lighting effects panel.

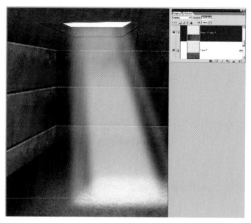

FIGURE 5.41 Overall view of lighting effects.

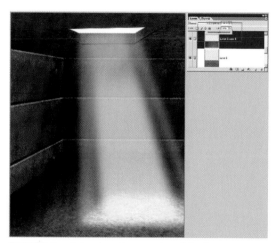

FIGURE 5.42 Adusting the opacity of the layer.

Step 4

Paint on a separate layer with the paintbrush blend mode set to Dissolve. To stay consistent with the lighting, white should be used as the foreground color. This gives the light source a sense that it is shining through a dusty atmosphere as shown in Figure 5.43a.

Step 5

Finally, place the chair or any object that you would like into a new layer set titled "Chair." Position it so that it rests inside and at the base of the volumetric light ray. To keep the lighting accurate place a shadow underneath by duplicating the chair layer and filling it with black (Edit > Fill > Fill With Black). Make sure the Preserve Transparency box is checked so that only the chair is filled instead of the entire layer. Drag this layer underneath the chair and transform it to reduce its height as well as to flip it upside down. Line up the tips of the legs from the shadow to the chair. Use the paintbrush to achieve this if necessary. Apply a Gaussian Blur to soften the edges and bring the layer opacity to around 50%. Finally, set the blend mode to Multiply (see Figure 5.43b).

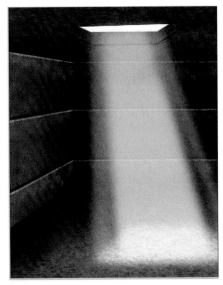

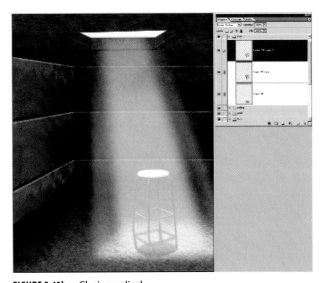

FIGURE 5.43b Chair applied.

FIGURE 5.43a Dissolve brush applied before placing the chair.

Wasn't that a fun exercise? Your results should look something like Figure 5.44. Now that we have some insight into applying Photoshop's animated brush effects, let's discover how to create a brush that will paint smoke.

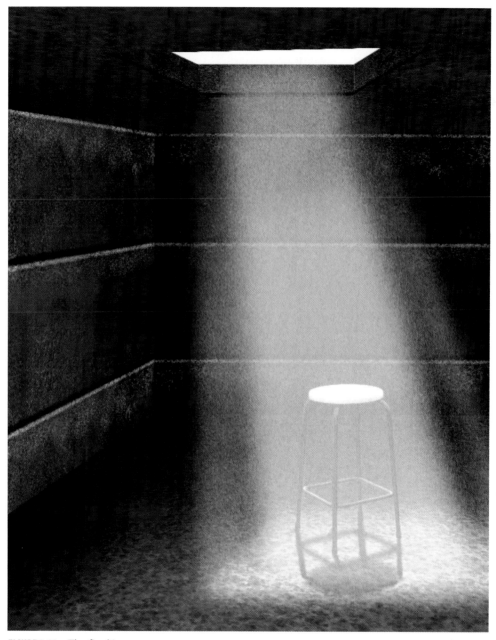

FIGURE 5.44 The final image.

CREATING SMOKE WITH ANIMATED BRUSHES

One of the joys of the Animated Brush palette is its ability to render a wide variety of effects as if the artist is painting them onto a canvas. You just have to use your imagination. When creating smoke the artist has to consider its nature. Smoke does not have a shape. It's transparent, but its transparency is not consistent. In other words some areas are more opaque than others. Smoke expands as it gets further away from the source that is creating it. Finally, as it rises it is rotating to some degree. Let's simulate these features with our brush. Let's apply this animated brush to an airplane in a distress scene. You can access what you need to create this tutorial in the Tutorials/Chapter5–Creating Smoke In The Distance/ on the companion CD-ROM.

Step 1

Two images are used to create the burning plane theme. The nose of the plane that dominates most of the composition helps to give the final scene a greater sense of volume. The backlit cloud image is a strong visual itself, but

in this case serves well as a background to complement the foreground (see Figures 5.45 and 5.46).

FIGURE 5.45 Plane image.

FIGURE 5.46 Backlit clouds.

After dragging the plane onto the backlit cloud image, use the Pen tool to outline the background elements not needed for this scene as shown in Figure 5.47. The path shape is nothing more than a sophisticated shape from which to create a selection. This shape is also previewed in the Paths palette (Windows > Paths).

FIGURE 5.47 Pen tool applied to background.

Step 2

With the Paths palette activated, create a selection by Ctrl clicking on the path or by clicking on the center icon on the base of the Path palette (see Figure 5.48).

FIGURE 5.48 Using Paths to create a selection.

Step 3

Remember, *selections and masks are the same*. Now that there is a selection to work with create a layer mask to expose the background (see Figure 5.49).

FIGURE 5.49 Making a layer mask to let the clouds show through.

Step 4

Now the goal is to eliminate the shadows. Use your Selection tools with a feather of three pixels and copy and paste large areas of texture over the shadow detail as shown in Figures 5.50 and 5.51).

In addition, use the Clone Stamp tool to accommodate small areas that are hard to get to such as near the edge of the plane. This procedure should be fairly quick. You will sample an area by simultaneously holding down the Alt key and clicking on an unblemished portion of the image. When done release the Alt key and just click on the shadow detail to replace it with the sampled texture (see Figure 5.52).

FIGURE 5.50 Selecting texture to copy.

FIGURE 5.51 Pasting texture over shadow.

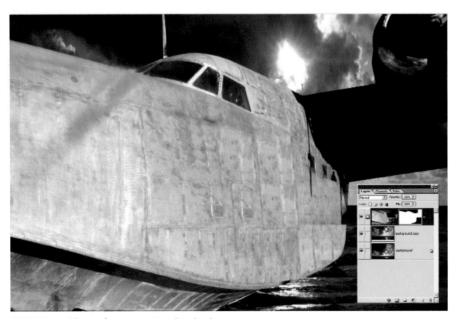

FIGURE 5.52 Plane after removing the shadow.

Step 5

Next, edit the mask of the plane to create a jagged opening in its side. Use the Polygonal Lasso tool and fill it with black as shown in Figure 5.53.

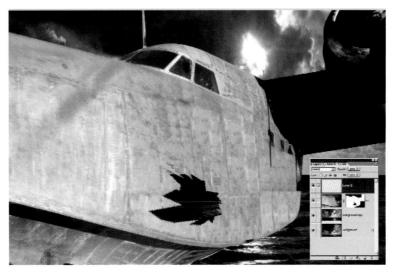

FIGURE 5.53 Hole created on mask.

Step 6

To give the jagged opening some depth, create a new layer and place it beneath the plane and paint black beneath the opening. It now appears as a separate entity from the rest of the plane (see Figure 5.54).

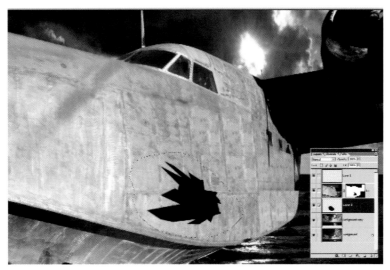

FIGURE 5.54 Painted layer beneath the plane.

Step 7

Duplicate the plane layer (Ctrl J). Turn off the visual aspects of the top so that you can view and edit the lower layer. The intention is to give some thickness to the edge of the jagged hole as shown in Figure 5.55. Add some noise (Filter > noise > add noise).

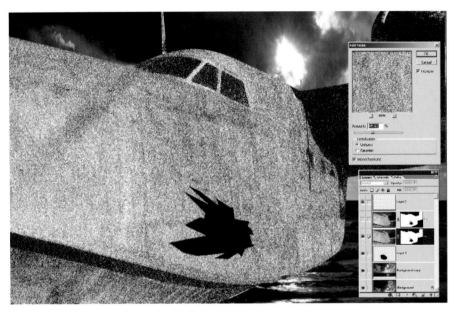

FIGURE 5.55 Noise is added to the duplicated plane layer.

Step 8

Next, to achieve an appearance of brushed metal, apply the Motion Blur at an angle of 52% and a distance strength of 999 pixels. The noise helps greatly to produce the streaking texture (see Figure 5.56).

Step 9

With the top plane layer turned back on the lower one, offset it slightly to the left and downward (see Figure 5.57).

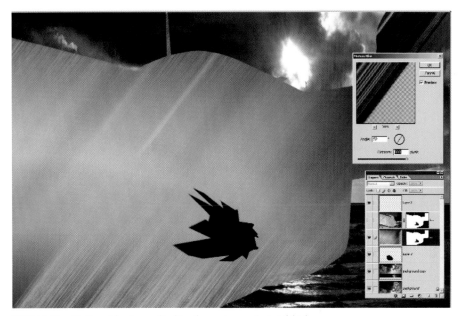

FIGURE 5.56 Motion Blur is applied to the noise we just added.

FIGURE 5.57 Lower plane layer offset.

In addition, edit the mask of the lower layer so that the edges appear as one continuous surface. To finalize the detail use the Burn tool to give the edges contour and depth (see Figures 5.58 and 5.59).

FIGURE 5.58 Edge effects are applied to the jagged hole.

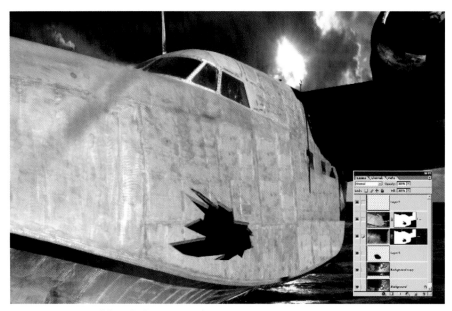

FIGURE 5.59 View of the whole image so far.

CREATING THE SMOKE BRUSH

Photoshop now gives you the ability to animate the brushes to apply a variety of shapes, colors, and opacities over the length of the stroke. Again, the Wacom pen and tablet is ideal for this.

Smoke has no shape. When smoke is created it not only dissipates over distance but it expands and rotates. Depending on the amount, it can be a rich black or white in tonality. The surrounding winds can cause it to rotate or quickly scatter.

Our ship has been damaged. As a result, smoke is streaming from the hole in its hull. The hole has been created, so let's add our smoke effect. An animated brush is ideal for this.

Step 1

Create a new file with a dimension of 1 × 1 inches at the resolution of the file it will be placed into. This isn't critical since we can enlarge the brush using the bracket keys ([]), but it does allow for the artist to work with adequate resolution.

Starting with the simple circular brush and black as the foreground color, paint a very light shape as shown in Figure 5.60. Smoke has no shape so it is important to make sure that the edges are soft and irregular.

FIGURE 5.60 Beginnings of the smoke brush.

Step 2

Continue to edit some areas so that they are denser than other locations. This is useful to help to define the areas of the smoke that will have more density (see Figure 5.61).

FIGURE 5.61 Darkening certain areas of the smoke brush.

Step 3

It's difficult to keep a soft edge, so it is recommended that you apply a slight Gaussian Blur as shown in Figure 5.62.

FIGURE 5.62 Gaussian Blur applied to smoke.

Step 4

Select the entire image (Ctrl A) and define it as a new brush (Edit > Define Brush Preset). In our example the new brush is named "Smoke" (see Figure 5.63).

FIGURE 5.63 Smoke brush defined as a preset.

If you access the Brush Preset palette on the options bar, the new brush is always the last one as shown in Figure 5.64.

FIGURE 5.64 The last brush is the one you just created.

Step 5

It's time to animate the new smoke brush. The secondary brush palette is where the magic takes place. As in the previous exercise, Shape, Scattering, Color, and Other Dynamics are selected. Let's take a look at each setting used in this tutorial. Remember that these are only examples; we encourage you to experiment to achieve other types of effects.

Shape Dynamics

The Angle Jitter is set to 61% and the Pen Pressure is chosen for the control. The rotation of the smoke changes according to the pen's pressure (see Figure 5.65).

FIGURE 5.65　Brush palette options.

Scattering Dynamics

The brush can be sprayed onto the canvas in a designated circumference de-fined here. In this case very little is applied to give more control over the smoke placement. This choice is purely up to the artist (see Figure 5.66).

Color Dynamics

The foreground and background color can be used interchangeably while the brush is applied. The amount of the exchange is set in the Foreground/Back-ground Jitter slider. The brightness is set to 15% to give the artist a little more control over the final color and to give a little variation to its intensity (see Figures 5.67 and 5.68).

FIGURE 5.66 Brush palette options.

FIGURE 5.67 Brush palette options.

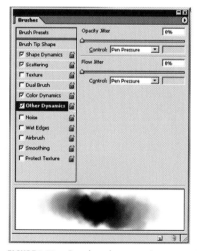

FIGURE 5.68 Brush palette options.

This area is important because it is where we tell Photoshop to control our setting with the Wacom® pen's pressure sensitivity.

Experiment with these settings regularly and don't be afraid to make mistakes. Sometimes mistakes can produce compelling results that would not otherwise have happened. Everything is set so let's paint some smoke.

APPLYING THE SMOKE

When applying the smoke, work slowly and press lightly on the pen or use lower opacity settings at first. Allow the results to suggest other possibilities.

Step 1

After creating a new layer set and calling it smoke, place a new layer inside it and draw a light smoke stream from the hole to the background (see Figure 5.69).

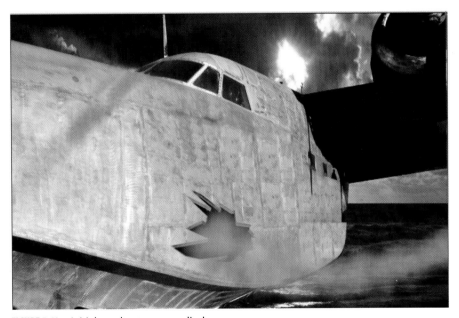

FIGURE 5.69 Initial smoke stream applied.

Step 2

Change the smoke brush blend mode to Multiply to apply a richer tonality. To achieve a brighter tonality switch the blend mode to Lighten. Editing is continued by switching the blend modes until complete (see Figures 5.70 and 5.71).

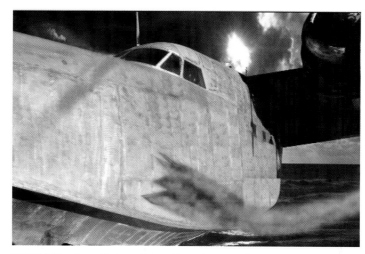

FIGURE 5.70 Brush blend mode is set to Multiply.

FIGURE 5.71 Overall view of the effect after switching blend modes as necessary.

Step 3

The smoke needs to have a little motion so duplicate the layer and add Motion Blur. The angle of the blur is set to match the angle of the smoke stream (see Figure 5.72).

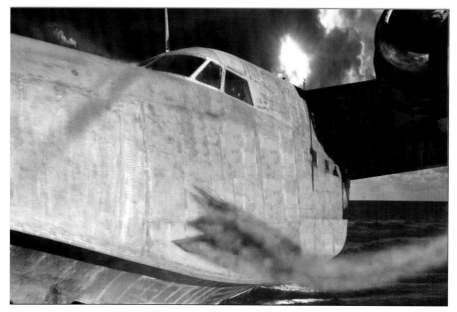

FIGURE 5.72 Motion Blur is applied to smoke layer.

Step 4

Apply a mask to the blurred smoke layer to allow the effect to be most promi-
nent in the rear with no effect in the front (see Figure 5.73).

FIGURE 5.73 Mask applied to blurred smoke layer.

Step 5

If there is smoke then somewhere there is fire. Create a new layer. Start the
fire with an orange-to-yellow gradient applied to a selection around one half
of the smoke. To get the color to integrate into the smoke set the blend mode
to overlay. Apply a mask and fill it with black to block out the fire effects.
With a soft-edged paintbrush apply white only to the areas where the fire ef-
fect is desired (see Figure 5.74).

FIGURE 5.74 Fire is added to the smoke.

Step 6

For a little more drama add lens flare to the source of the smoke and transform it to reflect the flow of the stream (see Figures 5.75 and 5.76).

FIGURE 5.75 Lens flare is applied to smoke.

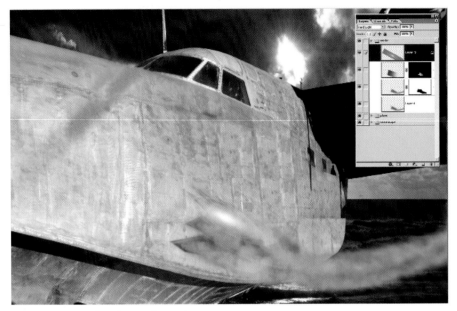

FIGURE 5.76 Lens flare is transformed.

Next, add some Motion Blur as shown in Figure 5.77.

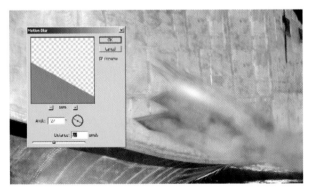

FIGURE 5.77 Motion Blur is added.

Step 7

Duplicate the lens flare twice and place each one near the source of the fire as shown in Figure 5.78.

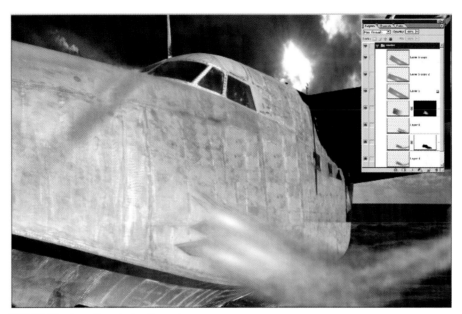

FIGURE 5.78 Lens flare is duplicated.

Step 8

Finally, add color and contrast adjustment layers. Also, apply Hue/Saturation adjustment layers to the smoke layers only, to give them more of a reddish tonality to reflect the reddish color cast that is consistent in this scene. Then adjust the contrast of the plane to enhance the texture as shown in Figure 5.79.

The resulting image is shown in Figure 5.80.

Wasn't that great fun? Animating brushes can be a blast. Experiment with them and develop your own results.

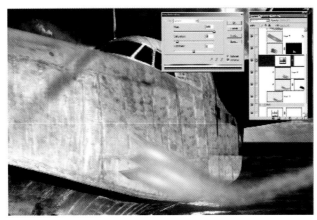

FIGURE 5.79 Hue/Saturation adjustment layer applied to smoke.

FIGURE 5.80 Final image.

WHAT YOU HAVE LEARNED

- How to use the animated brush engine to custom create rust
- How to apply the rules of perspective to create an interior
- Practical approaches to create the animated brush engine to custom create smoke
- Approaches to creating volumetric lighting

Now that we know how to use the animated brush engine, we'll move on to integrating 3D objects in Chapter 6, "Integrating 3D Objects into Photography."

INTEGRATING 3D OBJECTS INTO PHOTOGRAPHY

IN THIS CHAPTER

- How to compose 3D objects into photography
- FX tricks to create laser blasters
- FX tricks to create explosions
- How to create volumetric rays
- How to create an underwater landscape

Everyone loves science fiction battle scenes. They give the artist an excuse to breathe new life into alien life forms as well as depict the strange worlds in which they live. In essence, the science fiction genre is an excuse to allow the artist's imagination to soar beyond reality. In addition, the genre provides opportunities that challenge the artist to develop innovative ways to produce dynamic effects. Let's create some of our own.

In this example we have two starships. One will try to escape and the other will fire laser blasters to destroy it. One laser will miss the running ship as the other hits its side. As a result the side of the ship will melt and cause an explosion.

STARSHIP DOGFIGHT

We will create the entire scene with five images. One consists of a photographic landscape of the Salt Flats of Death Valley (see Figure 6.1) and two are cloud formations shot in Carmel, California (see Figures 6.2 and 6.3). The final two

FIGURE 6.1 Death Valley Salt Flats.

FIGURE 6.2 Cloudscape #1.

FIGURE 6.3 Cloudscape #2.

are 3D objects created in Newtek's venerable LightWave 3D version 8 (see Figures 6.4 and 6.5). You can access what you need to create this tutorial in the Tutorials/Chapter6–Starship Dogfight/ on the companion CD-ROM. You can learn more about LightWave at *www.newtek.com*.

FIGURE 6.4 LightWave 3D Object: Starship #1.

FIGURE 6.5 LightWave 3D Object: Starship #2.

Step 1

It's always a good practice to organize your layers into folders, so create a layer set titled "Landscape and Sky." We will create the basic landscape within it so let's get started. Starting with the Death Valley Salt Flats, use Free Transform (Ctrl T), shorten, and place the image in the lower one half of the composition as shown in Figure 6.6.

FIGURE 6.6 Placement of the Salt Flats.

Step 2

To pull out some of the overbearing bluish hue as well as to gain some contrast in the image, apply both a Levels and Hue/Saturation adjustment layer as shown in Figures 6.7 and 6.8.

FIGURE 6.7 Adjusting the hue/saturation.

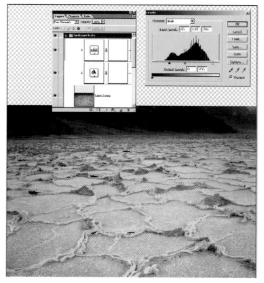

FIGURE 6.8 Adjusting the levels.

Step 3

Starting with Cloudscape #1, place it into its own layer underneath the Salt Flats layer and position it so that the lower horizon overlaps the upper horizon of the Salt Flats. By blending the two the image looks much more homogenous. So, let's do that in the next step (see Figure 6.9).

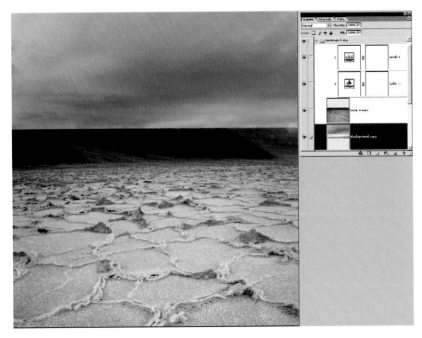

FIGURE 6.9 Cloudscape #1 positioning.

Step 4

Apply a layer mask to the Salt Flats with a soft edge brush and paint the mask with black so that the clouds gracefully integrate into the scene as shown in Figure 6.10.

Step 5

Next, drag Cloudscape #2 and apply a layer mask to it so that its visual aspects are only visible in the upper one third of the scene. Now, the cloudscape has much more personality (see Figure 6.11).

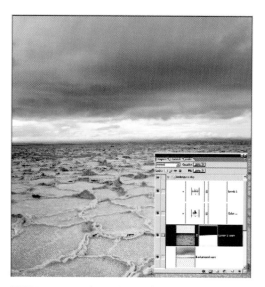

FIGURE 6.10 Mask applied to form the transition between land and sky.

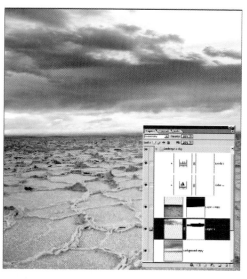

FIGURE 6.11 Placing and masking Cloudscape #2.

Step 6

The landscape appears tonally flat so apply a Curves adjustment layer. The intention is to give the Salt Flats some textural crispness by giving the shadow portions of the salt skin a richer character. With Curves we have the ability to control the outcome without over applying the effect (see Figure 6.12).

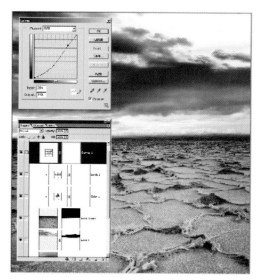

FIGURE 6.12 Curves adjustment layer to bring out the edges of the salt crusts.

Step 7

When the Curves adjustment layer is applied, the shadows (where most of the blue color resides) are enhanced, giving the image more of a blue cast. So by using a Color Balance adjustment layer let's tame the blue cast by adding its opposite color—yellow (see Figure 6.13).

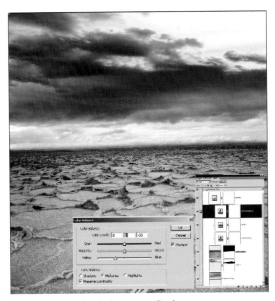

FIGURE 6.13 Color balance applied.

INTEGRATING THE 3D MODELS

There are two different views of the 3D model. One will be placed in the background to fire the laser blaster, and the other will escape into the foreground. The laser will hit the side and melt it. An explosion will result.

Step 1

Starting with Starship #1, place it onto its own layer into the landscape scene. The 3D object from the new LightWave 8 was rendered with an alpha channel and saved in a Photoshop format (.PSD) so it is already placed on a transparent layer (see Figure 6.14).

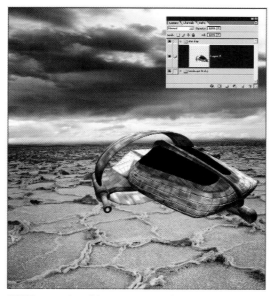

FIGURE 6.14 Starship #1 integrated.

Step 2

The 3D model is too blue in relation to the rest of the scene, so use a Color Balance adjustment layer to add yellow in both the midtones and the highlights of the image as shown in Figure 6.15.

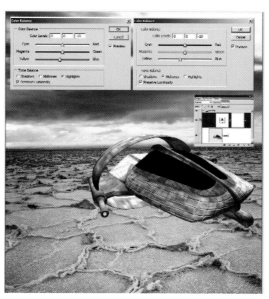

FIGURE 6.15 Color balance for midtones.

Step 3

Another angle was captured of the same 3D model to represent the predatory ship in the rear of our composition. Place this on its own layer as shown in Figure 6.16.

Step 4

Remember that one of our compositional rules is that anything in the background must be smaller to show depth, so Free Transform (Ctrl T) Starship #2 and resize it to be a quarter of its original dimensions. Place it near the top left to give it the appearance of distance (see Figure 6.17).

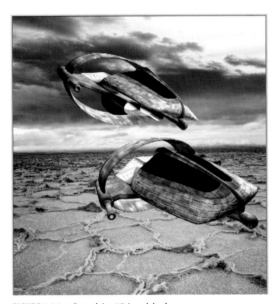

FIGURE 6.16 Starship #2 is added.

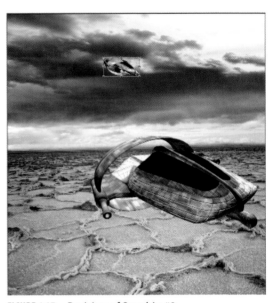

FIGURE 6.17 Resizing of Starship #2.

Step 5

Alter the ship in the foreground with Distort (Edit>Transform>Distort) so that the nose of the ship appears to come out at us a little more prominently as shown in Figure 6.18.

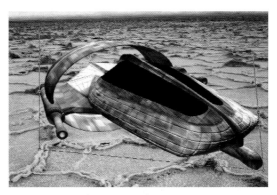

FIGURE 6.18 Reshaping Starship #1.

Step 6

To give our object a sense that it belongs in the scene we need to give it some distance from the ground by providing a shadow. Our goal is to create a customizable shadow where we have complete control over its size, shape, and opacity. Because the Layer Styles dialog box provided with every layer does not allow us to alter the shape of the shadow, it doesn't allow us to achieve our goal. We'll start by duplicating the layer (see Figure 6.19).

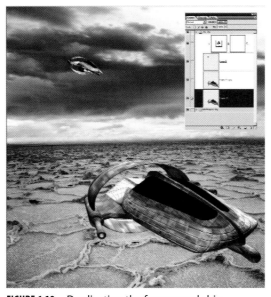

FIGURE 6.19 Duplicating the foreground ship.

Step 7

Fill the duplicate layer with black (Edit>Fill>Fill With Black). Make sure that the Preserve Transparency box is checked. If not, the entire layer will be filled with black. We want only the ship to be filled (see Figures 6.20 and 6.21).

FIGURE 6.20 Fill dialog box.

FIGURE 6.21 Results of Fill.

Step 8

Once the shadow is complete, place and transform it to match the direction of our ship and resize it smaller to give the appearance that there is distance between the ship and the ground as shown in Figure 6.22.

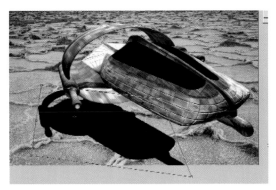

FIGURE 6.22 Transform the shadow.

Step 9

Shadows are not hard-edged, so let's apply Gaussian Blur (Filters>Blur>Gaussian Blur) to soften ours up a bit. Also, shadows are not completely solid in tonality since there is ambient light bouncing everywhere in the atmosphere. It is a good idea to give your shadows a blend mode of Multiply and take your opacity down a bit. Use your best judgment. See Figures 6.23 through 6.25.

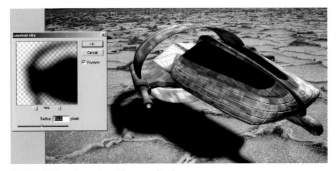

FIGURE 6.23 Gaussian Blur applied.

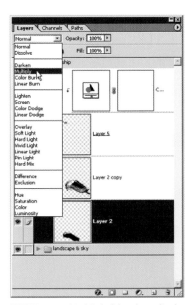

FIGURE 6.24 Multiply blend applied.

FIGURE 6.25 Layer opacity change.

Step 10

Apply a Color Balance adjustment layer to the second ship to keep the color consistent with the first starship as shown in Figure 6.26.

Step 11

Next we need to give our foreground ship some motion. Duplicate the Starship #1 layer and apply some Motion Blur to it as shown in Figure 6.27. You should match the angle of the direction that the ship is traveling. The amount of Motion Blur that should be applied depends mostly on the speed that you are trying to portray. For faster motion use greater distance and for subtle movement use less distance. Basically it's a creative call.

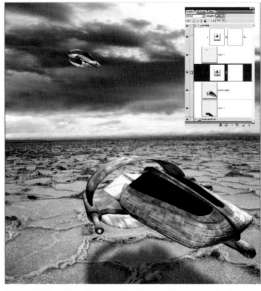

FIGURE 6.26 Duplicate adjustment layer applied.

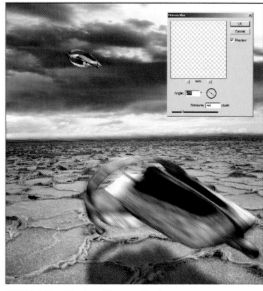

FIGURE 6.27 Motion Blur applied.

Step 12

We don't want our blur to completely obstruct our object so apply a layer mask to control exactly what areas will blur and which will not (see Figures 6.28 and 6.29).

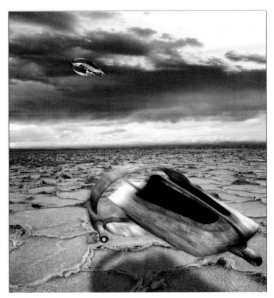

FIGURE 6.28 Current view of our scene.

FIGURE 6.29 View of masked layer.

Step 13

We will apply the same technique to the foreground landscape. This helps to accentuate the feel of motion as the starship is coming forward toward the camera view. Our landscape is currently a series of layers within the Landscape and Sky layer set. By adding a blank layer to the very top of the adjustments we can merge all of the visible layers into the newly created one. Make sure that the visibility is turned off on the starship layer set. Your canvas will now only show the landscape. Hold down your Alt key and access the layer submenu on the top right-hand portion of the Layers palette and click on Merge Visible. Your visible layers will merge into the newly created one without interfering with the others (see Figure 6.30).

FIGURE 6.30 Merge layers.

Step 14

Apply Motion Blur to the newly merged layer as shown in Figure 6.31.

FIGURE 6.31 Applying Motion Blur to landscape.

Step 15

The blur is applied to the entire layer. Just as we did in Step 13, apply a mask, but this time instead of painting, use a gradient from black to white so that the foreground takes on more of the effect than the background (see Figure 6.32).

FIGURE 6.32 Applying a mask to the Motion Blurred landscape.

Step 16

While still in the mask let's shift the tonal grays so that there is absolute control over where the blur effect is placed. This is done by applying the Levels command. Remember by shifting the shadow, midtone, or highlight sliders we can shift each of these tones in relation to one another (see Figure 6.33).

We're done with the landscape. Let's create the blaster fire.

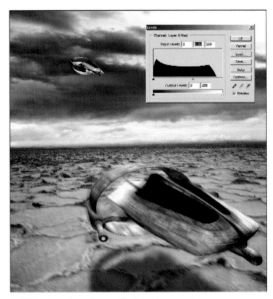

FIGURE 6.33 Levels applied to the mask.

CREATING THE LASER BLASTERS

You can have fun creating laser effects because there is no rule book that defines the proper look. They take on all types of visual identities depending on who creates them. They can be streams of light or they can resemble particle beams. In this example, we will stay with the Star Wars-like laser streams.

The key to mastering Photoshop is mastering selections. Selections, masks, and channels are identical.

Step 1

Create a new layer set and call it "Laser Blast." Within it we will create a new layer on which we will define the shape of our laser. Accessing the Rectangular Marquee tool, create a thin vertical shape across the horizon and fill it with a red hue as shown in Figure 6.34.

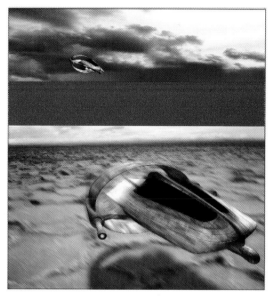

FIGURE 6.34 Filling the shape of the laser with red.

Step 2

Create another layer and fill a horizontal selection with yellow. Make sure that the selection is vertically smaller than the original. This will serve as the hot inner core of our laser blaster (see Figure 6.35).

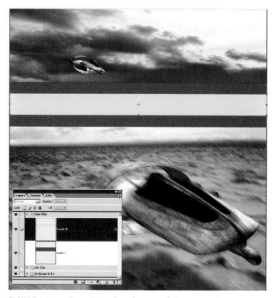

FIGURE 6.35 Creating the shape of the inner laser core.

Step 3

Lasers are usually not hard-edged, so we will apply a little Gaussian Blur (Filters>Blur>Gaussian Blur) to both layers as shown in Figure 6.36.

Step 4

Add a little extra effect by duplicating the red laser layer. Make sure that the bottom laser layer is selected and vertically stretch it just a bit larger than its counterpart (see Figure 6.37).

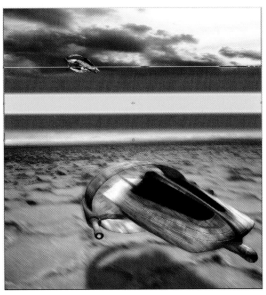

FIGURE 6.36 Gaussian Blur added to the yellow laser layer.

FIGURE 6.37 Stretching the bottom red laser layer.

Step 5

Apply Hue/Saturation (Ctrl U) and alter its color by dragging the hue slider. In this example it is changed to magenta to add some subtle contrast between colors. This adds a little more interest to our laser as shown in Figure 6.38.

FIGURE 6.38 Apply Hue/Saturation.

Step 6

The laser colors are still a little too independent so by linking the red and magenta lasers and merging them, Gaussian Blur is applied. Now the colors blend more harmoniously with one another (see Figures 6.39 and 6.40).

FIGURE 6.39 Merged layer dialog.

FIGURE 6.40 Gaussian Blur applied.

Step 7

Since the yellow laser layer is still independent, we apply Gaussian Blur to the merged layer again to blend the colors (see Figure 6.41).

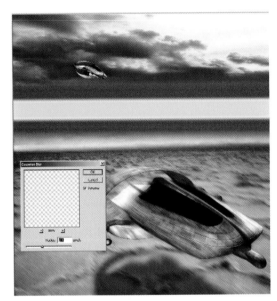

FIGURE 6.41 Free Transform layer.

Note that we could use a custom gradient from the start but then we would not have complete control over each stage of the process. The more control we have the wider our options are to make enhancements or changes.

Step 8

Again, according to the rules of perspective anything in the background is smaller. Anything in the foreground is larger. So, using the Perspective tool (Edit>Transform>Perspective) the left side of the laser is resized smaller to fit on the head of the blaster gun as shown in Figure 6.42. The other end will hit the ship, melt the side, and cause an explosion. We will do the same to the other laser but this one will miss the running ship.

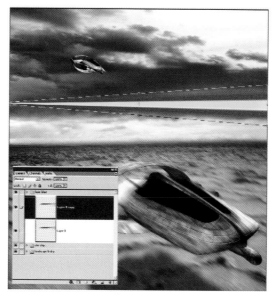

FIGURE 6.42 Perspective applied to lasers.

Step 9

Now we will add a little modification to the attacking ship in the background. The idea is to make it appear as if its laser cannon is lined up toward the other ship. Using the Distort command (Edit>Transform>Distort) we will modify the shape to give us the angles that we need as shown in Figure 6.43. Let's move on to attach our laser blast.

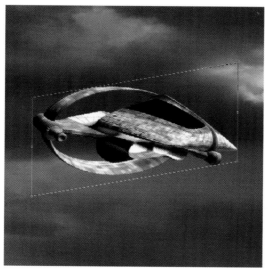

FIGURE 6.43 Distorting the ship.

Step 10

Apply the Free Transform command to the laser, zoom in close (Ctrl +), and place the rotation point on the tip of the laser nozzle as shown in Figure 6.44.

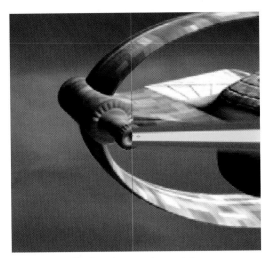

FIGURE 6.44 Placing the rotation point.

Step 11

Finally, rotate it so that the other end hits the side of the escaping ship as shown in Figure 6.45.

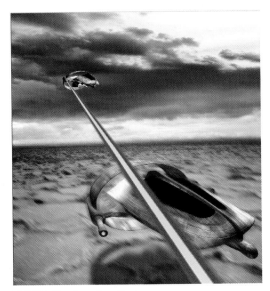

FIGURE 6.45 Rotating the laser.

Apply the same steps to the other laser and allow it to miss the ship entirely (see Figure 6.46).

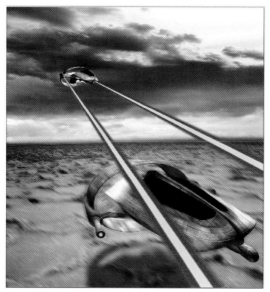

FIGURE 6.46 Rotating the other laser.

Step 12

Our laser is now emitting from the canon's nozzle. What we need are short explosions emitting from the tip of the nozzle. This is a good place to use our lens flare effect shown in Figure 6.47, so create the lens flare following the steps in Chapter 4, "Applying Our Principles from Scratch—Creating Ringed Planets."

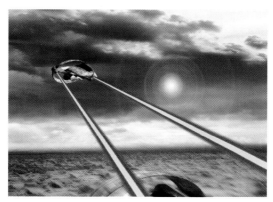

FIGURE 6.47 Creating lens flare.

Activate the Free Transform command and reduce the size of the lens flare to fit proportionately on the laser blaster (see Figure 6.48).

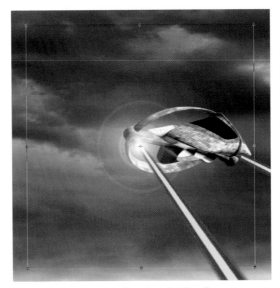

FIGURE 6.48 Free Transforming the first flare.

Next, activate your Move tool and hold down the Alt key and move the flare to the other nozzle. This shortcut duplicates the layer being dragged (see Figure 6.49).

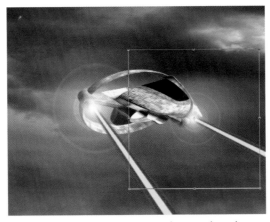

FIGURE 6.49 Repeating the procedure on the other flare.

Step 13

Use your Eraser tool and a soft edge brush to erase away portions of the laser in the foreground until it hits the side of the ship (see Figure 6.50).

FIGURE 6.50 Erasing the laser after it hits the ship.

CREATING THE EXPLOSION

Step 1

The laser hits the side of the ship and causes it to melt. To start our blast let's create the melting effect. We must make sure that we are working in the Starship #1 layer. Make an oval selection with a feather option of at least 20 pixels and transform it (Select>Free Transform) to match the size and direction of the blaster strike (see Figure 6.51).

FIGURE 6.51 Transform selection to follow the laser beam.

Step 2

By accessing the Glass filter (Filter>Distort>Glass) we can apply an effect that resembles melting metal as shown in Figures 6.52 and 6.53).

FIGURE 6.52 Glass distortion.

FIGURE 6.53 Taking a step back to view the glass distortion.

Step 3

When the laser makes contact with the ship the metal emits a hot white glow. This is achieved by applying another lens flare as shown in Figure 6.54.

FIGURE 6.54 Adding a lens flare to create the glowing effect.

Step 4

The goal is to apply some shrapnel. The Oak Leaf brush is great for this. It can be found in the Brush Stroke palette on the Options bar (see Figure 6.55).

FIGURE 6.55 Brush stroke options.

We will start by creating a new layer above the lens flare so that it is easier to see the results, but eventually we will place it below the lens flare. Using your Wacom pen and tablet, paint the animated leaf textures. Keep the paint strokes close to the vicinity of the lens flare. See Figures 6.56 through 6.59 for the settings that are used in this example.

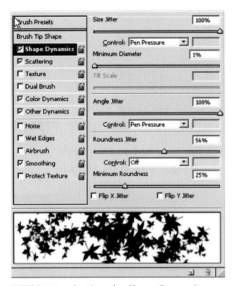

FIGURE 6.56 Setting the Shape Dynamics.

FIGURE 6.57 Setting the Scattering.

FIGURE 6.58 Setting the Color Dynamics.

FIGURE 6.59 Setting Other Dynamics.

Step 5

Once applied, place a circular selection around the painted leaf patterns. Apply some Radial Blur with the zoom setting activated. We now have our shrapnel. Play with the zoom effect to achieve an acceptable outcome. Place the shrapnel layer underneath the lens flare (see Figures 6.60 and 6.61).

FIGURE 6.60 Using Radial Blur to turn the leaf shapes into shrapnel.

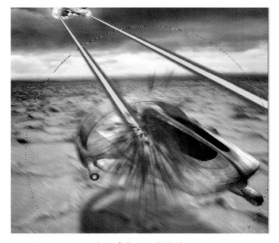

FIGURE 6.61 Results of the Radial Blur.

Step 6

This is the point where we move the shrapnel layer below the lens flare so that it blends with the overall blast as shown in Figure 6.62.

Step 7

The laser is too opaque. Since it represents light streaks it should have some transparency. If we use the layer opacity settings the laser will lose its brilliance, so we change the blend mode to Lighten. Be sure to scroll through all the various modes and experiment with them (see Figure 6.63).

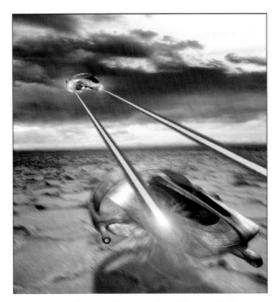

FIGURE 6.62 The new layer is placed beneath the lens flare layer.

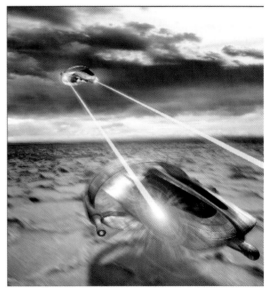

FIGURE 6.63 Lightening the laser beams.

Step 8

To create a greater sense of depth and motion, the ship in the rear is darkened slightly using our Levels command. Also, a slight Motion Blur is applied. The ship no longer appears static (see Figures 6.64 and 6.65).

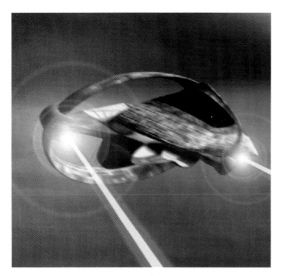

FIGURE 6.64 Motion Blur applied to Starship #2.

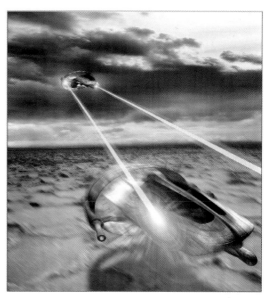

FIGURE 6.65 The current image.

Step 9

Let's add one last effect to the blast before finishing up the piece. We are going to apply flying sparks by activating the Paintbrush and setting its blend Properties in the Option bar to Dissolve. By painting on a new layer the paint is applied in speckles (see Figures 6.66 and 6.67).

FIGURE 6.66 Dissolve options.

FIGURE 6.67 Paint effect applied.

Place a circular selection around the paint effect and apply Radial Blur (see Figure 6.68).

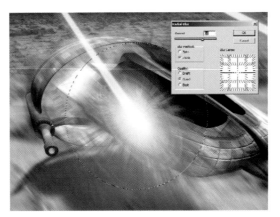

FIGURE 6.68 Selection applied along with Radial Blur.

We will apply the painting technique one more time but this time we will keep the speckle effect as shown in Figures 6.69 and 6.70.

FIGURE 6.69 Paint effect applied again.

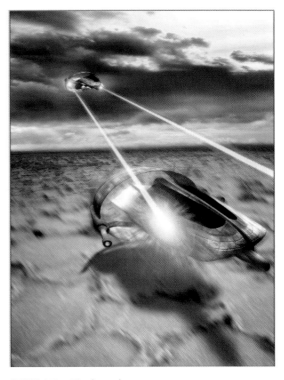

FIGURE 6.70 Final touches.

Step 10

For the grand finale we use nik Multimedia's Color Efex Pro 2.0 to enhance the atmosphere of the overall scene. Select the Bicolor/User Defined filter to define the colors for both the horizon and the foreground. Notice that you can also control the extent of the blend as well as the vertical placement of the blend. The opacity slider allows you to control the strength of the effect. If you choose to, you can rotate the blend. In this example rotation is not necessary due to the fairly stable horizon. After hues of blue for the sky and a warm brown for the foreground are applied, the changes are committed (see Figures 6.71 and 6.72).

FIGURE 6.71 Color Efex Pro 2.0.

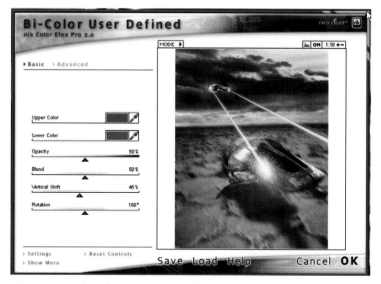

FIGURE 6.72 Color Efex Pro 2.0 user-defined preview.

What Color Efex Pro 2.0 has done is to create a new layer with the applied effects associated with a mask (see Figure 6.73).

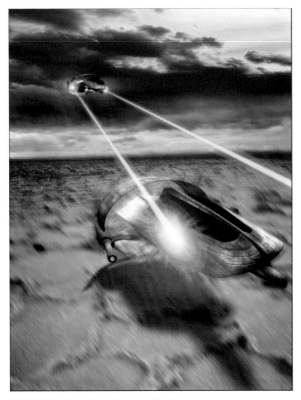

FIGURE 6.73 Results of Color Efex Pro 2.0.

By default the mask is filled with black so that you can apply its effect to any area of the image by painting it with white. Fill it with white (Edit>Fill>Fill with white) so that the entire effect is in view. Now adjust the layer opacity to your liking as shown in Figure 6.74.

FIGURE 6.74 Color Efex Pro layer with mask.

After adjusting the opacity to 58%, the filter not only pulls the scene together visually but allows us to control it so that the effect is not so obvious. This is important. Although filters can be a great benefit, we want to be sure that our image does not become stylized by their trickery, thus making the piece shallow in technique. See the final results shown in Figures 6.75 and 6.76.

Next we are going to apply our skills to another type of theme—an undersea scene.

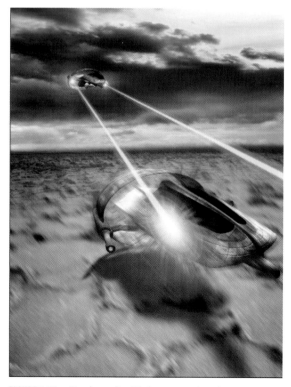

FIGURE 6.75 Final result with layer opacity change.

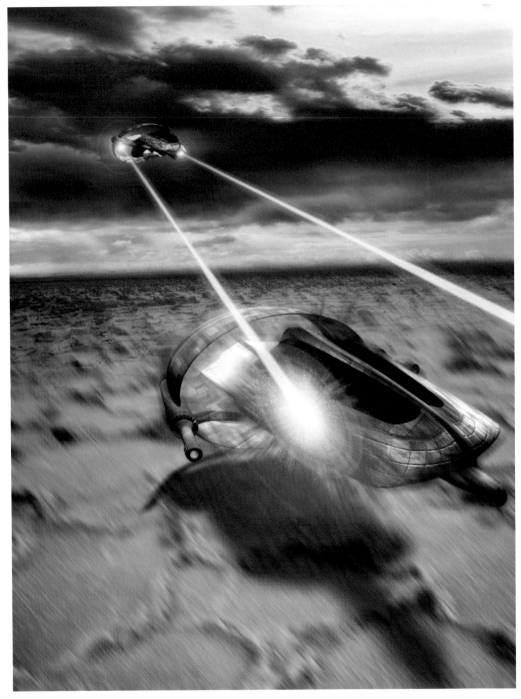

FIGURE 6.76 Final result without layer opacity change.

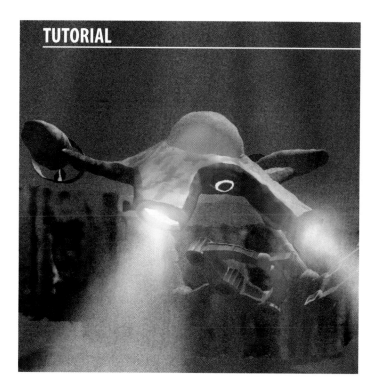

CREATING THE UNDERWATER LANDSCAPE

This chapter is really about creative freedom. In this process we will alter our landscape image to represent something that it was not originally meant to be. If we understand our digital tools, in this case Photoshop, then we have the capabilities to alter any image at will. As artists we are not concerned with the original imagery, we are concerned only with form, color, and composition. With these at our disposal we can truly use our medium to say what we want and to say it as elegantly and as poignantly as we choose.

CREATING THE OCEAN DEPTH

We will create the entire scene with two images. One is a photographic landscape of a Death Valley location and the other is a 3D object created in Newtek's LightWave 3D version 8 (see Figures 6.77 and 6.78). You can access what you need to create this tutorial in the Tutorials/Chapter6–Under the Sea/ on the companion CD-ROM. Let's begin.

ON THE CD

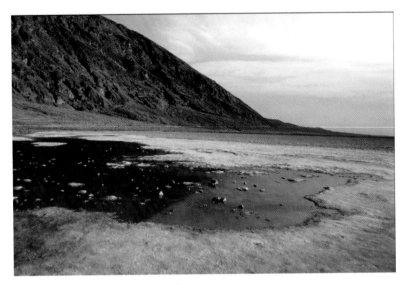

FIGURE 6.77 Death Valley landscape.

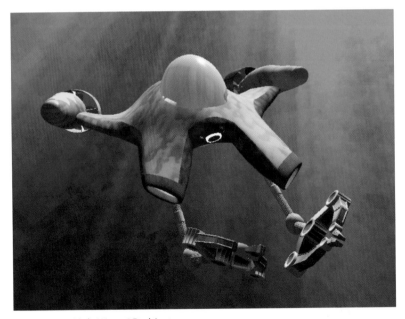

FIGURE 6.78 LightWave 3D object.

Step 1

The desert landscape of Death Valley is so versatile in nature that the images, if you use your imagination, can serve as dynamic visuals. The area called Bad-

water used here is not the most compelling composition, but in this case it serves a different purpose. Our goal is to alter the water in the foreground into an undersea cavern. Using the Rectangular Marquee tool, select one-third of the foreground so that we can stretch the water forward (see Figures 6.79 and 6.80).

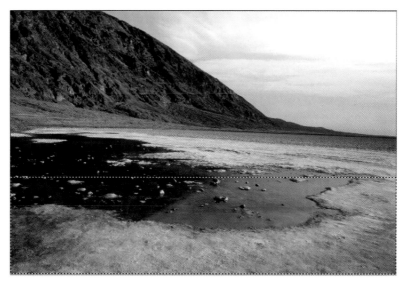

FIGURE 6.79 Selected foreground.

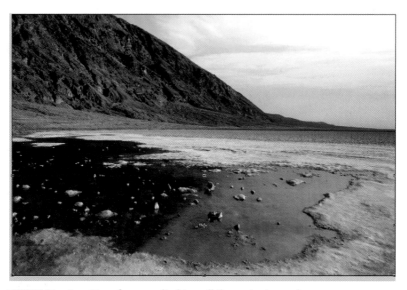

FIGURE 6.80 Free Transform applied to pull the water toward us.

Step 2

Using the Magic Wand tool, select most of the water. Note that some areas will give us trouble. Instead of using the Shift Left Click command to multiple select, let's access Quick Mask and accurately paint the area that we want selected (see Figure 6.81).

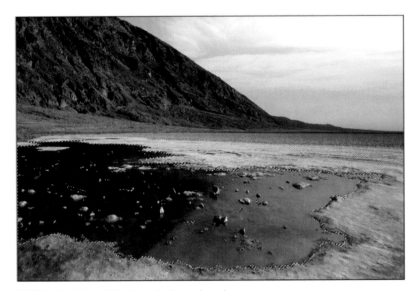

FIGURE 6.81 Magic Wand applied to select the wet area.

Step 3

Activate the Quick Mask command located below the foreground and background colors (see Figures 6.82 and 6.83).

What is going on here with all of this red? Again, let's return to before digital technology. If a client wanted an 8 × 10 inch black and white print of a portrait composed within an oval window, the photo lab used what is called ruby lith film. This is simply a clear sheet of acetate with a red gel on its surface. The lab technician cut an oval window on the acetate and then peeled off the red gel to expose the clear plastic beneath. This was placed on top of the 8 × 10 inch photographic paper. Black and white photo paper is orthochromatic, meaning it is sensitive to blue light, but not red light. In effect, the red areas around the oval did not expose the paper, leaving it white. This is how masking was done for years until Photoshop arrived on the scene.

FIGURE 6.82 Quick Mask activation button.

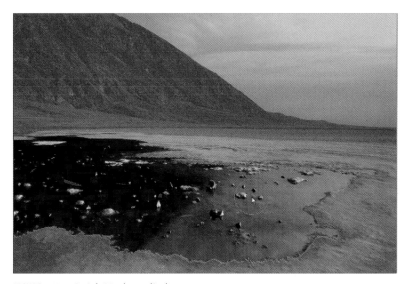

FIGURE 6.83 Quick Mask applied.

So, how do we edit our mask? If we paint with white we will discard from the mask and as a result, it will be clear. This is analogous to peeling away the red acetate. This is the area that will be selected. Conversely, if we paint with black this will add to our mask and make it red. This is the masked-off area. In this case the red specks in the center are edited out using white (see Figure 6.84).

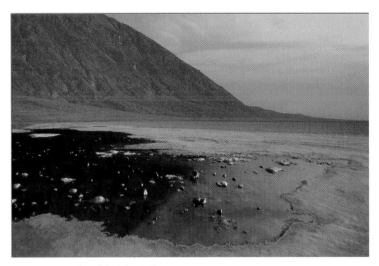

FIGURE 6.84 Edited Quick Mask.

Step 4

If you click the icon to the left of the Quick Mask button you can view your selection that is based on the edited mask. Now apply a layer mask to make the water go away. Remember if you need to you can edit the mask at any time (see Figure 6.85).

FIGURE 6.85 View with effects of layer mask.

Step 5

We are going to use a part of our mountain to make our clifflike cavern. Start by selecting the side of our mountain as shown in Figure 6.86.

FIGURE 6.86 Selecting the mountain detail.

Step 6

Next copy (Ctrl C) and paste (Ctrl V) it into its own layer and Free Transform it so that it fills most of canvas as shown in Figure 6.87.

FIGURE 6.87 Free Transform selected image.

Step 7

Place this underneath the Badwater landscape. Next we will add some cliff-like contour (see Figure 6.88).

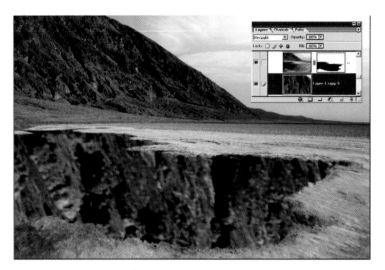

FIGURE 6.88 Repositioned selected layer.

Step 8

We will create a layer filled with medium gray that will give our cliff contour. Change its blend mode to Overlay to make the gray transparent. Remember that the Overlay mode affects the midrange grays only. By using the Burn/Dodge tool we can make portions of the image darker with Burn or lighter with Dodge. Our initial editing gives good results as shown in Figures 6.89 and 6.90.

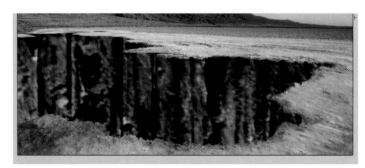

FIGURE 6.89 Beginning results of contour.

FIGURE 6.90 Layer view.

Step 9

Duplicate the texture layer twice and give one a blend mode of Pen Light and the other Exclusion. The two in combination produce a tonality that not only is close to the landscape foreground but also gives some prominent contrast that looks quite interesting. Let's create the water atmosphere (see Figure 6.91).

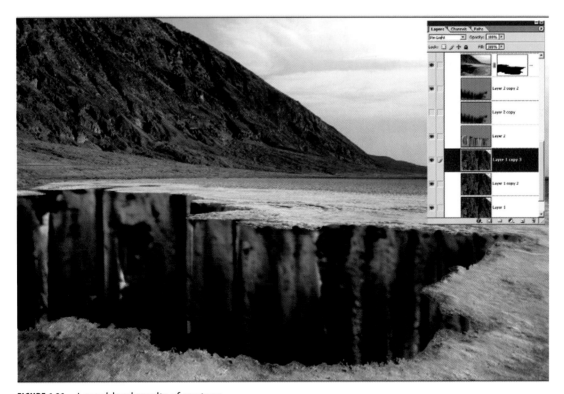

FIGURE 6.91 Layer blend results of contour.

CREATING THE MURKY WATER

This is where we will alter our Death Valley landscape into the murky depths of the sea. The sub will be visible in the foreground; however, the debris in the water will cause the background to fade away into a deep algae green opacity.

Step 1

We will start by filling the layer with an algaelike green hue and reduce the layer opacity 75% (see Figure 6.92).

FIGURE 6.92 Layer filled with green.

Step 2

Next apply a mask to the layer so that the cliff is less affected in comparison to the rest of the image (see Figure 6.93).

Step 3

Duplicate the layer to strengthen the algae effect as shown in Figure 6.94.

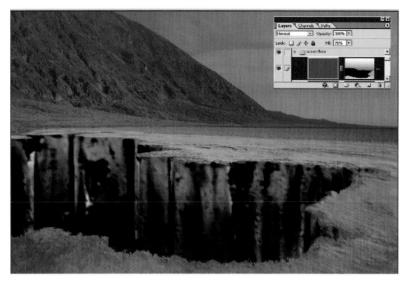

FIGURE 6.93 Layer with mask applied.

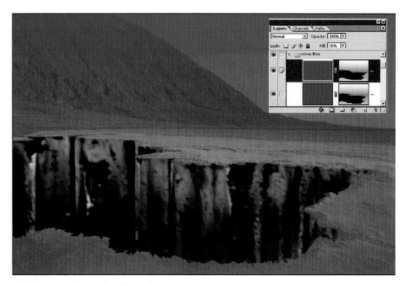

FIGURE 6.94 Layer duplicated.

Step 4

Finally, continue to duplicate a couple of more algae layers. On one mask edit it so that the background receives more of the murky effect as shown in Figure 6.95.

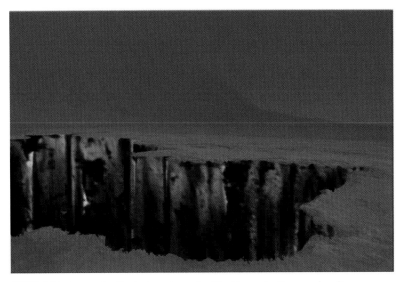

FIGURE 6.95 Layer duplicated again and edited to make it even cloudier.

The last layer is used to add the algae to portions of the cliff to allow it to integrate with the rest of the scene (see Figure 6.96).

FIGURE 6.96 Algae extending into the cliffs.

Compositing the Sub

Now it's time to introduce our sub into the scene. The model was lit in LightWave to match the lighting style of our scene. In addition to composing our model, we will create volumetric light rays coming through the surface of the sea.

Step 1

Place the sub so that it appears to be submerged over the cavern floor as shown in Figure 6.97.

FIGURE 6.97 Placing the sub.

Step 2

We will create the shadow before we add the lighting detail. This will give us fewer distractions. After duplicating the layer, fill it with black. When the Fill command is accessed the Preserve Transparency box must be checked (see Figures 6.98 and 6.99).

FIGURE 6.98 Sub layer duplicated.

FIGURE 6.99 Fill dialog box.

Step 3

The sub itself is now filled with black pixels (see Figure 6.100). This will become our shadow. Let's do some more work.

FIGURE 6.100 Layer view.

Using the Free Transform tool and grabbing the top center control point, pull downward to flip the shadow upside down but leave it truncated as shown in Figure 6.101.

FIGURE 6.101 Free Transform shadow.

After it is applied, delete the areas inside of the cliff drop-off to give the appearance that the sub is submerged just above the cliff (see Figure 6.102).

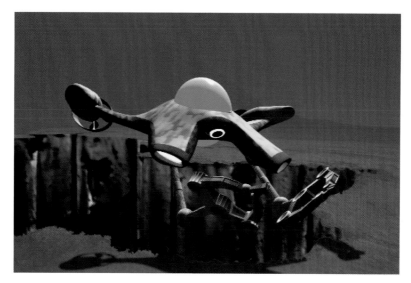

FIGURE 6.102 Edit shadow to reveal cliff.

ADDING THE SUNLIGHT

The sub 3D model is lit from above to simulate the light source beaming downward. For this final stage the volumetric light source for both the sunlight and the headlights are created in Photoshop. We will start with the main light source.

Step 1

Fill a layer with white and associate a mask with it. The mask is filled with black and white clouds, allowing for the white to have a marbled transparency (see Figure 6.103).

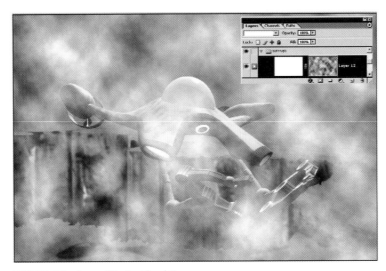

FIGURE 6.103 Layer filled with white.

Step 2

Create the streaking effect with the Motion Blur (Filter>Blur>Motion Blur) on the mask as shown in Figure 6.104).

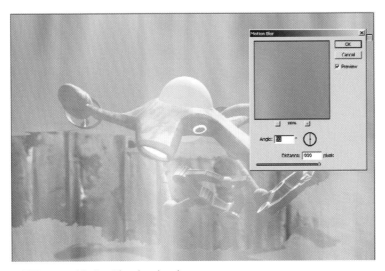

FIGURE 6.104 Motion Blur the clouds.

Step 3

The sunlight needs some perspective, so the Perspective command is utilized (Edit>Transform>Perspective). Since the results are satisfactory, Free Transform is applied to fill the space (see Figures 6.105 and 6.106).

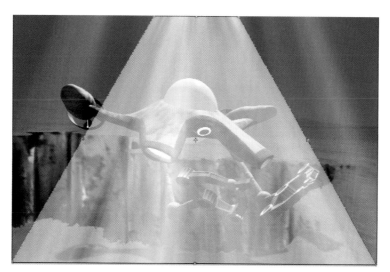

FIGURE 6.105 Perspective applied to clouds.

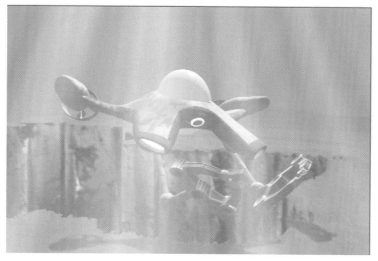

FIGURE 6.106 Free Transform applied to clouds to make them fill the canvas.

Step 4

The rays need some greater contrast so that each one maintains its own identity. By editing the mask with Levels (Ctrl T), we increase the density of the lower tones to give our sunrays a little more personality (see Figures 6.107 and 6.108).

FIGURE 6.107 Mask view of sunray effect.

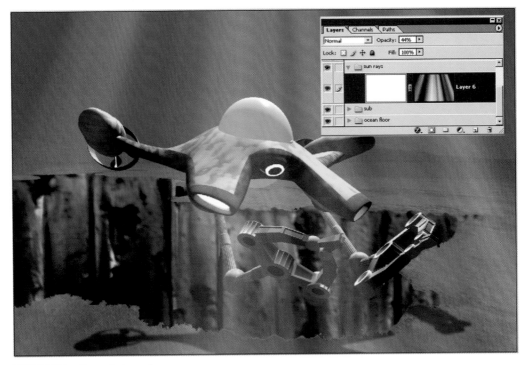

FIGURE 6.108 Current view of our scene.

Step 5

Now we can apply the headlight glow to the model. Just as we did in the previous chapters, lens fare is applied to both lights. After reshaping the lens flare with Free Transform, apply layer masks to control the light spill that is common with lens flare (see Figure 6.109).

FIGURE 6.109 Lens flare applied.

Step 6

Create the head beams on new layers and Gaussian Blur them. Next, reduce them to 45% to give them translucency as shown in Figures 6.110 and 6.111.

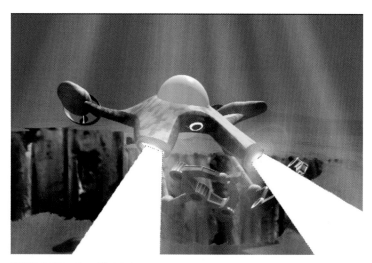

FIGURE 6.110 Headlight shapes.

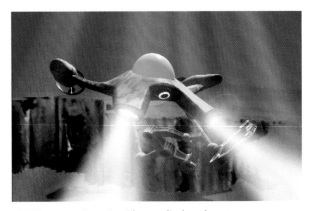

FIGURE 6.111 Gaussian Blur applied to shapes.

FLOATING DEBRIS

To depict our sub in the depths of the ocean there must be some debris in the overall atmosphere.

Step 1

Place two new layers on the top and fill them with 50% gray. The goal is to allow the visual aspects of the debris to obscure the entire image. Change the blend mode of the lower layer to Hard Light and the top one to Multiply. Both blend modes allow the gray tonality to go transparent but Multiply causes harsher shadow effects. This assists in gaining the murkiness. To create the debris apply the Noise filter (Filter>Nose>Add Noise) to both layers. Next, you will lessen the effect on the front portion of the sub to gain a greater sense of depth (see Figure 6.112).

FIGURE 6.112 Overall view with layers.

Place both layers into a layer set and title it "Debris." Apply a mask to the layer set and edit it to isolate the effects of the debris mostly to the background around the shape of the sub as shown in Figure 6.113.

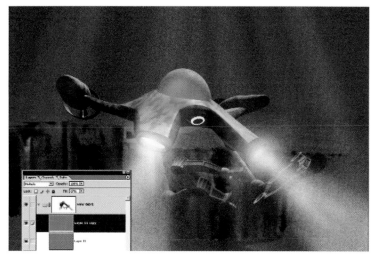

FIGURE 6.113 Place most of the debris behind the ship.

Finally, flatten all layers. Give the final image a watery look by adding the Glass filter as shown in Figures 6.114 and 6.115 (Filter>Distort>Glass).

FIGURE 6.114 Glass filter dialog.

Wow! Are you having fun yet? Once you understand the basic principles you can create any type of effect. Let's move on to learn how we deal with green or blue screen removal.

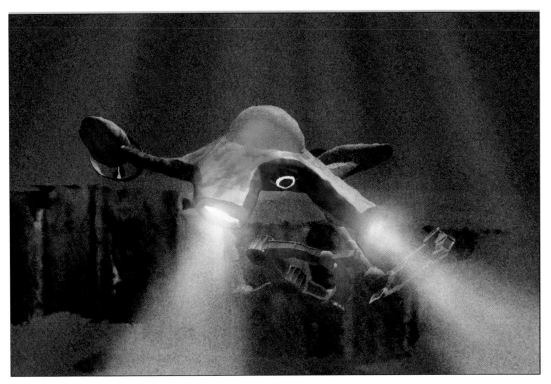

FIGURE 6.115 Final view.

WHAT YOU HAVE LEARNED

- Creative uses of 3D objects with photography
- How to create laser blasters
- FX tricks to create explosions
- How to create an underwater landscape from existing photography

In this chapter we covered integrating 3D objects into photography. Next we will delve into having fun with miniaturizing people.

WORKING WITH PEOPLE AND BACKGROUNDS

IN THIS CHAPTER

- How to mask out blue- or green-screened backgrounds for portraits
- FX Tricks for miniaturizing people to place in the palm of a hand
- How to add wings to people
- How to create softened backgrounds to gain a shallow depth of field
- Creative approaches to submerge people in custom created water

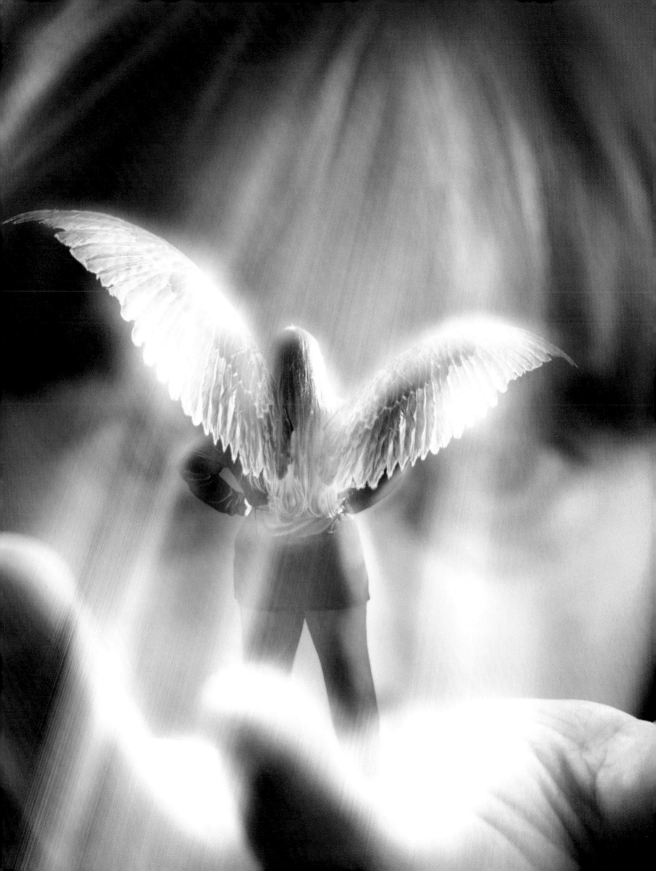

Often it is known ahead of time that a subject will be composited into another scene. To facilitate the compositing process the photographer places the subject in front of a background with a solid color so that the color can be easily identified and isolated with a mask. Once the mask is created, any background that the artist chooses can be placed behind the main subject.

This chapter deals with removing the background of a photograph originally shot in front of a color screen. The goal is to take the portrait and place it in the palm of the model's hand. Three images are used. One is of the model standing, another is a close-up of a face and hand, and the final is a shot of a hawk's wing (see Figures 7.1 through 7.3). You can access what you need to create this tutorial in the Tutorials/Chapter7–Miniatures/ on the companion CD-ROM.

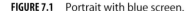
ON THE CD

FIGURE 7.1 Portrait with blue screen.

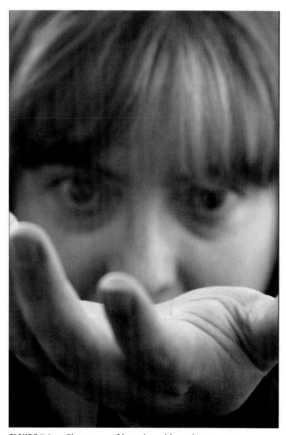

FIGURE 7.2 Close-up of head and hand.

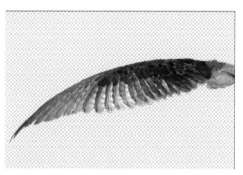

FIGURE 7.3 Hawk's wing.

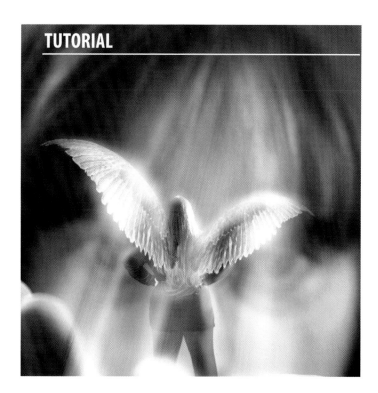

MINIATURES IN THE PALM OF YOUR HAND

REMOVING GREEN OR BLUE SCREENS

The objective is to isolate the blue color with a layer mask. Our miniature will be given a set of wings to be transformed angelically. However, the angellike creature is only three inches tall and will sit in the hand of the fascinated on-looker. Let's begin.

Step 1

For organizational purposes two layer sets are created in the head and hand close-up file. We will call this image "Close-up" from this point on. One folder is called "Miniature" and the other is called "Hand." Let's start working in the hand folder (see Figure 7.4).

Step 2

Some depth of field effects will be added to make the image more engaging. After duplicating the background close-up layer, blur it with Gaussian Blur as shown in Figure 7.5 (Filter > Blur > Gaussian Blur).

FIGURE 7.4 Two layer sets created.

FIGURE 7.5 Gaussian Blur applied to the hand layer.

Next, edit the mask so that the blur is only applied underneath the hand and around the corners of the photograph (see Figure 7.6).

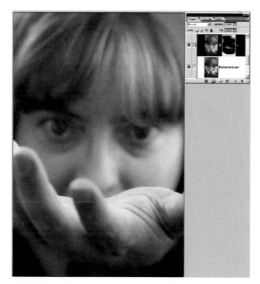

FIGURE 7.6 Visual results after editing the mask.

Step 3

To give the feeling that this scene is outdoors we warm up the features by applying a Color Balance adjustment layer as shown in Figure 7.7.

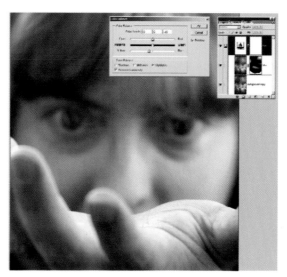

FIGURE 7.7 Color Balance adjustment layer.

Step 4

More depth must be applied to give the image more volume. We use a Curves adjustment layer to provide depth and richness as shown in Figure 7.8.

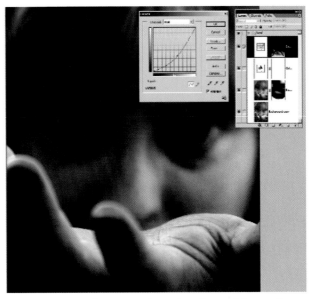

FIGURE 7.8 View of Curves without the effects of the mask.

Step 5

Next, we edit the Curves mask to restrict its effects underneath the hand (see Figure 7.9).

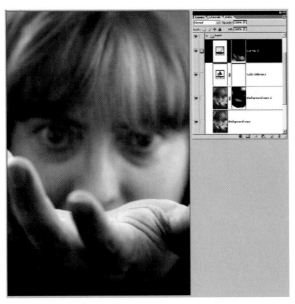

FIGURE 7.9 Visual results after editing the mask.

WORKING WITH THE BLUE SCREEN

Step 1

Make sure that you are in the miniature layer set and place the blue-screen portrait into it as shown in Figure 7.10.

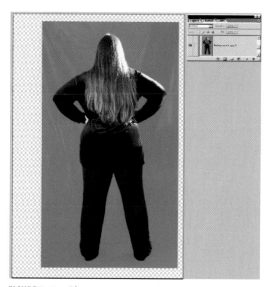

FIGURE 7.10 Blue-screen portrait.

Next, use Free Transform (Ctrl T) and position the image to fit in the palm of the hand as shown in Figure 7.11.

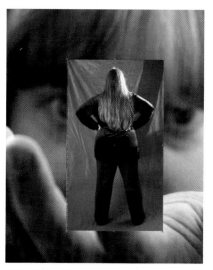

FIGURE 7.11 Transformed and fit in the hand.

Step 2

Now it's time to remove the background. Use Color Range (Select > Color Range) to select the colors that you need to isolate. In this example the color is the blue-screen background. When you take the eye dropper and click on the blue background notice that those areas on the mask become white. These are the selected pixels. Use the Fuzziness slider to fine tune the selection. By moving the slider to the right, more of the blue is included into the selection. If it is pulled to the left, less of the blue is selected. In the example shown in Figure 7.12 it is placed half way.

Step 3

Color Range has provided us with a selection around the color as shown in Figure 7.13.

FIGURE 7.12 Color range applied.

FIGURE 7.13 Selecting around the color.

By adding a layer mask the background remains but everything else goes away (see Figure 7.14). In this case we want the opposite to happen.

FIGURE 7.14 We want the opposite of this effect.

Click on the mask to make sure you are in Mask Editing mode and in-verse it (Ctrl I) as shown in Figure 7.15.

FIGURE 7.15 Mask inverted.

Step 4

Alt Click on the mask to see its results on the canvas as shown in Figure 7.16.

FIGURE 7.16 View of layer mask.

To make sure that everything in this image is properly masked use the Rectangular Marquee tool to select just inside of the black frame and inverse the selection (Ctrl Shift I). Now fill it with black. Everything becomes masked leaving only the outline of the figure as shown in Figure 7.17.

FIGURE 7.17 Visual results after editing the mask.

Step 5

After zooming out to view the complete image, continue editing the mask of the miniature model to allow the left leg to disappear behind the small finger (see Figure 7.18).

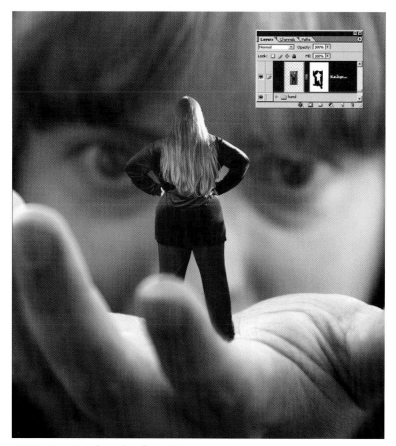

FIGURE 7.18 Visual results after editing the mask.

Step 6

To add further harmony, add Color Balance to the miniature to reflect the warmth of the scene. Add yellow to the midtones as shown in Figure 7.19.

FIGURE 7.19 Color balance is applied.

Step 7

The figure looks a little too sharp along the edge and it appears as if it's a cardboard cut out. To fix this, duplicate the layer and add Gaussian Blur. Associate a black-filled mask to this layer so the visual aspects of it disappear from view. Now edit the mask with white to the edges of the body to apply the blur (see Figures 7.20 and 7.21).

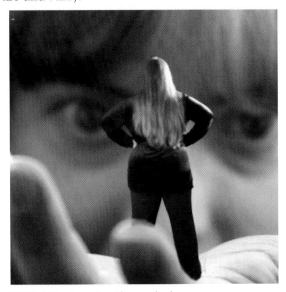

FIGURE 7.20 Gaussian Blur applied.

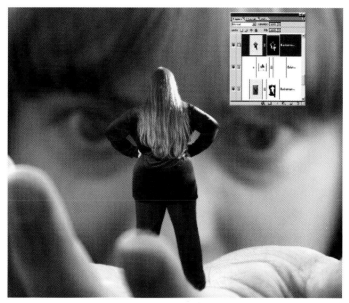

FIGURE 7.21 Visual results after editing the mask.

ADDING WINGS TO THE MINIATURE

Step 1

After placing the wing above all of the other layers within the miniature layer, set Free Transform and shape it to a size slightly taller than the miniature. Apply masking to allow the portion closest to the figure to integrate with the body (see Figure 7.22).

Step 2

To provide a little more luminosity to the wing, duplicate it and change its blend mode to Luminosity. Again, a mask is provided so that you can control the effects of that layer where needed (see Figure 7.23).

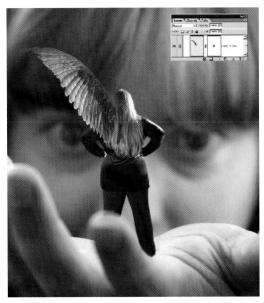

FIGURE 7.22 Transformed wing added to the body.

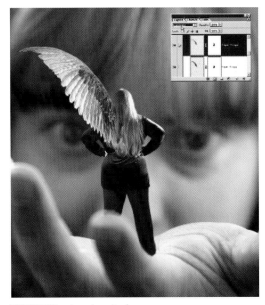

FIGURE 7.23 Luminosity layer.

Step 3

Follow Steps 1 through 3 for the right side. In addition, distort this wing slightly to give it its own identity as shown in Figure 7.24.

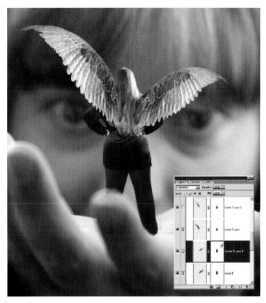

FIGURE 7.24 Right wing created.

ADDING LIGHT STREAK EFFECTS

Our angel-like character must emanate from heaven with beaming lights. Let's get started.

Step 1

Design the basic shape of the light source with the Polygonal Lasso tool on a new layer. Fill it with 50% gray and white clouds (Filter > Render > Clouds). Next, change the blend mode to Hard Light to make the gray transparent (see Figure 7.25).

Step 2

Define the streaks with Motion Blur (Filter > Blur > Motion Blur) and make sure that the angle matches the flow of the light source (see Figure 7.26).

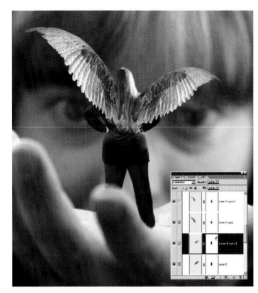

FIGURE 7.25 Light shape defined.

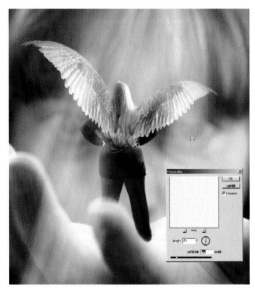

FIGURE 7.26 Motion Blur applied.

Step 3

Change the foreground color to a hue of yellow. After duplicating (Ctrl J) the light streak layer is filled with yellow (Edit > Fill > Fill With Foreground). Don't forget to make sure the Preserve Transparency is selected so that only

the white streaks are filled in. By adding a layer mask the streaks can be edited so that their transparency can be altered in various locations. This ensures that the look is not too consistent and therefore predictable (see Figure 7.27).

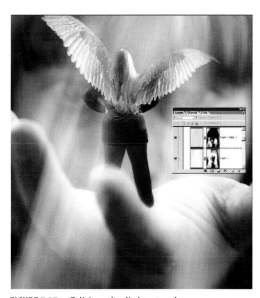

FIGURE 7.27 Editing the light streaks.

Step 4

Duplicate the light streak layer, but this time change the blend mode to Screen. Edit the mask so that localized areas of the wing tips and the palm of the hand receive the glowing effect as shown in Figure 7.28.

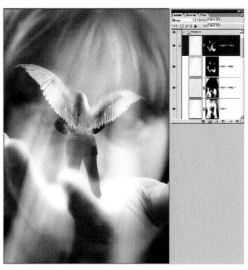

FIGURE 7.28 Duplicated light streak applied.

ON THE CD

To enhance the final image a couple of effects are added using nik Multimedia's Color Efex Pro 2. One is called Darken/Lighten Center and the other is Fog. You will find a demo on your CD-ROM. Let's finish up.

Step 5

Choose Darken/Lighten Center from the Color Efex Pro 2 selective panel (File > Automate > nik Multimedia's Color Efex Pro 2). See Figure 7.29.

FIGURE 7.29 Color Efex Pro 2 selective panel.

Next, play with the options to achieve the result you want (see Figures 7.30 and 7.31).

FIGURE 7.30 Darken/Lighten Center options.

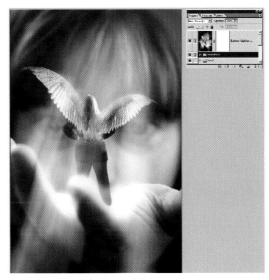

FIGURE 7.31 Final effect of filter.

Step 6

Now for the final touch. Choose Fog from the Color Efex Pro 2 selective panel and experiment with the Fog options (see Figure 7.32).

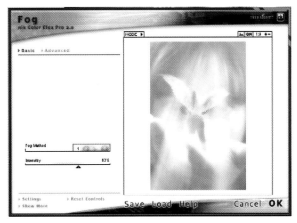

FIGURE 7.32 Fog filter options.

Step 7

All that's left to be done is to edit the mask to apply the extra glow to the perimeter of the body, the wings, and the light streaks (see Figure 7.33).

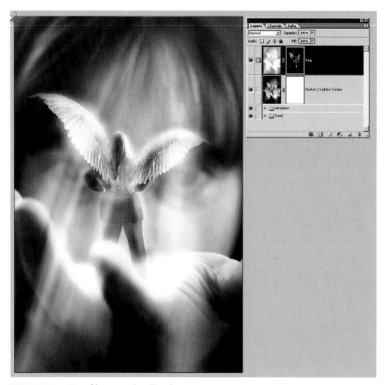

FIGURE 7.33 Fog filter mask edited.

Let's take a look at the final image shown here (Figure 7.34).

Since we have learned how to remove a solid color background, let's explore how to remove a more complicated background.

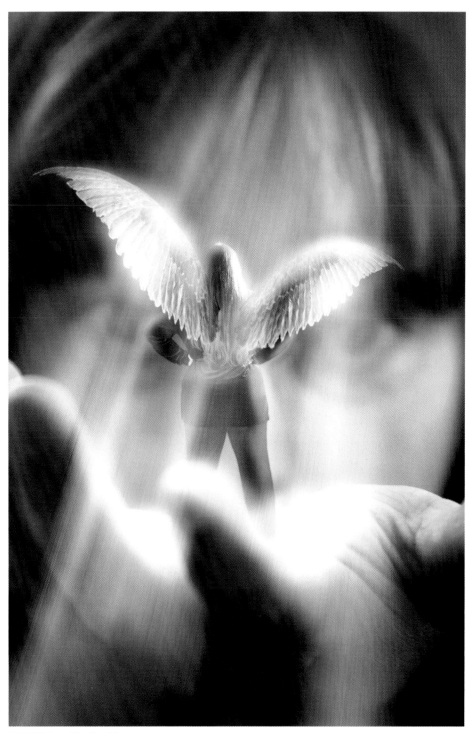

FIGURE 7.34 The final image.

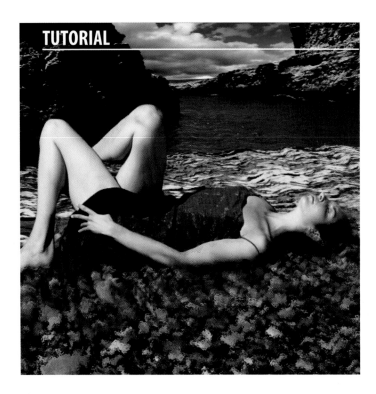

REPLACING COMPLICATED BACKGROUNDS

In this exercise the background will be removed from around the model so that she can be placed into custom-created water. This is a good example of working with an image that does not have sufficient consistent background detail to select with a single tool in Photoshop, like Color Range. There are many details and varying colors that are so similar to the main subject that we need to use a different approach to isolate the background. Let's apply this approach.

Figures 7.35 and 7.36 are the only images used to create this scene. You can access what you need to create this tutorial in the Tutorials/Chapter7–Background Removal/ on the companion CD-ROM.

Our intention is not only to remove the background but also to remove the arm above the model's head. We will retain the foreground that consists of the smooth ocean rocks.

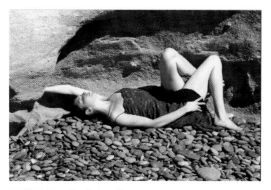

FIGURE 7.35 Reclining figure.

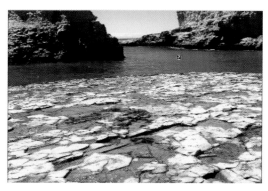

FIGURE 7.36 Coastal landscape.

Step 1

First, place the portrait on top of the waterscape into its own layer. On inspection of the portrait you'll see tonalities in the surrounding background that are too close to that of the model's hair, skin, and dress. This makes it very difficult to use tools like the Magic Wand or Color Range. To have complete control over what is selected or discarded, use Quick Mask to paint in the areas that will separate the background from the model. Activating the Paintbrush with black as the foreground color, apply the mask so that the areas intended to be discarded are painted with red (see Figure 7.37).

FIGURE 7.37 Quick Mask applied.

Step 2

After the editing is complete, switch back to selection mode to turn your Quick Mask into a selection (see Figure 7.38).

FIGURE 7.38 Marching ants applied from Quick Mask.

Step 3

Once you have the marching ants, create a layer mask. When done, the waterscape in now visible as the new background as shown in Figure 7.39.

FIGURE 7.39 Mask applied to show new background.

Step 4

Next, the lighting on the model is coming from the opposite direction in relation to the waterscape, so flip the portrait layer horizontally (Edit > Transform > Flip Horizontally). Now, create a new empty layer above the portrait. Hold the Alt key and merge all visible layers. As you can see, they merge into the new layer and leave the others untouched. Afterward, brighten up the background hills a bit using the Dodge tool to match the overall luminance of the scene as shown in Figure 7.40.

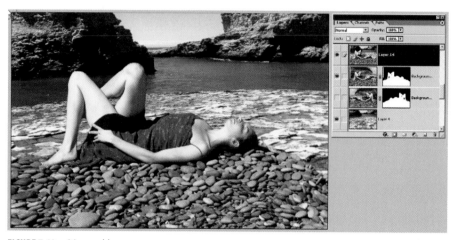

FIGURE 7.40 Merged layers.

Step 5

Going forward, duplicate the layer and apply Hue/Saturation (Ctrl U) to shift the entire image to a blue cast. The colorize check box is activated to give the image a monotone color cast and hue. In addition, the saturation sliders help to define the color's intensity. This will become the water (see Figure 7.41).

Step 6

After a mask is applied, edit the layer so that the blue image begins at the base of the mountains and stretches forward. The face, chest, legs, and finger are masked to surface above the water (see Figure 7.42).

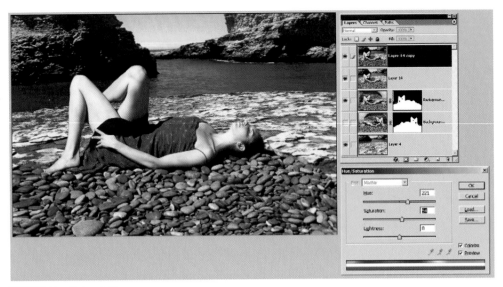

FIGURE 7.41 Color shift.

FIGURE 7.42 Masking the water.

MAKING THE WAVES

Next, we will create custom waves using the Displacement filter, but first we must create the waves using gray scale data. The Displacement filter will use white tonalities to create raised texture and darker tonalities to create valleys. The end result is a 3D effect.

Step 1

Create a new file (Ctrl N) to match the size and dimensions of the one currently being used. In addition, create a new layer and fill it with medium gray. When complete, apply the Lined Halftone pattern. (Filters > Sketch > Halftone Pattern). The colors produced are based on the foreground and background colors, so for this exercise we will use white and medium gray. Because subtlety is the goal, we don't choose black and white because they would produce too drastic a wave effect. Sometimes this can look too obvious and distract the viewer from seeing the whole creation as one harmonious piece. But then again, you can experiment (see Figure 7.43).

This filter created horizontal lines but for this example the waves will span outward to the viewer. So with Free Transform (Ctrl T) rotate the layer 90° clockwise as shown in Figure 7.44.

FIGURE 7.43　Lined halftone applied.

FIGURE 7.44　Lined halftone rotated.

Step 2

Let's make some more waves, so access the Shear filter (Filter > Distort > Shear) and apply a shape similar to that shown in Figure 7.45

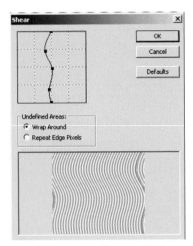

FIGURE 7.45 Shear filter applied to lined halftone.

Step 3

Even after the Shear filter is applied the image looks too consistent, so with the help of Liquefy (Filters > Liquefy) the lines can be pushed around to achieve a unique pattern (see Figures 7.46 and 7.47). Next, the file must be saved onto your hard drive as a PSD format, but since the Displace filter only reacts to

FIGURE 7.46 Liquefy filter applied to lined halftone.

FIGURE 7.47 End result of the liquefy filter.

tones of gray, the file should be changed to grayscale (Image > Mode > Grayscale). This way it is easier to anticipate how the final image will react to the displacement. Also, it's a good idea to create a folder on your hard drive that is comprised of any textures that will be used for this technique. So, when done, save it out and call it ripple.psd.

Step 4

Let's go further and give the waves some perspective as well (Edit > Transform > Perspective) by making the front end larger to give the feeling that the water is coming toward the viewer (see Figures 7.48 and 7.49). When complete, save your file again but this time title it ripple 2.psd.

FIGURE 7.48 Perspective applied.

FIGURE 7.49 Final result of Perspective.

Step 5

It's time to go back to the portrait file and make sure the layer selected is the one that will become the blue water. This is where the real fun begins. When the Displace filter is activated (Filter > Distort > Displace), leave the defaults as they are (see Figure 7.50).

FIGURE 7.50 Displace filter activated.

Next, the program needs to know which Photoshop file to use to create the effects. This is where you navigate to the folder with the texture files. In this case, choose ripple 2.psd (see Figure 7.51).

FIGURE 7.51 Displace filter navigation.

Let's see the effects of the filter as shown in Figure 7.52.

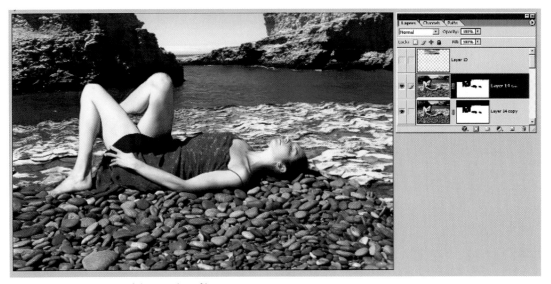

FIGURE 7.52 The results of the Displace filter.

Step 6

After duplicating the current layer, apply the Displace filters again but this time use ripple.psd as shown in Figure 7.53.

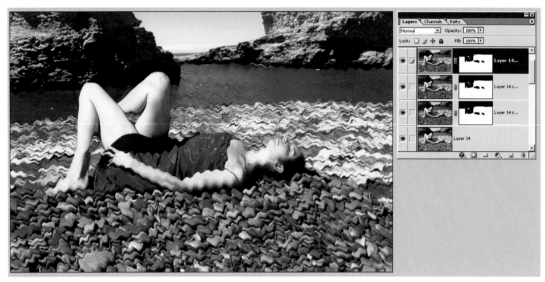

FIGURE 7.53 The Displace filter used again, but with a different ripple file used for the texture.

Step 7

Our goal is to isolate the effect from the model's shoulder toward the foreground by way of a layer mask. Now the scene looks as if there are larger waves to the rear and choppier ones in the foreground (see Figure 7.54).

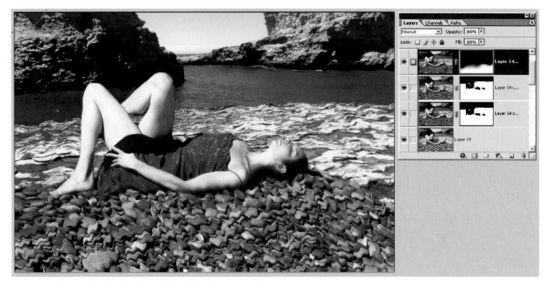

FIGURE 7.54 Displace filter isolated to the foreground.

Step 8

To simulate more of the rough water, apply the Ocean Ripple filter as shown in Figures 7.55 and 7.56 (Filter > Distort > Ocean Ripple).

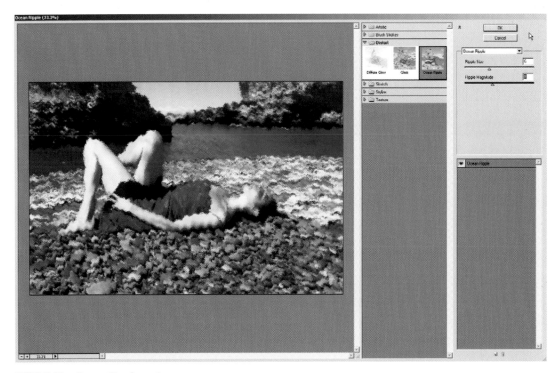

FIGURE 7.55 Ocean Ripple options.

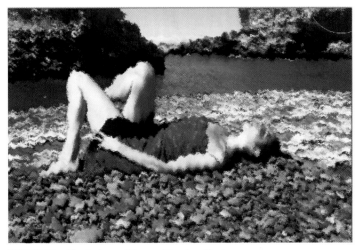

FIGURE 7.56 Final view of Ocean Ripple effect.

Step 9

As we did in Step 6, mask the Ocean Ripple effects to the foreground (see Figure 7.57).

Now that the water is complete, let's add some detail to the sky.

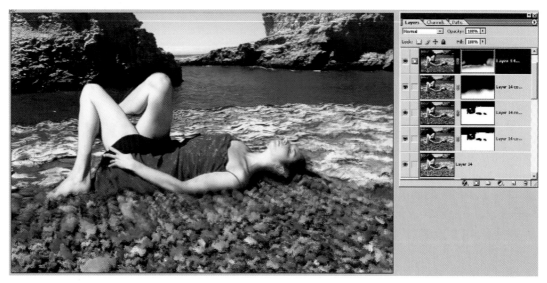

FIGURE 7.57 Masked Ocean Ripple effect.

ADDING CLOUDS

Although the sky is fairly small it is also mundane. So adding some cloud detail will spice it up a bit. We will start by accessing the layer beneath the four layers used to create the water effects.

Step 1

Since the colors in the sky are somewhat close in hue and tonality, the Magic Wand works well to isolate it (see Figure 7.58).

FIGURE 7.58 Magic Wand applied to the sky.

Step 2

After applying a mask, the results are the opposite of what we want (see Figure 7.59).

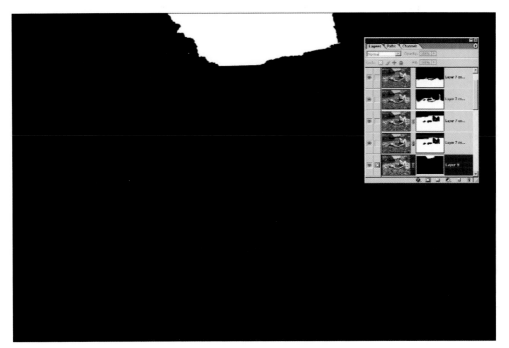

FIGURE 7.59 Mask view.

The sky region needs to be black and everything else should be white, so let's invert it (Ctrl I) as shown in Figure 7.60.

FIGURE 7.60 Inverted mask view.

Now let's place the clouds into the layer beneath the model to expose them in the sky region as shown in Figure 7.61.

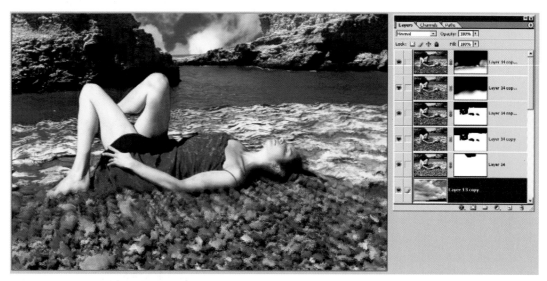

FIGURE 7.61 Cloud layer exposed.

Finally, the clouds are Free Transformed (Ctrl T) to match the perspective of the overall scene as shown in Figure 7.62.

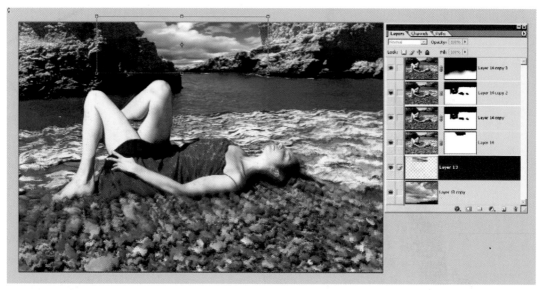

FIGURE 7.62 Cloud layer transformed.

Step 3

Taking a closer look at the edge detail of the cliffs, we see that the mask did not perfectly isolate the original sky associated with the cliffs. This can be seen on the edges of the cliff as shown in Figure 7.63.

FIGURE 7.63 Cliff detail with original sky.

By Alt-clicking on the mask the tonal detail is revealed to show a hard transition from white to black along the edges of the cliff (see Figure 7.64).

FIGURE 7.64 Mask detail.

There is very little midtone to help with the transition, so let's provide it by adding a slight Gaussian Blur as shown in Figure 7.65.

FIGURE 7.65 Gaussian Blur added to mask to soften the transition.

Step 4

Going back to the full color view of the image, you'll see that the edge detail is softened by the midtone detail produced by the Gaussian Blur as shown in Figure 7.66.

FIGURE 7.66 Color view Gaussian Blur effects.

This is essential because now we have the ability to shift the tones to expose only the details that we want. Next, making sure that the mask is selected, apply the Levels (Ctrl L) command so that the midtones can be shifted. If the midtone slider is pulled to the left, more of the original sky is exposed (see Figure 7.67).

FIGURE 7.67 Levels adjustment showing mostly original sky.

If it is pulled to the right, the sky is masked out leaving only the cliff detail. This is much more acceptable, as shown in Figures 7.68 and 7.69.

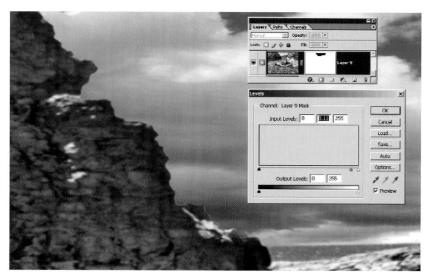

FIGURE 7.68 Levels adjustment showing mostly the cliff.

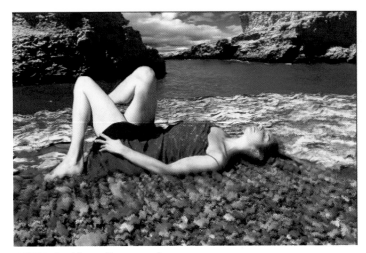

FIGURE 7.69 View of image so far.

Step 5

One last little cloud detail: they need to be color balanced to match the rest of the scene. So we apply the Color Balance adjustment layer. We add yellow and red to both the shadows and midtones of the clouds as shown in Figures 7.70 and 7.71.

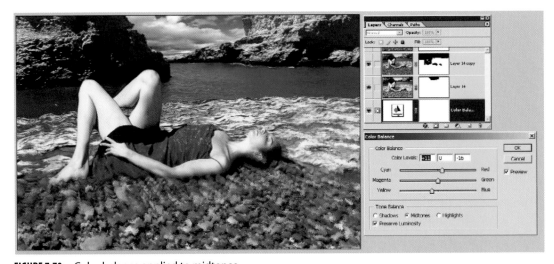

FIGURE 7.70 Color balance applied to midtones.

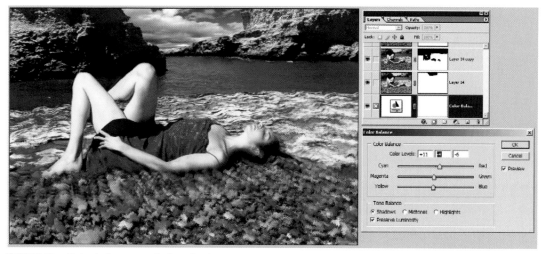

FIGURE 7.71 Color balance applied to shadows.

Step 6

The Bicolor/User-defined filter in Color Efex Pro 2.0 assists in isolating the model as the primary subject by placing color hues in the horizon and foreground of the image as shown in Figures 7.72 and 7.73.

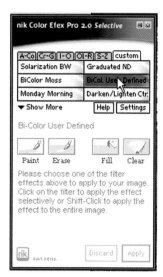

FIGURE 7.72 Bicolor/User-defined filter.

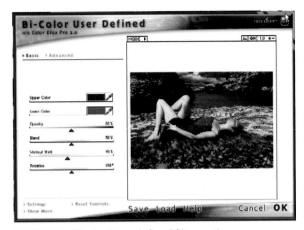

FIGURE 7.73 Bicolor/User-defined filter options.

Step 7

Because the filter causes the cloud detail to go a little dingy as shown in Figure 7.74, we need to lessen the effect by providing a mask for the sky region.

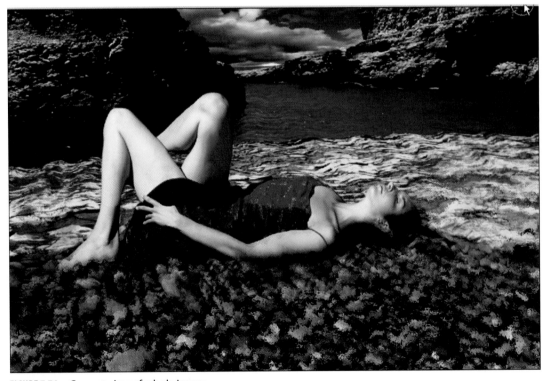

FIGURE 7.74 Current view of whole image.

Step 8

By Ctrl-clicking on the original sky mask, the marching ants are displayed as shown in Figure 7.75.

FIGURE 7.75 Activating marching ants.

Step 9

With the Color Efex Pro layer mask selected, fill the marching ants with black. Because black on the mask blocks out the visual aspects of the layer it is associated with, it gives us the original bright clouds (see Figure 7.76).

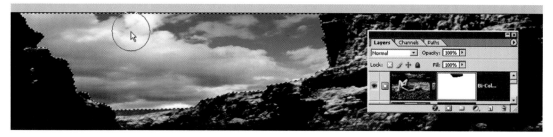

FIGURE 7.76 Marching ants filled with black to expose the original clouds.

Step 10

With the mask still selected, apply Brightness/Contrast (Image > Adjust > Brightness/Contrast) to brighten up the black tonality toward a more gray shade. This gives a 50% blend of the Color Efex Pro filter so that the effect is not so harsh (see Figures 7.77 and 7.78).

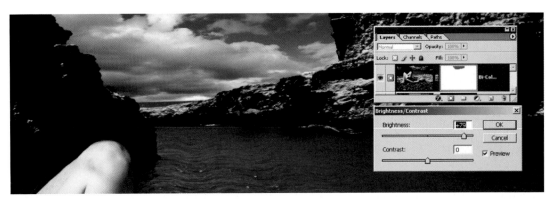

FIGURE 7.77 Changing the brightness and contrast of the image.

FIGURE 7.78 Mask view of the whole scene.

Our final view displays a complement of the brighter sky and the filtered one (see Figure 7.79).

Let's go forward, take what we have learned, and apply it to something more emotional than conceptual. Next, we will explore a fine art application of this digital language.

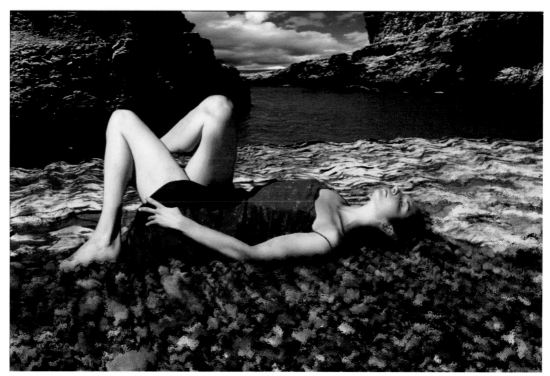

FIGURE 7.79 Final view.

WHAT YOU HAVE LEARNED

- How to isolate color using the Color Range Selection command
- FX tricks for blurring the background to create a shallow depth of field
- How to add wings to people
- How to create displacement effects from scratch
- Creative approaches to using existing images to create water

In this chapter we have created some interesting effects with people. In Chapter 8, "Fine Art Applications," we will apply the knowledge we have gained to fine art applications.

FINE ART APPLICATIONS

IN THIS CHAPTER

- How to mask out blue- or green-screened backgrounds for portraits
- How to morph animal features with human faces
- FX tricks for integrating texture with human skin
- How to create softened backgrounds to gain a shallow depth of field
- How to create fine art using everyday common images
- A painter approach to applying textures

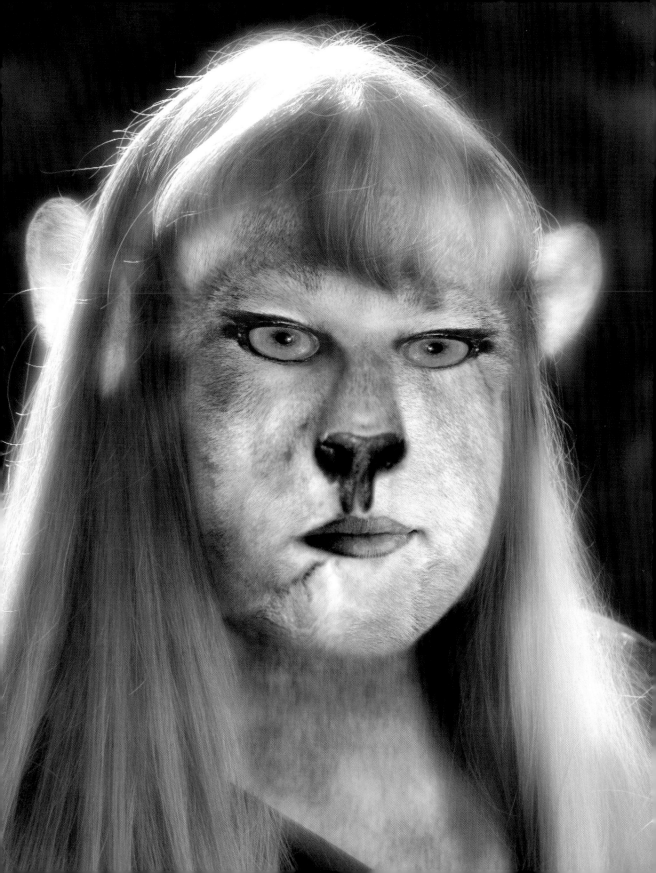

Some of the most popular fantasy movies are those where human beings are transformed into something not so human. Historically, there has always been a fascination and love of animals—especially for those that possess great speed and strength. In films, this theme is often portrayed with werewolves, but since the model in our tutorial is female, we'll use something feline—a mountain lion. Characteristics of the mountain lion include power, agility, and a sleek elegance of movement. For this tutorial the character of the lion will become the spirit of a human being.

The images were shot with the Canon EOS D-60 in the Cannon Raw format. This produced a 6.1 mega pixel file. In other words this camera is limited to a maximum of 6.1 million pixels to create each file. This equates to a file size of 18 MB. Depending on the manufacturer, each digital camera is limited to recording a limited number of pixels. Therefore, to get the most information recorded onto your storage card, photograph in Raw mode. This mode captures the raw information of the image in the form of ones and zeroes. In essence, the raw mode not only retains the most color and tonal information, but also has the ability to capture 16 bits of information. That's almost 65,000 shades of gray per channel in comparison to 256 shades of gray per channel in 8-bit

FIGURE 8.1 Portrait.

mode. This truly allows for more flexibility later on when it becomes necessary to make color and tonal alterations to the file. Shall we morph the images now?

ON THE CD

We will use three images: the model and two different perspectives of the mountain lion (see Figures 8.1 through 8.3). You can access what you need to create this tutorial in the Tutorials/Morphing/ on the companion CD-ROM.

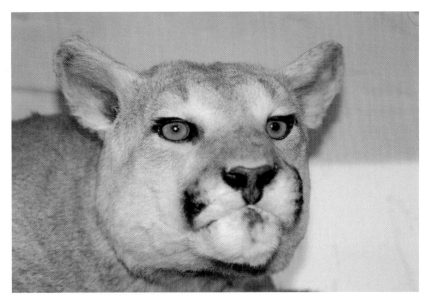

FIGURE 8.2 Lion headshot.

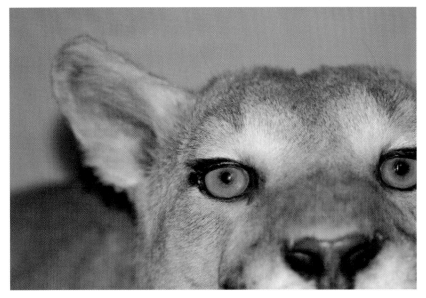

FIGURE 8.3 Lion close-up.

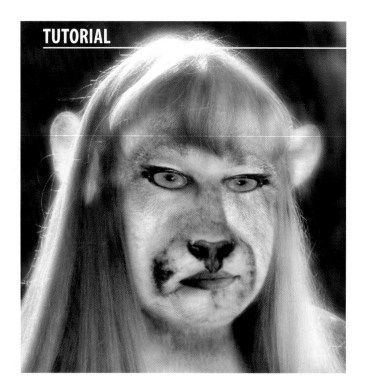

MORPHING HUMAN AND ANIMAL FACES

Our objective is to isolate the detail of the mountain lion to the flesh of the model. We will use layer masking to achieve this. It's a good idea to start with the eyes because the results can produce a character that can offer visual clues as to how to proceed with the look of the final image. Allow serendipity to guide your imagination. Try not to take control. Allow the image to speak to you and guide your imagination to the end result.

Step 1

To start, drag the close-up view of the mountain lion into the portrait file and transform it to match the size and shape of the model's left eye. The transparency is set at 50% to assist in the transformation (see Figure 8.4).

Step 2

Next, while holding the Alt key, add a layer mask to the mountain lion layer. This will add a mask that is filled with black instead of its default white. Using

the Paintbrush tool, paint with white with a low opacity to gently reveal the eye of the mountain lion as shown in Figures 8.5 and 8.6.

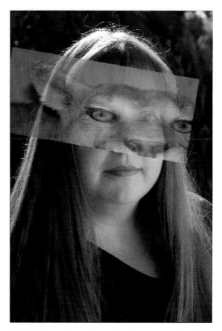

FIGURE 8.4 Morphing the lion to match the model's eye.

FIGURE 8.5 View of layer mask after it's edited.

FIGURE 8.6 Results after editing the mask.

Step 3

Duplicate the mountain lion layer (Ctrl J) and flip it horizontally (Edit>Transform>Flip Horizontally). Follow Steps 1 and 2 for the right eye and make sure that the shape of the lion's eye lines up fairly close with the model's (see Figures 8.7 through 8.9). Since this is an exercise on morphing it does not have to be perfect.

FIGURE 8.7 Morphing lion to match the model's other eye.

FIGURE 8.8 View of layer mask for left eye after it's edited.

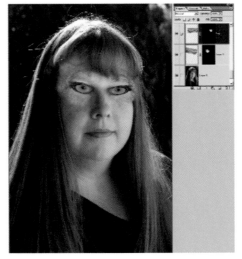

FIGURE 8.9 Results after editing the mask for the left eye.

Step 4

Now that we have the beginning of our morph let's add a little detail to her forehead. After placing another close-up of the mountain lion on top of the other layers, we create a mask filled with black and edit it to reveal the lion's fur in the region of the model's forehead as shown in Figure 8.10.

FIGURE 8.10 Mask applied to forehead.

Step 5

Let's add some fur to the neck. Transform the headshot of the lion and rotate it 90° counter clockwise so that the coat of fur overlaps the neck of the model. Then, apply a mask so that the portrait has a fury neck as shown in Figures 8.11 through 8.13.

FIGURE 8.11 Rotate lion to match the
model's neck region.

FIGURE 8.12 View of layer mask after
it's edited.

FIGURE 8.13 Visual results after editing the mask.

Step 6

Duplicate the neck layer and change its blend mode to Multiply. After applying a black mask, the richer tonalities are revealed by painting with white on the mask just underneath the chin to give contour as well as to offer the perception of a shadow (see Figure 8.14).

FIGURE 8.14 Bringing out tones by editing another mask.

Step 7

Apply the same technique for the left side of the face. This time transform the lion so that its profile lines up with the portrait (see Figures 8.15 through 8.17).

FIGURE 8.15 Transform the lion to match the left side of the model's face.

FIGURE 8.16 View of the layer mask after editing.

FIGURE 8.17 View of the image after editing the mask.

Step 8

Duplicate the mountain lion layer (Ctrl J) created in Step 7 and flip it horizontally (Edit>Transform>Flip Horizontally). Edit its mask to accommodate the right side of the face (see Figures 8.18 through 8.20).

FIGURE 8.18 Transform the lion to match the right side of the model's face.

FIGURE 8.19 View of the layer mask after it's edited.

FIGURE 8.20 Results of editing the layer.

Step 9

Continue with the technique of adding the masked lion layer. Reveal the fur to replace the black detail on the left side of the model's mouth as shown in Figure 8.21.

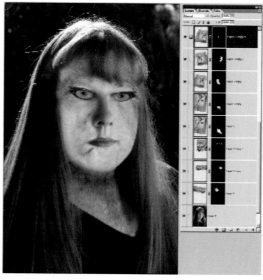

FIGURE 8.21 Continuing the placement of the masked lion layer.

Step 10

The nose is fairly straightforward. Use the straight-on headshot view of the lion and transform it to match the model's nose as closely as possible. Then use the mask to reveal its detail where desired (see Figures 8.22 and 8.23).

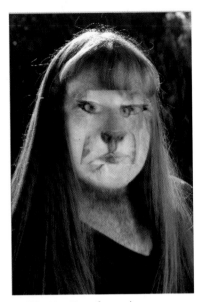

FIGURE 8.22 Transformed nose.

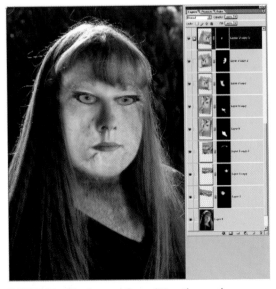

FIGURE 8.23 The image after editing the mask.

Step 11

As shown in Figures 8.24 through 8.26, the ears are added using the same technique.

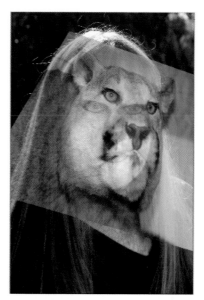

FIGURE 8.24 Positioning the lion's ear.

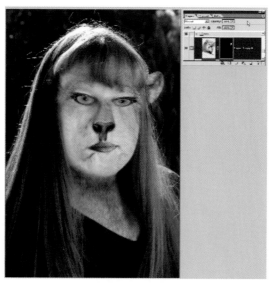

FIGURE 8.25 Removing the rest of the lion image.

FIGURE 8.26 View of the mask.

Step 12

Duplicate the mountain lion layer used to create the ear from Step 11 (Ctrl J) and flip it horizontally (Edit>Transform>Flip Horizontally). Place it so that the model has an ear on the right side of her head. Use the Distort tool (Edit>Transform>Distort) to alter the shape so that it's not obvious that the ear is a duplicate (see Figure 8.27).

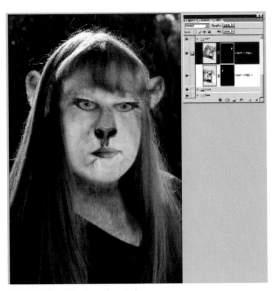

FIGURE 8.27 Placing the right ear.

Step 13

To gain some luminosity in the face we add a Levels adjustment layer. The highlight slider is moved to the base of the curve to brighten the lighter values. Since the adjustment layer has its own mask it is edited to allow the effect to take place only in the face (see Figure 8.28).

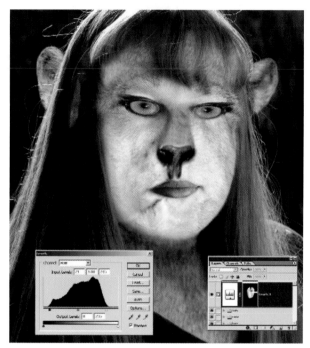

FIGURE 8.28 Levels adjustment layer applied.

Step 14

The background is slightly too busy so let's achieve a shallow depth of field. Create a new layer and make sure that it is above all of the previous ones. Holding the Alt key, merge the visible layers. The Alt key will merge all layers into the newly created one but will leave the others untouched. Then apply a Gaussian Blur (Filters>Blur>Gaussian Blur) to taste as shown in Figure 8.29.

The next procedure should be obvious to us by now. Add a layer mask and paint in the blur where you want it. In this case it is the background (see Figure 8.30).

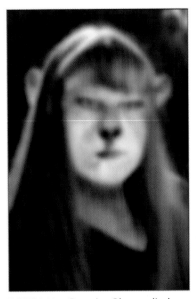

FIGURE 8.29 Gaussian Blur applied.

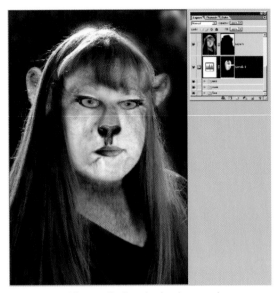

FIGURE 8.30 Blur applied to the background.

Step 15

Let's use that blur layer to add some softening effects to the model. Duplicate it and change its blend mode to Screen. This will give off a glowing softening effect that is often used for female portraits. This time edit the mask so that the face is untouched and the surrounding area receives the effect as shown in Figure 8.31.

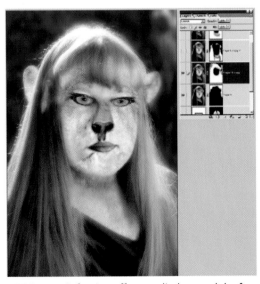

FIGURE 8.31 Softening effect applied around the face.

Step 16

Finally, duplicate the blur layer from Step 15 again and edit the mask to allow the glow to affect the hair as shown in Figure 8.32.

Figures 8.33 through 8.35 show the final image with a variation on the theme by including the lion's snout.

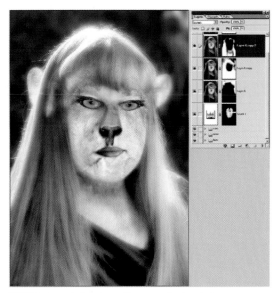

FIGURE 8.32 Softening effect applied to hair.

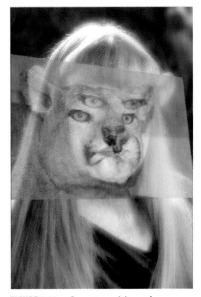

FIGURE 8.33 Snout positioned.

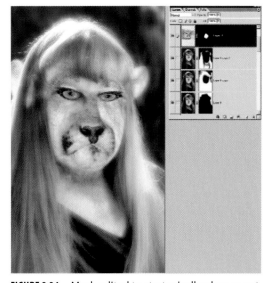

FIGURE 8.34 Mask edited to strategically place snout.

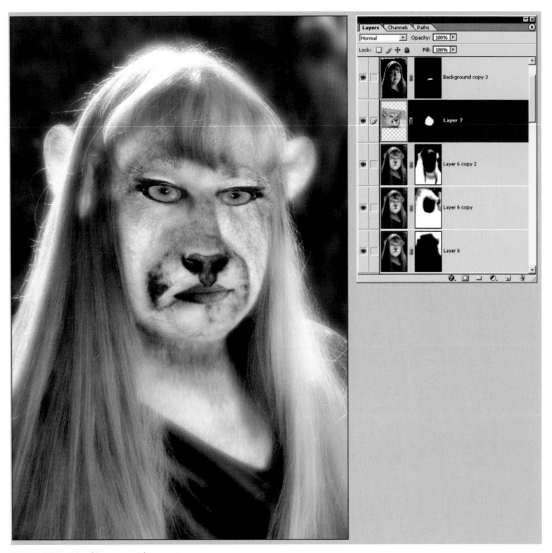

FIGURE 8.35 Final image with snout.

Now let's discover a fine art application of what we have learned.

HOW THE COVER IMAGE WAS CREATED

This is where we apply our understanding of Photoshop so that we can fluently communicate to our viewers. Being an artist is all about communication through your medium whether it is paint, stone, photography, or drawing. These mediums mean very little unless you are fluent in their language. The language that we choose is the language of digital; Photoshop is the interpreter.

The image for the cover of this book, titled *"Womb"* (see Figure 8.36), was created using dissimilar imagery in that each image has no thematic relationship to one another. Working this way not only adds mystery to the final piece but it challenges the artist to use his imagination and understanding of composition to bring forth conformity from unique and sometimes conflicting imagery. *"Womb"* was created using six images (see Figures 8.37 through 8.42).You can access what you need to create this tutorial in the Tutorials/ Chapter8–Fine Art/ on the companion CD-ROM.

ON THE CD

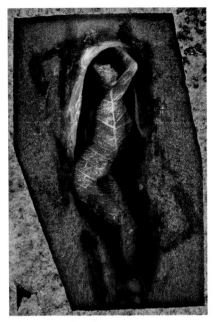

FIGURE 8.36 *Womb.*

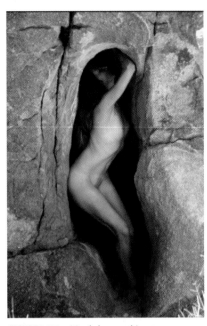

FIGURE 8.37 Model posed in stone.

FIGURE 8.38 Rust detail.

FIGURE 8.39 Aged kelp.

Each of the images was scanned with a Nikon 8000 film scanner at a resolution of 4000 pixels per inch, with the exception of the kelp, metal strap,

and watermelon leaf. Each of these was scanned directly into Photoshop using a Hewlett Packard Scanjet flatbed scanner at a resolution of 1200 pixels per inch. All of the scans produced file sizes of 55 MB plus.

FIGURE 8.40 Rusted metal strap.

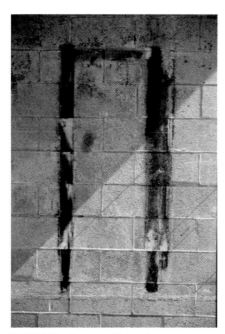

FIGURE 8.41 Stone wall detail.

FIGURE 8.42 Watermelon leaf.

Step 1

Simplifying the process by which we create is essential to produce dynamic results. In this example, layer masking is used for most of the steps. The aggressive nature of the aged kelp has an intriguing feel against the smooth skin, so a mask is applied to restrict most of the visual effects to the model (see Figure 8.43).

Step 2

The original stone that the model is posed into reveals how the image was created, so we need to insert a little unpredictability. In other words, make it less obvious how our final result was achieved. Therefore, the stone wall detail is placed on top of the kelp layer and given a blend mode of Hard Light to blend the wall aggressively with the original stone. A mask is applied to restrict its effects to the perimeter of the model (see Figure 8.44).

FIGURE 8.43 Dried kelp masked to model.

FIGURE 8.44 Wall detail applied.

Step 3

Using the Magic Wand select the black paint on the wall and fill it with black on a new layer. Set its blend mode to Hard Light. Rotate this layer 45° to the left to offset the vertical static feeling the composition has at this point. In essence, a little motion is added (see Figure 8.45).

FIGURE 8.45 Second wall detail applied.

Step 4

Step 2 is repeated but this time the mask is applied to the rust detail (see Figure 8.46).

FIGURE 8.46 Third wall detail applied.

Step 5

Next, the watermelon leaf is placed on top of all of the other layers and its blend mode is set to Hard Light as shown in Figures 8.47 and 8.48.

FIGURE 8.47 Watermelon leaf applied.

FIGURE 8.48 Watermelon leaf layer set to Hard Light.

Step 6

The watermelon leaf is masked so that it is applied mostly to the body of the model. In addition the Eraser tool is used to assist (see Figure 8.49).

FIGURE 8.49 Watermelon leaf further applied to model.

Step 7

Now it's time to create the frame as well as to create a couple of layer sets to keep organized. We will place all of the layers associated with the model in a layer set called "Figure." We will put the strap metal placed on the right edge of the image in a layer set called "Frame" to aid in visualizing the final outcome (see Figure 8.50).

Step 8

Next, duplicate it so that there are four layers positioned on each edge of the frame as shown in Figure 8.51.

Step 9

Using the Polygonal Lasso tool, draw out the shape of the frame as shown in Figure 8.52.

FIGURE 8.50 Strap metal placed into file.

FIGURE 8.51 Strap metal duplicated.

FIGURE 8.52 Frame shape outlined.

Step 10

Once the shape is outlined, use the Rubber Stamp tool to paint in the metal strap texture within the shape on a new layer as shown in Figure 8.53.

FIGURE 8.53 Frame created.

Step 11

Now that we have our frame let's add a shadow to give it some dimension. Duplicate the frame layer and fill the shape with black (Edit>Fill>Fill With Black). To fill only the shape make sure that the Preserve Transparency box is checked. Place this below the frame layer and offset it to the left and downward. Don't forget to add the Gaussian Blur to soften the edges to reduce the opacity (see Figure 8.54).

Step 12

The overall image has a dense look, so apply the Curves adjustment layer to brighten things up a bit as shown in Figure 8.55.

Step 13

The figure itself still needs luminosity, so we apply a levels adjustment layer and isolate to the body of the model as shown in Figure 8.56.

FIGURE 8.54 Frame shadow created.

FIGURE 8.55 Curves adjustment applied.

FIGURE 8.56 Levels adjustment applied.

Step 14

Finally, the kelp layer is still a little too dominant and needs to be integrated more with the model. To achieve this a layer blend mode of Overlay is used for the kelp instead of Normal. This achieves our goal as shown in Figure 8.57.

FIGURE 8.57 Overlay applied to kelp.

After giving the image a little more saturation the outcome is quite interesting (see Figure 8.58).

Understanding our tools allows us to be more effective visual communicators because tools can be applied intuitively. Being a digital artist is not only about knowing the program, it's also about expressing emotions, thoughts, and ideals without technical hindrance. When the artist achieves this he has mastered his craft.

WHAT YOU HAVE LEARNED

- How to position two layers for the purpose of morphing
- FX tricks for integrating texture with human skin
- How to create fine art using everyday common textures

In Chapter 8 we have learned tricks to create fine art using common images. Read About the CD-ROM to learn how to use the CD-ROM when creating the projects covered in this book.

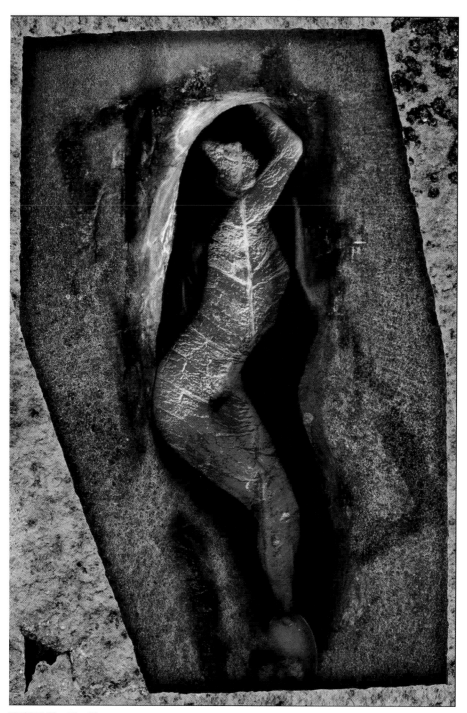

FIGURE 8.58 Final image.

ABOUT THE CD-ROM

The CD-ROM included with *Photoshop CS Trickery and FX* includes all of files necessary to complete the tutorials in the book. It also includes the images from the book in full color, and demos for you to use while working through the tutorials and exercises.

CD FOLDERS

IMAGES: All of the images from within the book are in full color in Jpeg format. These files are set up by chapter.

TUTORIALS: All of the files necessary to complete the tutorials in the book, including, backgrounds, textures, and images. These files are all in Tif formats that can be read by most graphic applications. They are set up in folders designated by chapter and tutorial heading under the Tutorial folder with the exception of Chapters 1 and 2, which is just theory and Chapter 4 where everything is created from scratch.

DEMOS: We have included a demo of Photoshop CS (PC only), Nik Multimedia's Color Efex Pro 2.0 and Nik Sharpener.

The first is a demo version of Photoshop CS. This is a 30-day time-limited fully working demo. Contact *www.adobe.com* to get student or full prices if you are interested in downloading the Macintosh version, or in purchasing this powerful package.

The second application is a demo version of Nik Multimedia's Color Efex Pro 2.0. This is a fully functioning package with no time limitations, however, a watermark stamp will appear on rendered images. A PDF user's manual is included in the Color Efex Pro folder. See *www.nikmultimedia.com* for more information.

The third application is a demo version of Nik Multimedia's Nik Sharpener Pro. This is a fully functioning package with no time limitations, however, a watermark stamp will appear on rendered images. A PDF user's manual is included in the Nik Sharpener Pro

MINIMUM SYSTEM REQUIREMENTS

System Requirements: For both systems you will need Photoshop CS. The trial version for the PC included on this CD-ROM will let you work through the projects, with no limitations with the exception that it is time limited to 30 days. The Macintosh version is available for download at *www.adobe.com*.

Windows

Intel® Pentium® III or 4 processor
Microsoft® Windows® 2000 with Service Pack 3 or Windows XP
(Adobe applications on Windows XP with Service Pack 2)
192MB of RAM (256MB recommended)
280MB of available hard-disk space
Color monitor with 16-bit color or greater video card
1,024 × 768 or greater monitor resolution
CD-ROM drive
Internet or phone connection required for product activation

Macintosh

PowerPC® G3, G4, or G5 processor
Mac OS X v.10.2.4 through v.10.3 with Java Runtime Environment 1.4
192MB of RAM (256MB recommended)
320MB of available hard-disk space
Color monitor with 16-bit color or greater video card
1,024 × 768 or greater monitor resolution
CD-ROM drive

INSTALLATION

To use this CD-ROM, you just need to make sure that your system matches at least the minimum system requirements. Each demo has its own installation instructions and you should contact the developer directly if you have any problems installing the demo. The images and tutorial files are in the Tif file format and should be usable with any graphics application.

INDEX